The Robert Lehman Collection

VIII

The Robert Lehman Collection

VIII

American Drawings and Watercolors

CAROL CLARK

The Metropolitan Museum of Art, New York
in association with
Princeton University Press, Princeton

Egbert Haverkamp-Begemann, Coordinator

Published by The Metropolitan Museum of Art

John P. O'Neill, Editor in Chief
Sue Potter, Editor
Bruce Campbell, Designer
Matthew Pimm, Production Supervisor
Jean Wagner, Bibliographer

All photographs of drawings in the Robert Lehman Collection
were supplied by The Photograph Studio, The Metropolitan Museum of Art.
Color photographs of Maurice Prendergast's watercolors were taken
especially for this volume by Karin L. Willis of The Photograph Studio

Type set by U.S. Lithograph, typographers, New York
Printed and bound by The Stinehour Press, Lunenberg, Vermont

LIBRARY OF CONGRESS CATALOGING-IN-PUBLICATION DATA
Clark, Carol, 1947–
American drawings and watercolors / Carol Clark.
p. cm.—(The Robert Lehman Collection; 8)
Includes bibliographical references and indexes.
ISBN 0-87099-639-8—ISBN 0-691-03208-4 (Princeton)
1. Drawing, American—Catalogs.
2. Drawing—19th century—United States—Catalogs.
3. Drawing—20th century—United States—Catalogs.
4. Watercolor painting, American—Catalogs.
5. Watercolor painting—19th century—United States—Catalogs.
6. Watercolor painting—20th century—United States—Catalogs.
7. Lehman, Robert, 1892–1969—Art collections—Catalogs.
8. Drawing—Private collections—New York (N.Y.)—Catalogs.
9. Watercolor painting—Private collections—New York (N.Y.)—Catalogs.
10. Drawing—New York (N.Y.)—Catalogs.
11. Watercolor painting—New York (N.Y.)—Catalogs.
12. Metropolitan Museum of Art (New York, N.Y.)—Catalogs.
I. Title II. Series
NC107.C585 1992 741.973'074'7471—dc20 92-2808 CIP

Contents

FOREWORD BY EGBERT HAVERKAMP-BEGEMANN / vii

ACKNOWLEDGMENTS / ix

NOTE TO THE READER / xi

CATALOGUE / 1

CONCORDANCE / 245

BIBLIOGRAPHY / 247

INDEX OF ARTISTS / 253

INDEX OF PREVIOUS OWNERS / 254

INDEX / 255

Foreword

The sketchbook and the nineteenth century are inextricably linked. The age of positivism spawned a need to investigate the visible world and to record it, and artists complied with enthusiasm, sensitivity, and intelligence. Never before or after have artists recorded their studies of the world around them so frequently on the pages of sketchbooks, usually small enough to fit easily into a coat pocket but sometimes larger and carried as portfolios. And they did not discard such sketchbooks but kept them as a store of motifs and ideas for later use in paintings or other works of art.

Fortunately, some nineteenth- and twentieth-century collectors understood the need to preserve these sketchbooks, however ephemeral and preliminary most of the drawings in them appeared to be. Among the great collectors of drawings around the turn of the century the most persistent and devoted in this respect was undoubtedly Etienne Moreau-Nélaton (1859–1927). His ample gifts of drawings to the Louvre included about a hundred sketchbooks, by artists from David to Gauguin, making the Louvre the greatest repository of such multiple works of art.

It is not surprising that Robert Lehman's interest in art as it reflected life drew him to the sketchbook, the artist's vehicle for recording impressions, whether of quotidian events or of sites visited and events witnessed. The narrative elements, among other features, that attracted him in European master drawings are the main emphasis of sketchbooks. Rather than acquiring European sketchbooks – few of which were available after the concerted collecting of Moreau-Nélaton and his contemporaries – he purchased some excellent ones by American artists.

In Maurice Prendergast's so-called *Paris Sketchbook* (No. 3), Robert Lehman found not only an early instance of Prendergast's fascination with people in city streets and parks but also tangible evidence of an American artist embracing the French passion for selecting and interpreting one's impressions in a sketchbook. To this sketchbook, the only one known from Prendergast's trip to Paris in 1891–94, Robert Lehman added sketchbooks recording the travel experiences of other artists in later years. Together, these form a remarkably homogeneous group. Robert Henri's sketchbook (No. 10) invites us to reexperience his lively observations of life in various Spanish cities during a trip he made in 1906, whereas the tentative and ingenuous drawings of figures, animals, and landscapes made in 1901 by Marjorie Organ (No. 20), then only fifteen years old, show us a budding young artist's early experiments with the concept of a sketchbook. David Levine's sophisticated characterizations of people who caught his eye during his Grand Tour of Europe in 1960 (No. 26), rendered with a spare line and yet so wittily defined, bring the vehicle of the sketchbook into our own time.

As if to demonstrate that there is another dimension to this type of work of art, Robert Lehman included in his collection the *Large Boston Public Garden Sketchbook* (No. 4), also by Maurice Prendergast but quite different from the *Paris Sketchbook* and from a later period (1895–97). The word "sketchbook" is valid here only in a limited sense, inasmuch as these drawings were once bound together and include a few summary sketches.

An *album* rather than a *carnet*, the *Large Boston Public Garden Sketchbook* contains finished watercolors, all approximately the same size, that are a brilliant demonstration of Prendergast's ability to create self-sufficient works of art in splendid color. Many depict scenes in the Boston Public Garden, but they are also partly fantasy, and they reflect the artist's many talents. It is possible, as the catalogue entry indicates, that Prendergast used this "sketchbook" as a presentation piece to show others, particularly potential patrons, what he was capable of, much as artisans centuries ago presented chefs d'oeuvre to guilds and patrons to document their abilities.

In the decade before he died in 1969, Robert Lehman also acquired a number of individual drawings and watercolors by Prendergast and other American artists, among them Prendergast's contemporaries George Luks, William Glackens, Elmer MacRae, and James Preston. These and the small group of sketchbooks have been catalogued by Carol Clark, who has not only thoroughly examined the originals and their characteristics as drawings, but also given us a clearer understanding of the historical and artistic circumstances that helped shape them.

Egbert Haverkamp-Begemann
John Langeloth Loeb Professor of the History of Art, Institute of Fine Arts, New York University; Coordinator of the Robert Lehman Collection Catalogue Project

Acknowledgments

Anyone who prepares a catalogue of a collection necessarily relies on the published and unpublished scholarship of others. I have been fortunate to enjoy the cooperation of many of my colleagues who generously shared their research findings with me or indicated new paths for my own work. For their guidance and assistance in many ways I would like to thank Philip S. Bergen, Robert J. Bezucha, Peter Bower, Annette Blaugrund, Stanley Cuba, Margaret Holben Ellis, Rowland Elzea, Ruth Fine, Joseph E. Garland, W. Anthony Gengarelly, James Gibb, Rebecca Hague, Elisabeth Haveles, Anne Havinga, Marie-Hélène Huet, John Krill, Cecily Langdale, Henry Lee, Cheryl Leibold, Nancy Mowll Mathews, Peter E. McCauley, Jr., Margaret F. MacDonald, Elizabeth Milroy, Leslie Paisley, Bennard B. Perlman, Helen Otis, Roy Perkinson, Sue Welsh Reed, the late Stephen Rubin, Susan Strickler, Carol Troyen, Peter A. Wick, and Elizabeth L. Will. Diana Linden is due special thanks for her skilled and perceptive research work at the very first stages of the project.

Artists, members of their families, and former owners of works in the Robert Lehman Collection welcomed my inquiries, and I am deeply grateful to Harvey Dinnerstein, the late Nancy and Ira Glackens, Alfred E. Hammer, Leslie Katz, Phyllis and Stuart Martin Kaufman, Janet J. Le Clair, David Levine, Eugénie Prendergast, and Seymour Remenick.

Robert Lehman acquired his American works from a small number of sources. I am especially indebted to Roy Davis and Cecily Langdale for responding to my many requests for them to review their records, which they did with care and appreciation for the accuracy of these provenances. I extend my thanks as well to Charles Childs, D. Roger Howlett, M. P. Naud, Antoinette Kraushaar, Carole Pesner, and the late Victor Spark for their many kindnesses and help with this as with other projects.

The staff of the Robert Lehman Collection at the Metropolitan Museum kindly accommodated me in many ways. I am especially indebted to Laurence B. Kanter, Curator of the Robert Lehman Collection, and to former departmental assistants Amy-Jo Koslow and Andrea Lowen. Librarians at the Watson Library at the Metropolitan Museum performed many services for me, and I am grateful to them and to the staffs of the following institutions: the Prendergast Archive and Study Center, Williams College Museum of Art (particularly Ann Greenwood); the Sterling and Francine Clark Art Institute Library; Frost Library, Amherst College; the Beinecke Rare Book and Manuscript Library, Yale University; Archives of American Art; the Boston Public Library (particularly Janice Chadbourne and Karen Shafts); the Bostonian Society (particularly Philip S. Bergen); the Greenwich Library (particularly Richard Hart and Carol Mead); the Historical Society of the Town of Greenwich (particularly Susan Richards). And for her administrative assistance with the project I thank Lillian Silver of Amherst College.

Several colleagues read portions of the manuscript and offered fine suggestions, many of which they will recognize but for which I hasten to absolve them of responsibility. I am grateful to Robert Getscher, William Innes Homer, Judith H. O'Toole, Gwendolyn Owens, and Richard J. Wattenmaker. I am indebted as well to Carolyn Logan for

verifying the technical descriptions of the drawings, to Jean Wagner for her work on the bibliography, and to Bruce Campbell for his fine design of the book. My greatest editorial debt is to Sue Potter for bringing to my manuscript her commitment to consistent presentation and clear writing, balanced by her concern for the nuances of scholarship, which saved me from potential embarrassments, large and small.

To Egbert Haverkamp-Begemann I happily express my appreciation for his patience with the slow progress of this research and writing. He made possible my every opportunity to study the collection, but more than that, his interest in this small part of a larger project extended from a perceptive reading of the manuscript to the role of site photographer. For all of this I am very grateful.

In this book, as in so many things, my greatest debt is to Charles Parkhurst.

Carol Clark
Professor of Fine Arts and American Studies,
Amherst College, Amherst, Massachusetts

Laurence B. Kanter, Curator of the Robert Lehman Collection, has furthered this catalogue in countless ways. He made the drawings available, supported their study, and made constructive suggestions concerning many aspects of the catalogue and its illustrations. Furthermore, without the assistance of his staff, especially Monique van Dorp and Veda Crewe, the project would never have been completed. Most constructive also was Sue Potter's careful and sensitive editing of the manuscript. I wish to thank her and those who assisted her in preparing the manuscript for the press, in particular Susan Bradford, Joanne Greenspun, Kendra Ho, Steffie Kaplan, and Jean Wagner. We are indebted to Bruce Campbell for his fine design of the catalogue and to Matthew Pimm for overseeing the production of the volume. And, as has been the case with previous volumes in this series, we are particularly grateful to Paul C. Guth, Secretary of the Robert Lehman Foundation, for his continuing assistance with the scholarly catalogue project.

Egbert Haverkamp-Begemann

Note to the Reader

The sketchbooks and drawings have been remeasured for this catalogue. Measurements have been taken through the center. Height precedes width.

"Inscription" and "inscribed" refer to comments, notes, words, and numbers presumably written by the artist who made the drawing; "annotation" and "annotated" refer to the same when added by another hand.

In the provenance sections, names and locations of dealers are enclosed in brackets. If known, the year a collector or dealer acquired a drawing or sketchbook is given after that collector's or dealer's name.

All pages of sketchbooks that contain discernible drawings, inscriptions, or annotations have been reproduced; blank pages have not been reproduced.

References to books and articles have been abbreviated to the author's name and the date of publication, and references to exhibitions have been abbreviated to city and year. The key to these abbreviations is found on pages 247–51.

CATALOGUE

James Abbott McNeill Whistler
Lowell, Massachusetts, 1834–London (Chelsea) 1903

The first years of Whistler's life were spent with his family in Massachusetts and Connecticut and in Saint Petersburg, Russia, where his father, a civil engineer, served as consultant on the construction of the railway to Moscow. Soon after his father died in Russia in 1849 Whistler and his mother and brother returned to Connecticut. In 1851 Whistler entered the United States Military Academy at West Point. He was dismissed three years later; although he excelled in his drawing classes with Robert W. Weir, he was unable to master chemistry. The next summer he left for Europe to study art. In Paris from 1855 until his move to London in 1859, he came under the influence of avant-garde critics, poets, and painters, especially Gustave Courbet and his circle, and he determined to follow their path as a modern artist.

Even after he moved to London Whistler continued to frequent Paris and to paint and exhibit his works there as well. *Symphony in White, No. 1: The White Girl* (1862; National Gallery of Art, Washington, D.C.) was rejected by the Royal Academy of Arts in 1862. When the Salon of 1863 also declined to show it, it became one of the controversial paintings in that year's Salon des Refusés. Whistler's friends enthusiastically admired the painting for its modernity in facture and meaning.

Whistler was a leading figure of the aesthetic movements of his time, and over the years he associated with Charles Baudelaire, Algernon Swinburne, Comte Robert de Montesquiou-Fezensac, Stéphane Mallarmé, and Oscar Wilde, among others. He often called his works *nocturnes, harmonies, symphonies,* or *arrangements* in specific colors and fought against literary or narrative interpretation of his subjects. He wrote in 1878 that "the picture should have its own merit, and not depend upon dramatic, or legendary, or local interest. As music is the poetry of sound, so is painting the poetry of sight, and the subject-matter has nothing to do with harmony of sound or of colour."[1]

Whistler's attempts to control the reception of his work extended to a concern with the presentation of his art, from the frames for his paintings to the design of their installation in exhibitions. He also created entire decorative interiors, of which only the Peacock Room (Freer Gallery of Art, Smithsonian Institution, Washington, D.C.), the dining room he decorated in 1876–77 for Frederick R. Leyland, has survived. The Peacock Room is remarkable for its orientalized exoticism (which became characteristic of many of Whistler's paintings from as early as 1863), but it was also renowned for the problems it caused between the artist and his patron.

The expense of countering criticism of his work ended in Whistler's bankruptcy in 1879, as a result of the celebrated libel suit he brought against John Ruskin in 1878. Ruskin had called *Nocturne in Black and Gold: The Falling Rocket* (ca. 1875; Detroit Institute of Arts) a work of "wilful imposture": "I have seen, and heard, much of Cockney impudence before now; but never expected to hear a coxcomb ask two hundred guineas for flinging a pot of paint in the public's face."[2] Whistler won the suit, but the court awarded him a farthing in damages and assessed him half the costs.

Although Whistler did not submit works to the Royal Academy after 1872 or to the Salon after 1891, he continued to present atmospheric seascapes and cityscapes, as well as innovative portraits of his family, friends, and patrons, for exhibition in London, on the Continent, and in the United States. A prolific painter and draftsman, he addressed subjects of contemporary life in prints as well; he made prints throughout his career that won him critical acclaim and commercial success. He completed a number of important sets of etchings, of French subjects, of the Thames River, and of Venice, a city he also painted in pastels.

In 1891 the French government purchased *Arrangement in Gray and Black: Portrait of the Artist's Mother* (1871; Musée du Louvre, Paris), which signaled the increased acceptance of Whistler's work during the last two decades of his life. He never returned to the country of his birth, yet he counted many American artists among his friends, and his international reputation attracted ardent followers in America as well as abroad.

NOTES:
1. Whistler, "The Red Rag," *World*, 22 May 1878, quoted in Young, MacDonald, and Spencer 1980, p. 101.
2. Ruskin, *Fors Clavigera*, letter 79 (2 July 1877), quoted in Young, MacDonald, and Spencer 1980, p. 98.

LITERATURE: Pennell and Pennell 1908; Young, MacDonald, and Spencer 1980; Lochnan 1984; Washington, D.C. 1984; Getscher and Marks 1986; Fine 1987.

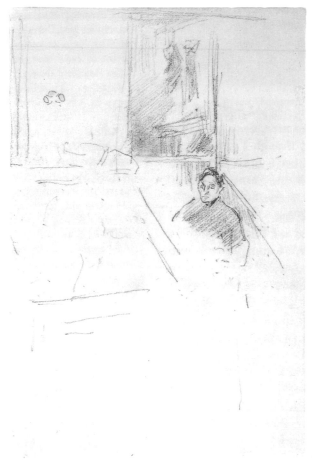

No. 1

1. Museum Interior(?) with a Man Seated, 1901

1975.1.974
Pencil. 11.9 x 7.6 cm. Signed with the butterfly in pencil upper left.

In the fall of 1900 Whistler was suffering from fatigue and poor health, and his doctor prescribed a sea voyage to a warmer climate. On 15 December he and his brother-in-law, Ronald Birnie Philip, left London for Gibraltar and from there traveled to Algiers and Tangier and then back to Marseilles. Still searching for good weather, in late January 1901 they sailed to Corsica, where they remained, at the Hôtel Schweizerhof in Ajaccio, until 1 May. During his stay on Corsica Whistler worked in one sketchbook and made a few oils, watercolors, pencil drawings, and etchings.[1] *Museum Interior(?)* is one of those drawings.[2]

Contrary to his expectations, the weather in Ajaccio did not always permit working out-of-doors, so during a particularly rainy spell in February Whistler accepted the use of a studio from the keeper of the local museum. "Now Monsieur le Conservateur of the Museum here has lent me a corner of his atelier," he wrote to his sister-in-law, Rosalind Birnie Philip, in late February. "Well I was goose enough to rush into it with joy! – and of course I cannot possibly paint under his nose! – and yet I have been doing that very absurd thing quite hopelessly & uselessly – & bothered myself to death with little ragamuffins who are entirely too wild to sit!"[3]

With the exception of views into doorways, little of Whistler's work from Ajaccio shows interiors, and although the interior in this drawing is difficult to decipher, it is quite possibly a room in the local museum.

3

Maurice Brazil Prendergast
Saint John's, Newfoundland, 1858–New York 1924

Maurice Prendergast's father, a shopkeeper in Saint John's, moved his family from Newfoundland to Boston in 1868, when Maurice and his twin sister, Lucy (who died when she was eighteen or twenty), were ten and their younger brother, Charles, was seven. Maurice left school after the eighth grade and had no formal training in art, but by his mid-thirties he had transformed himself from an amateur into a professional artist. In 1886–87 Charles Prendergast (see No. 9) made two trips to England on a cattle boat, and on the second trip Maurice went with him. In 1891 the brothers traveled to Paris. Charles left in 1892, but Maurice stayed on for nearly two more years. While he was in Paris Maurice enriched his study at the Académie Julian and in Colarossi's studio by frequenting cafés and sketching life on the city's streets. During the summers he traveled to paint in the coastal towns of Normandy and Brittany. Upon his return to Boston in 1894 he pursued a commercial career as a book illustrator and poster designer, even as his watercolors of scenes in France and at Boston's new urban parks and seaside resorts were beginning to receive favorable notice in local exhibitions.

Prendergast returned to Europe in 1898–99, this time to Italy, and there he produced works of even greater assurance. He had been back in Boston only a few months when his first major one-artist exhibition opened in March 1900 at William Macbeth's gallery in New York. The exhibition included a significant number of works in monotype, a medium he had found especially expressive during the 1890s and in which he produced an important body of work that is as highly regarded as his watercolors.

After his return from Italy Prendergast began to spend more and more time in New York. The city provided new subjects for his increasingly experimental watercolors, and he also met a number of other artists there, most notably Robert Henri, George Luks, William Glackens (see Nos. 10–15), John Sloan, Everett Shinn, Arthur B. Davies, and Ernest Lawson – the group who, with Prendergast, would become known as The Eight. In 1905–6 Prendergast stopped working for a time as he searched for a cure for his worsening deafness, but he was painting again by 1907, when he spent several months in France. His contribution to The Eight's independent exhibition at the Macbeth Gallery in 1908 included small oils he had begun in France in 1907 under the powerful influence of the Post-Impressionists and the Fauves.[1]

After 1908, although he continued to paint in watercolor, oil became Prendergast's chosen medium for major works. These new paintings were larger and less descriptive than any of his previous efforts. He continued to depict his favorite seaside and park settings, but his true subject became the control and manipulation of color, often manifest in dense and complex surfaces. About 1914–15 he experimented with an even larger format when he designed two decorative panels, *Picnic* and *Promenade*. The "decorations" (one 2 × 2.7 m, the other 2.3 × 3.4 m) were executed in oil on canvas, from Prendergast's watercolor sketches, by Walt Kuhn's Co-operative Mural Workshops in New York.[2]

Prendergast showed seven paintings at the famous International Exhibition of Modern Art (the Armory Show) in New York in 1913. In 1914 Charles won a commission to make eighteen frames for a Philadelphia insurance company, and with the $1,800 he was paid the brothers moved to New York. Both the Armory Show and the move to New York helped bring Prendergast's work to the attention of important collectors like Ferdinand Howald, Edward Root, Lillie Bliss, Albert C. Barnes, John Quinn, and Duncan Phillips, who appreciated his arcadian friezes of promenading figures that are as modern as the European art that inspired them.

NOTES:
1. For a discussion of William Macbeth and the independent exhibitions of the early 1900s, see Milroy 1991 and Owens 1991.
2. The oils are illustrated in Clark, Mathews, and Owens 1990, nos. 406, 411; for the watercolor sketches, see ibid., nos. 1183, 1214, ill. See also Bolger 1989. In his "Reminiscences of an Early Art Career," a typescript of a recording made in 1953 (Archives of American Art, Smithsonian Institution, Washington, D.C.), the painter Samuel Wood Gaylor describes working for the Co-operative Mural Workshops on a Prendergast decoration that was probably *Promenade* and mentions one other. I am indebted to Richard Wattenmaker, director of the archives, for bringing this to my attention.

LITERATURE: Boston (and other cities) 1960–61; College Park (Md.) (and other cities) 1976–77; New York 1979; Langdale 1984; Gengarelly 1989; Hitchings 1989; Clark 1990; Clark, Mathews, and Owens 1990; Madormo 1990; Mathews 1990; Owens 1990; New York (and other cities) 1990–91.

3. Paris Sketchbook, 1891–94

1975.1.923

90 pages, with 121 sketches in Conté crayon,[1] 10 in pencil, 9 in Conté crayon and pencil, and 3 in watercolor over Conté crayon, bound in a notebook with black marbled covers, a green canvas spine, and pink endpapers. 17.2 x 11.5 cm. Printed on a label on inside front cover: *PAPETERIE DES ÉTUDIANTS / et de l'Odéon N° 61 B . . . / CHÉLU & BÉNARD / F. BÉNARD, succ^r / 10, Galerie de l'Odéon / et 16, RUE DE VAUGIRARD / en face la rue de Médicis . . .* Signed, dated, and inscribed in pencil on front endpaper: *Prendergast / July 2, (or 21?) / 92, (or 94?) / pont Australitz 3.* Annotated in blue pencil on front endpaper in Charles Prendergast's hand: *90 Sketches by / Maurice Prendergast / 90 / Collection of / Charles Prendergast / Westport / Conn.* (all gone over in blue ballpoint pen). *Mrs.*, written first in pencil and then in blue ballpoint pen, added after *Collection of*, probably by Eugénie Prendergast. (*90* may also have been added.) Annotated (upside down) on recto of back endpaper in pencil in a contemporary hand: *ave Monsouris / No. 4 / 3 etage / chambre / Mlle / Chemeuse* (*Mlle Chemeuse* erased). Paginated in blue pencil, probably by Charles Prendergast (the numbers appear to be in the same hand as the annotation in blue pencil on the front endpaper), in upper right corners of rectos (except page 1, which is numbered at upper left of verso).[2] One page removed after 14v, 40v, 50v, 51v, 56v, 68v, 69v, and 74v; two pages removed after 47v; and three pages removed after 90v.

In France from at least January 1891 through the summer of 1894, Prendergast spent most of his time in Paris. He studied briefly at the Académie Julian and in Colarossi's studio, but the friendships he made and the art he saw, especially that of the Nabis and Whistler (see No. 1), had a more lasting effect. He sketched along the Parisian boulevards and in parks and cafés and spent his summers with fellow artists on the Norman and Breton coasts.

The Paris sketchbook in the Robert Lehman Collection is one of eighty-eight extant sketchbooks by Prendergast, only a few of which date to before 1900.[3] It is the only notebook from his almost four-year stay in Paris. Like the more than one hundred watercolors and small oils from that sojourn, it records part of the life of an American who in his thirties had determined to study abroad and become a professional artist. Indeed, in 1893, while he was still abroad, Prendergast began listing himself in the *Boston City Directory* as "artist," rather than "designer" or "decorator."[4]

The drawings in this small Paris sketchbook range from succinct outlines of figures to fully developed sketches, three of them with watercolor additions. They already reveal Prendergast's interest in observing women – always with an eye for current fashion – on the boulevards, in cafés and parks, and along the banks of the Seine. Occasionally, he included men in his scenes, and he also drew horses and carriages, ballerinas (which are probably related to his circus scenes), and a nun. Some nude female figures

appear opposite clothed women on facing pages, showing that Prendergast sketched from the model and was interested in the relationship between the nude and clothed figure.

The three addresses written in the book indicate that as Prendergast carried it about with him he used it as a daybook, a practice he would continue all his life. The addresses – Pont d'Austerlitz 3 (written in Prendergast's own hand on the front endpaper); 21, rue du Cherche-Midi (on 80r); and 4, avenue du Parc de Montsouris (on the back endpaper) – as well as his sketches of the Pont Neuf (29v–30r, 30v–31r, 32r), locate him along the Seine and near the Jardin des Plantes, the Jardin du Luxembourg, and the Parc de Montsouris, which was laid out in 1878 in the southern part of the city. These probably are the settings for his figural studies in the sketchbook and also for many of the watercolors he painted in Paris. Two of his highly finished, independent watercolors, *Boulevard des Capucines* (private collection) and *La Porte Saint Denis* (estate of Ned L. Pines),[5] place the artist on the fashionable boulevards of the Right Bank, areas he may have thought would appeal to potential patrons.

The sketchbook also served Prendergast as a record for later reference. Several of these sketches are studies for watercolors he completed during his stay in Paris. The woman and girl on 24r are related to the figures in *In the Bois* (Fig. 3.2).[6] The horse-drawn carriage on 42r was used in the background of *Along the Boulevard* (Fig. 3.4).[7] The drawing on 79r is a sketch for *In the Park* (Fig. 3.6).[8] The woman and girl walking in the rain on 85r appear in *Woman and Girl* (Fig. 3.7).[9] The figures on 86v and the carriages and lampposts on 87r are studies for *Paris Boulevard in the Rain* (Fig. 3.8).[10] The two women on 89v appear in *Afternoon in the Park* (Fig. 3.9),[11] and Prendergast also used the seated figure in *Two Women in a Park* (Fig. 3.10).[12] Two of the drawings, on 26r and 27r, can be related to the figures in a watercolor Prendergast finished after his return to Boston, *Two Girls on a Bridge* (Fig. 3.3).[13] Thus early in his career he had begun his practice of developing an image sketched on the street into a completed watercolor for exhibition. He worked this way in oil as well, for the girl sketched on 50v is a study for one of the figures in *Sketches in Paris* (Fig. 3.5), a group of seven panels he also painted in Paris.[14]

Prendergast's work first appeared in reproduction in 1893, when the London magazine *The Studio* published six of his sketches not only without his permission or knowledge but under the name of Michael Dignam, who had purportedly stolen them from Prendergast's studio in Paris.[15] These sketches, five of them of fashionably dressed women

Fig. 3.1 Maurice Prendergast, *Woman Walking Seen from Behind*. Ca. 1891–93. Reproduced from *The Studio* (London) 1 (1893), p. 188; collection of the Sterling and Francine Clark Art Institute, Williamstown, Massachusetts. Photograph by Le Clair Custom Color, courtesy of the Prendergast Archive and Study Center, Williams College Museum of Art, Williamstown, Massachusetts

(see Fig. 3.1) and one of riders in open carriages, resemble those in this Paris sketchbook. "Of all the most fruitful places for study to an artist with any eye for character or natural grace in men and women, what can surpass the freest of all resorts, the public thoroughfare?" began George Thomson's "Sketch-Book in the Street," one of the three articles that accompanied the sketches in *The Studio*.[16]

The first appearance of Prendergast's sketches as magazine illustrations presaged his short career in 1895–97 as a poster designer and book illustrator.[17] And, although the atmosphere of Boston hardly resembled that of Paris, he continued the practice of "sketching in the street" after he returned home in 1894. Charles Prendergast remembered one time in Boston when he and his brother went into a restaurant with another artist: "My brother brought out his notebook from the side pocket of his coat – he never went anywhere without his notebook – and started to sketch some of the young ladies in the restaurant. In Paris, if you do that sort of thing, nobody pays any attention, unless it is to look over your shoulder to see how you're getting along. Not in Boston, though. Not in those days. The manager of the restaurant came up to our table, and he was very angry. My, my! I've never seen anybody as angry as he was. He told us we were insulting the young ladies and had to get out. So we got out and never went in there again. But that's Boston, you know."[18]

NOTES:

1. I am grateful to Margaret Holben Ellis, chairman of the Conservation Center at the Institute of Fine Arts, New York University, and consulting conservator of prints and drawings at the Metropolitan Museum, for identifying the medium of most of these sketches as Conté crayon, rather than graphite pencil.
2. Note, however, that no page numbers are visible in the illustrations of 53r and 62r in Smith 1956 (p. 55) and of 53r in Brooklyn 1957 (no. 33).
3. In addition to the two sketchbooks in the Robert Lehman Collection (Nos. 3, 4), there are four in the Cleveland Museum of Art (Clark, Mathews, and Owens 1990, nos. 1479, 1483, 1544, 1552); five in the Williams College Museum of Art, Williamstown, Massachusetts (ibid., nos. 1481, 1507, 1559, 1561, 1562); one in the Wadsworth Atheneum, Hartford (ibid., no. 1532); one in the Delaware Art Museum, Wilmington (ibid., no. 1547); and one at the Spanierman Gallery, New York (ibid., no. 1554). The remaining seventy-four are in the Museum of Fine Arts, Boston (ibid., nos. 1475, 1478, 1480, 1482, 1484–1506, 1508–31, 1533–43, 1545, 1546, 1548–51, 1553, 1555–58, 1560).
4. See ibid., pp. 726–27.
5. Ibid., nos. 541, 542, ill.
6. Ibid., no. 555, ill.
7. Ibid., no. 547, ill.
8. Ibid., no. 573, ill.
9. Ibid., no. 552, ill.
10. Ibid., no. 549, ill.
11. Ibid., no. 581, ill.
12. Ibid., no. 580, ill.
13. Ibid., no. 603, ill.
14. Ibid., no. 14d, ill.
15. *The Studio* 1 (1893), pp. 187–91; Clark, Mathews, and Owens 1990, no. 1765a–f, ill. See also Brooks 1938, p. 566.
16. Quoted in Clark 1990, pp. 24–25.
17. See Clark, Mathews, and Owens 1990, nos. 1766–76.
18. Quoted in Basso 1946, pt. 2, p. 32.

PROVENANCE: Charles Prendergast, 1924; his widow, Eugénie Prendergast, 1948; Robert Lehman, 1961.

EXHIBITED: Brooklyn 1957, no. 33, ill. (53r); Boston (and other cities) 1960–61 (at Boston only; not in catalogue); New York 1976–77, no. 46; New York 1982, no. 45; Williamstown (Mass.) 1985, no. 26; New York 1988.

LITERATURE: Smith 1956, p. 55, ill. (53r, 62r); Wick in M. Prendergast 1960, p. 12; Oklahoma City–Memphis 1981–82, p. 11, fig. 1 (2v–3r); Clark, Mathews, and Owens 1990, no. 1476; Parkhurst 1990, p. 76.

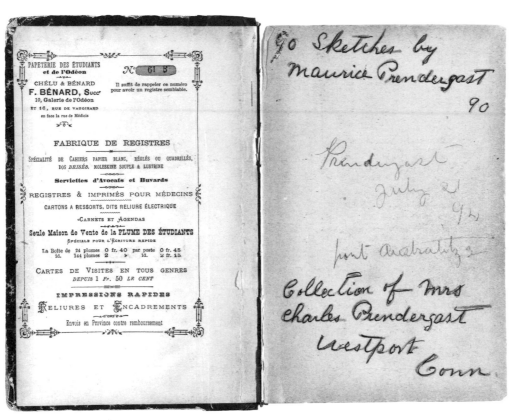

1r. Blank.

1v. Working men in the street. Conté crayon.

2r. Two horses, one facing right, the other left. Conté crayon.

No. 3, inside front cover and recto of front endpaper

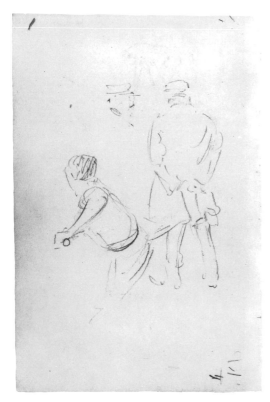

No. 3, 1v

No. 3, 2r

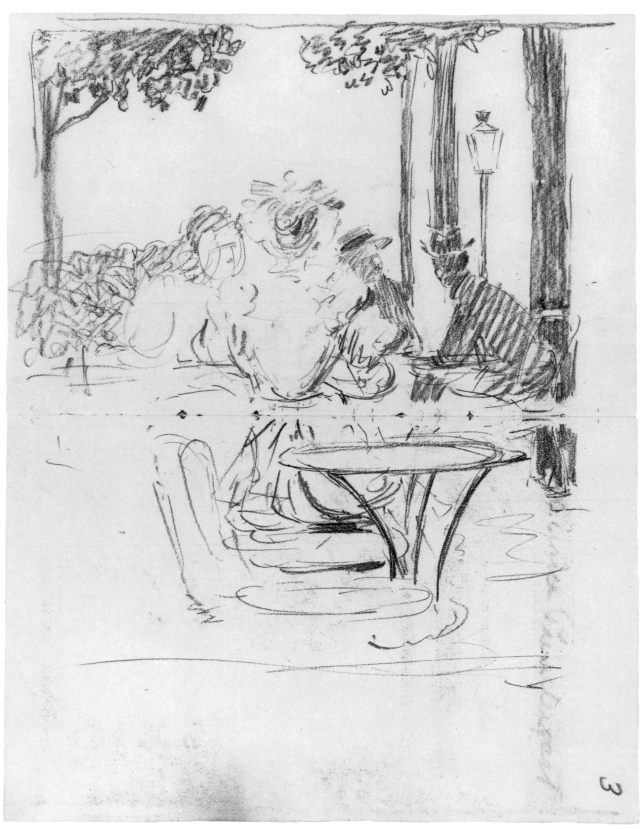

No. 3, 2v–3r

2v–3r. Two-page sketch of men and women at an outdoor café. Conté crayon; bordered. *aurice Prendergast* traced through onto 3r when the front endpaper was annotated.

3v. A street sweeper and two horses. Conté crayon.

4r. A horse in harness facing right, with other sketches of horses. Conté crayon.

4v. A horse facing left. Conté crayon.

No. 3, 3v

No. 3, 4r

No. 3, 4v

No. 3, 5r

No. 3, 5v

No. 3, 6r

5r. A horse walking toward the left. Conté crayon.

5v. Two horses, one walking toward the right, the other toward the left. Conté crayon.

6r. A horse facing left, the hindquarters of a horse, and a carriage with a driver. Conté crayon.

6v. Blank.

7r. A woman wearing a hat. Conté crayon.

7v. A horse(?). Conté crayon.

8r. A horse seen from behind. Conté crayon.

8v. A horse facing right. Conté crayon.

No. 3, 7r

No. 3, 7v

No. 3, 8r

No. 3, 8v

No. 3, 9r

No. 3, 9v

No. 3, 10r

No. 3, 10v

No. 3, 11r

No. 3, 11v

No. 3, 12r

9r. A horse in harness with a blanket, facing left. Conté crayon.

9v. A horse in harness facing right. Conté crayon.

10r. A horse in harness facing right. Conté crayon.

10v. A horse facing right. Conté crayon.

11r. A horse seen from behind. Conté crayon.

11v. A horse seen from behind. Conté crayon.

12r. A horse seen from behind and a horse facing left. Conté crayon (the back view of a horse) and pencil (the horse facing left).

12v. Blank.

13

No. 3, 13r

14

No. 3, 14r

No. 3, 14v

13r. A woman and a girl walking toward the left. Conté crayon.

13v. Blank.

14r. Two (or three?) women facing left, with the head of a man in a top hat in the background. Conté crayon.

14v. Two girls, one crouching, the other lying down. Pencil.

Page removed between 14v and 15r.

15r. Blank.

15v–16r. Two-page sketch of a woman with a parasol seated on a chair and a girl standing behind another chair in a garden. Conté crayon.

16v. Blank.

No. 3, 15v–16r

No. 3, 17r

17r. Head and shoulders of a woman against a background of trees. Conté crayon; bordered.

17v. Blank.

18r. Blank.

18v–19r. Two-page sketch of two women, one holding a closed parasol, seated on chairs in a garden. Conté crayon; bordered.

19v. Blank.

20r. Head and shoulders of a woman with a parasol. Conté crayon. This appears to be the same woman as in the more developed sketch on 20v.

20v. A woman with a parasol standing in a garden. Conté crayon. See 20r.

21r. Blank.

No. 3, 20r

No. 3, 20v

No. 3, 18v–19r

No. 3, 21v–22r

21v–22r. Two-page sketch of women with parasols seated on chairs in a garden. Conté crayon.

22v. Blank.

23r. A woman and a girl facing right, with another girl to the right. Pencil; bordered.

23v. Blank.

24r. A woman and a girl seen from behind. Pencil. Two similar figures appear in the watercolor *In the Bois* (Fig. 3.2).

24v. Blank.

25r. A woman with her arms raised. Conté crayon.

25v. Blank.

No. 3, 23r

No. 3, 24r

No. 3, 25r

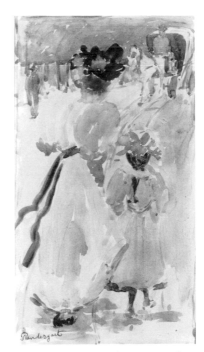

Fig. 3.2 Maurice Prendergast, *In the Bois*. Watercolor, ca. 1893–94. Collection of George K. Allison. Photograph courtesy of M. B. McKenzie, New York

No. 3, 26r

No. 3, 27v

26r. A girl looking out over a balustrade. Conté crayon. This girl resembles the figure on the left in the watercolor *Two Girls on a Bridge* (Fig. 3.3), and the same girl is sketched at the left on 26v–27r.

26v–27r. A woman leaning on a balustrade and looking toward a girl. Conté crayon. This sketch is related to the watercolor *Two Girls on a Bridge* (Fig. 3.3). See also 26r.

27v. Women seated on the ground. Conté crayon.

No. 3, 26v–27r

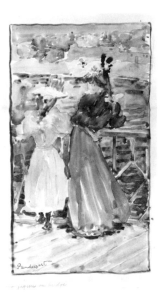

No. 3, 28r

Fig. 3.3 Maurice Prendergast, *Two Girls on a Bridge*. Watercolor, ca. 1895–97. Collection of Mr. and Mrs. Herbert Gussman. Photograph courtesy of the Photograph Archives of the National Gallery of Art, Washington, D.C., from a negative made by Taylor and Dull for Parke-Bernet Galleries

28r. Three women, one reading a book, and a small child seated on the ground. Conté crayon.

28v–29r. Two-page sketch of women seated along the tree-lined bank of the Seine. Conté crayon; bordered.

No. 3, 28v–29r

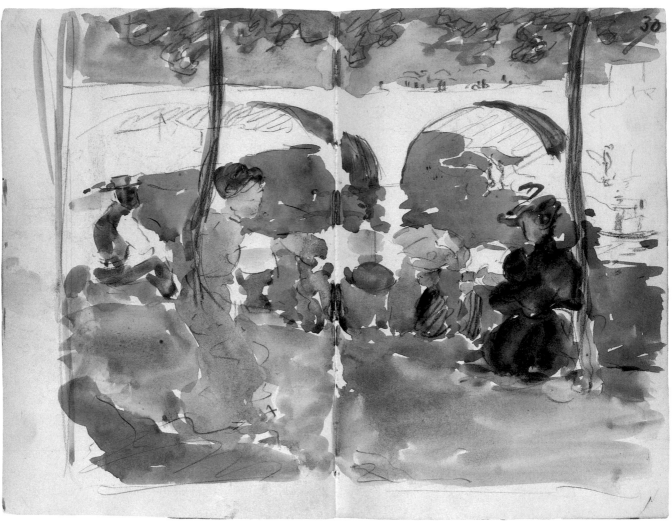

No. 3, 29v–30r

29v–30r. Two-page sketch of men and women standing and sitting on the tree-lined bank of the Seine. Watercolor over Conté crayon and some pencil; bordered in Conté crayon and watercolor. The bridge is probably the Pont Neuf.

30v–31r. Two-page sketch of women and children seated on the bank of the Seine near a stand of trees. Watercolor over Conté crayon. The bridge is probably the Pont Neuf.

31v. Blank.

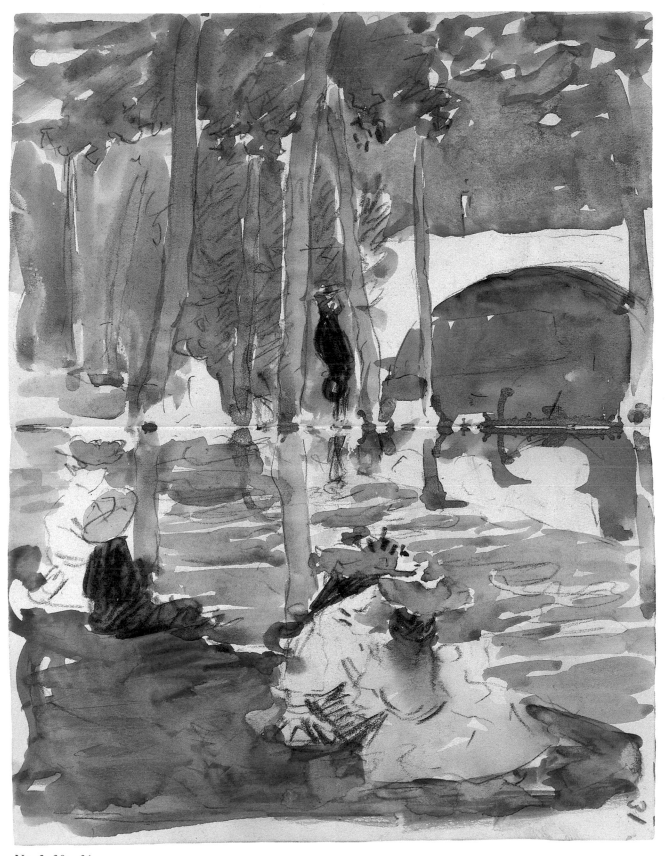

No. 3, 30v–31r

No. 3, 32r

No. 3, 32v

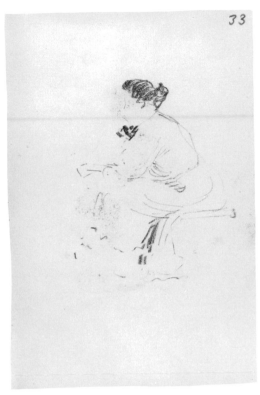

No. 3, 33r

No. 3, 34r

32r. Women seated on the tree-lined bank of the Seine, with a boat in the middle ground. Watercolor over Conté crayon; bordered in Conté crayon and watercolor. This watercolor was still wet when the sketchbook was closed, so that it smudged the opposite page. The bridge in the distance is probably the Pont Neuf.

32v. A woman, probably a nursemaid, seated on a folding stool with her head in her hands. Conté crayon. The same woman appears on 33r.

33r. A woman seated on a folding stool, facing left, with her elbow on her knee. Conté crayon. See 32v.

33v. Random marks in Conté crayon.

34r. A man wearing a hat and lying on the ground on his stomach. Conté crayon.

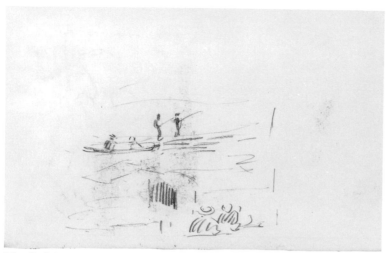

No. 3, 34v

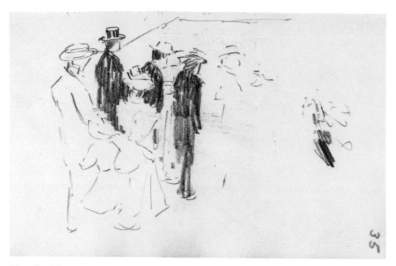

No. 3, 35r

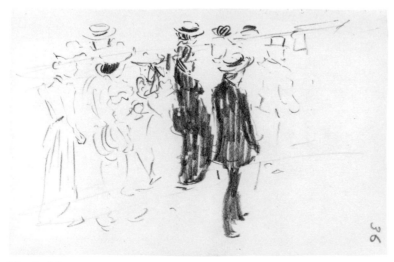

No. 3, 36r

34v. Men in boats on the river and two men fishing from the shore. Conté crayon.

35r. A crowd of men, women, and children on a street. Conté crayon.

35v. Blank.

36r. A crowd of men, women, and children on a street. Conté crayon.

36v. A crowd of men, women, and children standing on a street corner, seen from above. Conté crayon.

37r. A crowd of men, women, and children. Conté crayon.

37v. Blank.

38r. An open carriage with a driver. Conté crayon.

38v. A ballerina or circus performer in a tutu. Conté crayon.

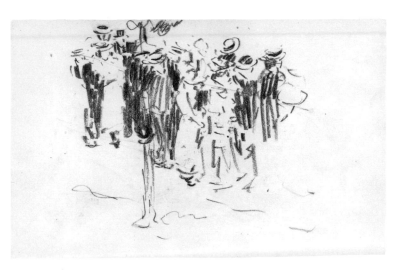

No. 3, 36v

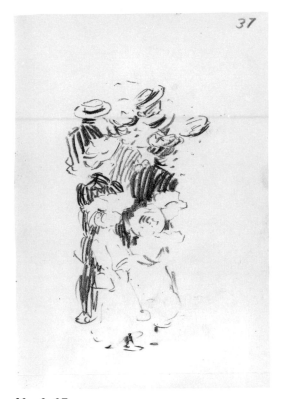

No. 3, 37r

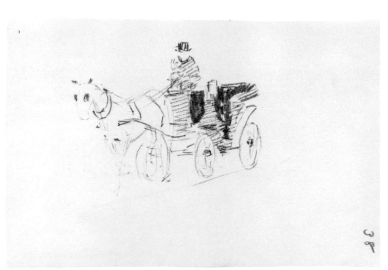

No. 3, 38r

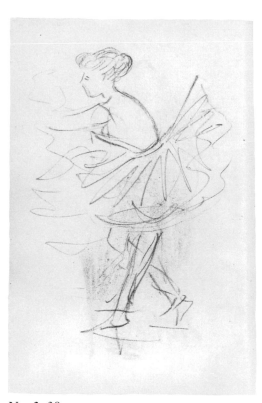

No. 3, 38v

No. 3, 39r

No. 3, 39v

39r. A nun carrying a closed umbrella or parasol. Conté crayon.

39v. A nude female figure seated on a chair. Conté crayon.

40r. Two women, one carrying a parasol. Conté crayon.

40v. Two women, one carrying a parasol and running, the other riding in an open carriage. Conté crayon.

No. 3, 40r

No. 3, 40v

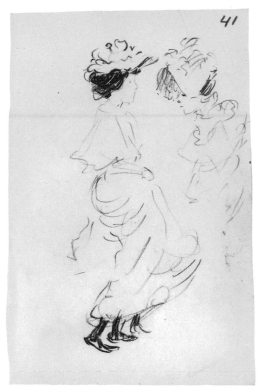

No. 3, 41r

No. 3, 41v

Page removed between 40v and 41r.

41r. Two women, both wearing elaborate hats, one gathering up her skirt in front of her as they converse. Conté crayon. Two diagonal creases at upper right.

41v. A woman carrying a parasol and gathering up her skirt in her left hand as she walks. Conté crayon.

42r. A carriage with a driver and a sketch of a horse's head. Conté crayon. Two diagonal creases in upper right corner. The carriage appears in the background of the watercolor *Along the Boulevard* (Fig. 3.4).

No. 3, 42r

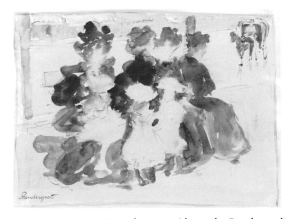

Fig. 3.4 Maurice Prendergast, *Along the Boulevard*. Watercolor, ca. 1893–94. Albright-Knox Art Gallery, Buffalo, The Room of Contemporary Art Fund. Photograph by Sherwin Greenberg, McGranahan and May, Buffalo

No. 3, 42v

No. 3, 43r

42v. A nude female figure walking or stepping up. Conté crayon.

43r. A woman carrying a closed parasol or umbrella. Conté crayon; bordered.

43v. Two standing nude female figures. Conté crayon.

44r. A woman holding up her skirt as she walks toward the right. Conté crayon.

44v. Two standing nude female figures. Conté crayon. See 45r.

45r. Two women in hats, the one in the foreground gathering up her skirt in her right hand as she walks toward the viewer, the other, at the right, standing facing left. Conté crayon (the figure at the left) and pencil (the figure at the right). The pose of the woman in the foreground, who is wearing a veiled hat, is the same as that of the nude on the left in 44v.

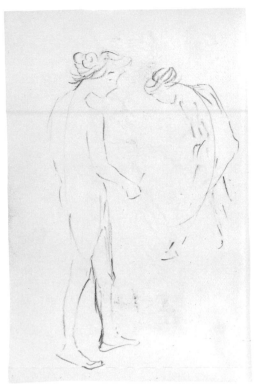

No. 3, 43v

No. 3, 44r

No. 3, 44v

No. 3, 45r

No. 3, 45v

No. 3, 46r

No. 3, 46v

No. 3, 47r

No. 3, 47v

No. 3, 48r

45v. Head and shoulders of a woman in a hat and the head of a woman in a veiled hat. Conté crayon. See 46r.

46r. Head and shoulders of a woman in a hat. Conté crayon. The same woman is sketched at the bottom of 45v.

46v. Two seated nude female figures, facing right. Conté crayon.

47r. A woman walking toward the right. Conté crayon.

47v. Head of a man and two standing nude female figures. Pencil.

Two pages removed between 47v and 48r.

48r. Storefronts and steps(?). Conté crayon.

48v. A woman gathering up her skirt in her right hand as she walks toward the right. Conté crayon and pencil.

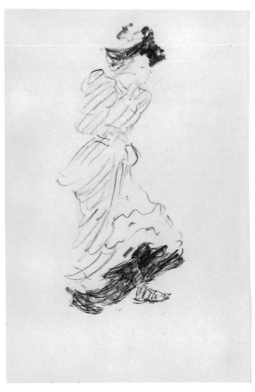

No. 3, 48v

No. 3, 49r

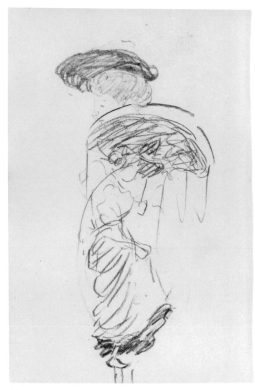

No. 3, 49v

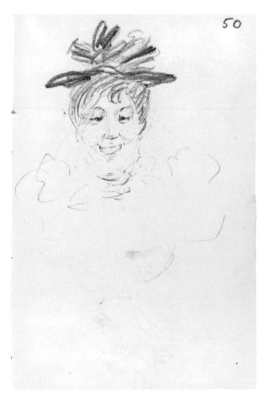

No. 3, 50r

49r. Head of a smiling girl and an indecipherable sketch. Conté crayon (the sketch) and pencil (the girl's head).

49v. Head of a woman wearing a hat and a woman carrying a parasol or umbrella and gathering up her skirt in her right hand. Conté crayon (the woman with the umbrella) and pencil (the woman's head).

50r. Head and shoulders of a smiling woman wearing a prominent hat. Pencil.

50v. A girl walking toward the right. Conté crayon and pencil. The same girl appears in one of Prendergast's *Sketches in Paris* (Fig. 3.5), seven oil panels he painted in Paris in about 1892–94.

Page removed between 50v and 51r.

51r. Head of a smiling woman superimposed on a sketch of a woman wearing a short cloak. Conté crayon (the woman's head) and pencil (the figure).

51v. Head and shoulders of a woman wearing a hat and facing right and two sketches of the face of a woman or girl in right profile. Pencil.

Page removed between 51v and 52r.

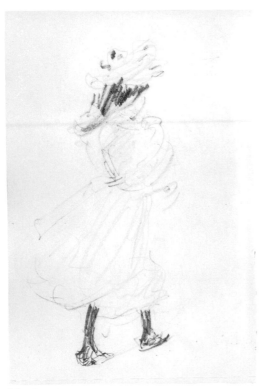

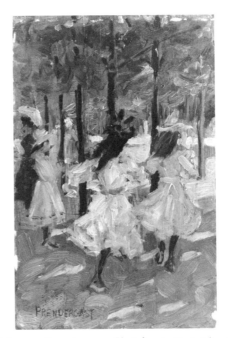

Fig. 3.5 Maurice Prendergast, *Sketches in Paris* (detail). Oil on panel, ca. 1892–94. Addison Gallery of American Art, Phillips Academy, Andover, Massachusetts

No. 3, 50v

No. 3, 51r

No. 3, 51v

No. 3, 52r

No. 3, 52v

No. 3, 53r

No. 3, 53v

No. 3, 54r

No. 3, 54v

No. 3, 55r

52r. Three women's faces below the head and shoulders of a woman wearing a prominent hat and facing left. Conte crayon.

52v. Three men, one pushing a cart. Conté crayon.

53r. Two women seated in a garden, one doing needlework(?), the other, her foot on a small garden fence, reading a book. Conté crayon.

53v. Two men, one walking toward the right, the other standing facing left. Conté crayon.

54r. A closed carriage with a driver. Conté crayon.

54v. Two men seated at a table. Conté crayon.

55r. A man seated on a chair facing right and two men's heads in profile. Conté crayon. Vertical tear at upper left.

No. 3, 55v

No. 3, 56r

No. 3, 56v

55v. A horse walking toward the left and a nude woman seated on a chair arranging her hair. Conté crayon.

56r. A closed carriage and a woman walking toward the left. Conté crayon.

56v. A crowd of girls and women, some protected by parasols, on a street. Conté crayon.

Page removed between 56v and 57r.

57r. A girl carrying a parasol. Conté crayon.

57v. A man seated with his legs crossed reading a newspaper. Conté crayon.

58r. A man with a cane seated on a bench, with a sketch of the head and shoulders of another man to the right. Conté crayon with some touches of pencil in the seated man's hair.

58v. Two girls, one carrying a parasol. Conté crayon.

No. 3, 57r

No. 3, 57v

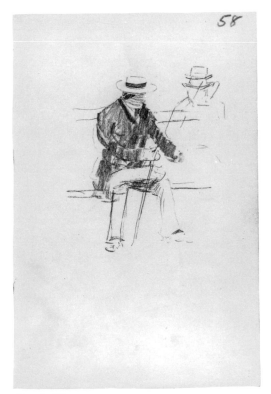

No. 3, 58r

No. 3, 58v

No. 3, 59r

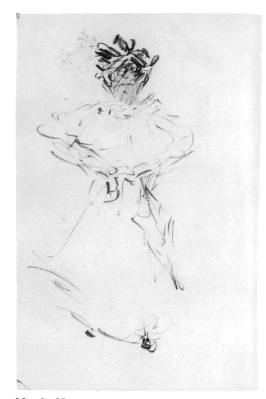

No. 3, 59v

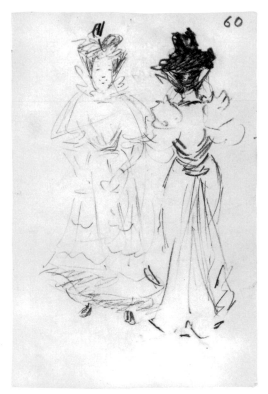

No. 3, 60r

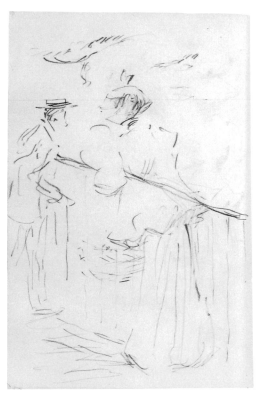

No. 3, 60v

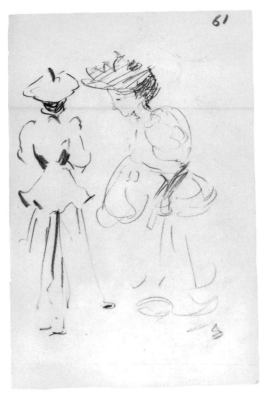

No. 3, 61r

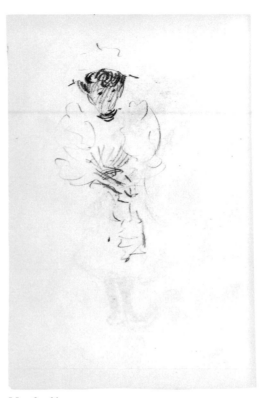

No. 3, 61v

59r. A woman wearing a hat and standing facing right. Conté crayon.

59v. A woman wearing an elaborate veiled hat and carrying a closed parasol. Conté crayon.

60r. Two women, one seen from behind, conversing. Conté crayon.

60v. A man and woman looking over a balustrade. Conté crayon with some pencil in the woman's skirt and hat.

61r. Two women in hats, one seen from behind, the other facing left. Conté crayon.

61v. Half-length figure of a woman wearing a veiled hat. Conté crayon.

62r. A girl with a sash tied in a large bow at the back. Conté crayon.

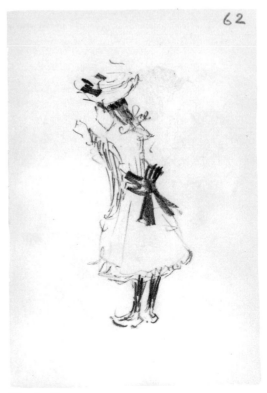

No. 3, 62r

No. 3, 62v

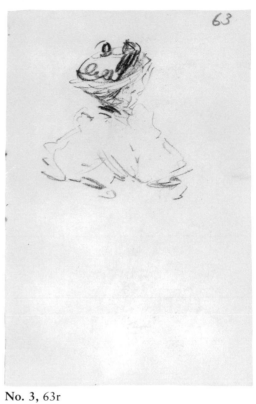

No. 3, 63r

No. 3, 63v

No. 3, 64r

No. 3, 64v

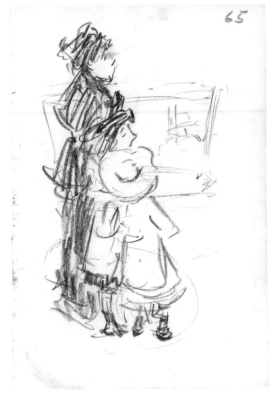

No. 3, 65r

62v. Men and women seated at tables at an outdoor café. Conté crayon.

63r. Head and shoulders of a woman wearing an elaborate hat. Conté crayon.

63v. Two ballerinas or circus performers in tutus. Conté crayon.

64r. A woman riding in a carriage. Conté crayon.

64v. A ballerina or circus performer in a tutu. Conté crayon.

65r. A woman and two girls on a street. Conté crayon.

65v. A woman wearing an elaborate hat and reading on a park bench. Conté crayon. The legs of the bench continue onto 66r. Women sitting on a similar park bench are the subject of *The Tuileries Gardens, Paris* (Fig. 4.6), a small oil Prendergast painted in about 1892–94, during this same stay in Paris, and a woman in a pose much like that of this woman appears on page 11r of the *Large Boston Public Garden Sketchbook* (No. 4).

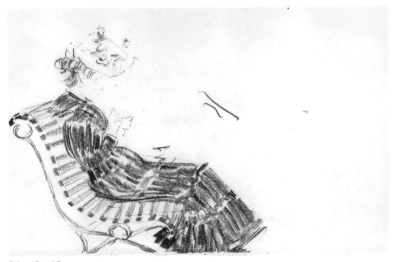

No. 3, 65v

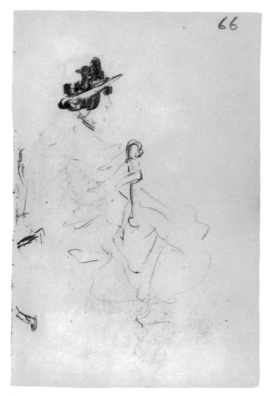

No. 3, 66r

No. 3, 66v

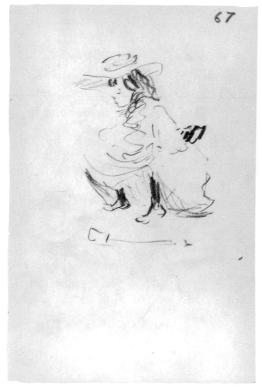

No. 3, 67r

No. 3, 67v

No. 3, 68r

No. 3, 68v

No. 3, 69r

66r. A seated woman wearing an elaborate hat and holding a closed parasol. Conté crayon. See also 65v.

66v. A girl walking, seen from behind. Pencil.

67r. A crouching girl facing left. Conté crayon. See 67v and 68r.

67v. Two girls, the older one sitting on a bench and the younger one standing in front of her. Conté crayon. The younger girl appears on 67r and 68r.

68r. Two sketches of a crouching girl facing left. Conté crayon. The same girl appears on 67r and 67v.

68v. A crouching girl facing right. Conté crayon.

Page removed between 68v and 69r.

69r. A crouching girl with her head turned to face the artist. Conté crayon. Vertical tear at upper left.

No. 3, 69v

No. 3, 70r

No. 3, 70v

No. 3, 71r

No. 3, 71v

No. 3, 72r

No. 3, 72v

69v. Legs and skirt of a crouching girl and a nude female figure seated on a chair. Conté crayon.

Page removed between 69v and 70r.

70r. Head of a woman wearing a prominent hat and facing right. Conté crayon. See 71r.

70v. A nude female figure seated on a chair. Conté crayon.

71r. Head and shoulders of a woman wearing a large hat. Conté crayon. The same woman appears on 70r.

71v. A woman in a veiled hat walking and carrying a closed parasol. Conté crayon.

72r. Heads and shoulders of a woman and a girl against a background of trees. Conté crayon.

72v. A woman protected by a parasol and seated on a bench by a window. Conté crayon. See 73v.

No. 3, 73r

No. 3, 73v

No. 3, 74r

No. 3, 74v

No. 3, 75r

No. 3, 76r

73r. A woman and a girl seated on chairs in a park. Conté crayon.

73v. A woman with a parasol seated on a bench and looking out a window. Conté crayon. The same woman is sketched on 72v.

74r. Heads of three women wearing hats. Conté crayon.

74v. Two women seated on chairs in a park. Conté crayon.

Page removed between 74v and 75r.

75r. A girl seen from behind seated on a chair. Conté crayon. Diagonal crease at upper right. See 76r.

75v. Blank.

76r. Two girls seated on chairs and talking. Conté crayon. Diagonal crease at upper right. The girl at the right appears on 75r.

76v. Blank.

77r. Blank. Diagonal crease at upper right.

77v. Blank.

78r. Blank.

78v. Two women seated on benches in a park. Conté crayon.

No. 3, 78v

No. 3, 79r

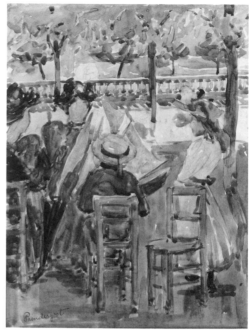

Fig. 3.6 Maurice Prendergast, *In the Park*. Watercolor, ca. 1893–94. Fine Arts Museums of San Francisco, Achenbach Foundation for Graphic Arts, Memorial Gift from Dr. T. Edward and Tullah Hanley, Bradford, Pennsylvania

No. 3, 79v

No. 3, 80r

No. 3, 80v

No. 3, 81r

No. 3, 81v

79r. People seated on chairs in a park. Conté crayon. This sketch was used for the watercolor *In the Park* (Fig. 3.6).

79v. A ballerina or circus performer in a tutu and the head and shoulders of the same woman. Conté crayon.

80r. Inscribed in Conté crayon along right edge: *2 1 rue Chreche Midi.*

80v. Head of a smiling woman. Pencil. See 81r.

81r. Full-length sketch of a woman wearing a hat. Pencil. The same woman's face is sketched on 80v.

81v. A woman wearing a large hat. Pencil.

No. 3, 82r

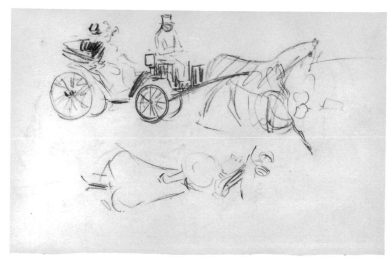

No. 3, 83v

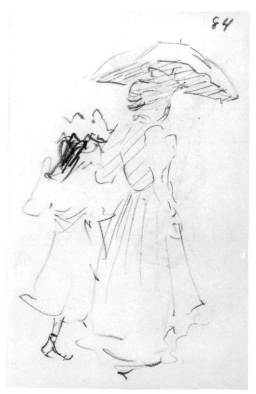

No. 3, 84r

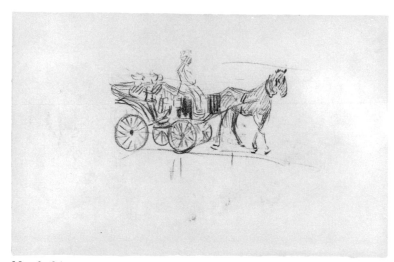

No. 3, 84v

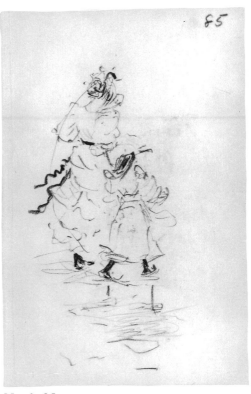

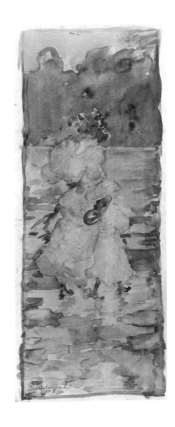

Fig. 3.7 Maurice Prendergast, *Woman and Girl*. Watercolor, ca. 1893–94. Present location unknown. Photograph courtesy of M. Knoedler and Co., New York

No. 3, 85r

No. 3, 85v

82r. A woman seen from behind. Conté crayon; bordered.

82v. Blank.

83r. Blank.

83v. A couple riding in an open carriage, with a sketch of a girl facing left. Conté crayon.

84r. A woman and a girl, seen from behind, protected by a parasol as they walk. Conté crayon.

84v. A couple riding in an open carriage. Conté crayon.

85r. A woman and a girl, seen from behind, walking along a wet street. Conté crayon. These two figures appear in the watercolor *Woman and Girl* (Fig. 3.7).

85v. A woman walking, seen from the front. Conté crayon.

No. 3, 86r

No. 3, 86v

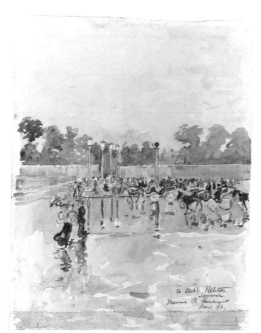

Fig. 3.8 Maurice Prendergast, *Paris Boulevard in the Rain*. Watercolor over pencil, 1893. Collection of Marcia Fuller French. Photograph by Linda Lorenz, courtesy of the Amon Carter Museum, Fort Worth, Texas

No. 3, 87r

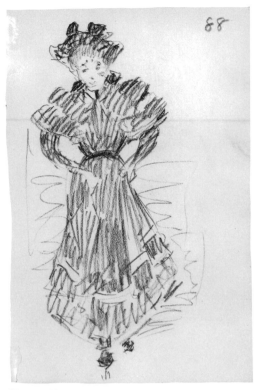

No. 3, 87v

No. 3, 88r

86r. A couple riding in an open carriage. Conté crayon.

86v. Two women walking under umbrellas on a wet street. Conté crayon. These figures were used in the left foreground of the watercolor *Paris Boulevard in the Rain* (Fig. 3.8). See also 87r.

87r. Carriages and a row of lampposts on a wet street. Conté crayon. Prendergast also used these lampposts and carriages in *Paris Boulevard in the Rain* (Fig. 3.8). See also 86v.

87v. A woman walking, seen from the front. Conté crayon. See 88r.

88r. A woman walking, seen from the front. Conté crayon. This is a more developed sketch of the woman on 87v.

88v. Blank.

89r. Blank.

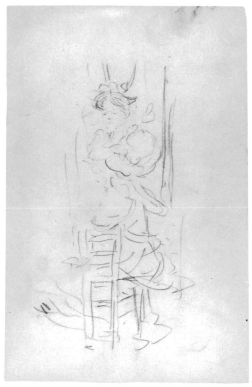

No. 3, 89v

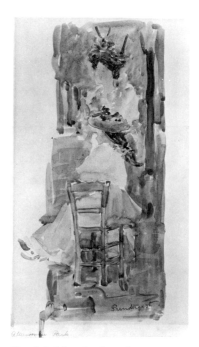

Fig. 3.9 Maurice Prendergast, *Afternoon in the Park*. Watercolor, ca. 1893–94. Present location unknown. Photograph courtesy of M. Knoedler and Co., New York

Fig. 3.10 Maurice Prendergast, *Two Women in a Park*. Watercolor, ca. 1893–94. Collection of Margaret L. Conner. Photograph by Will Brown, Philadelphia

No. 3, 90r

No. 3, recto of back endpaper

89v. Two women in a park, one seated in a chair, the other standing. Conté crayon. Both figures, in the same poses, appear in the watercolor *Afternoon in the Park* (Fig. 3.9), and Prendergast must also have referred to this sketch for the girl sitting sideways in a chair in *Two Women in a Park* (Fig. 3.10).

90r. A girl seen from behind and the head of a woman wearing a hat. Pencil.

90v. Blank.

Three pages removed between 90v and endpaper.

Maurice Prendergast

4. Large Boston Public Garden Sketchbook, 1895–97

1975.1.924–67

44 pages, with 40 sketches in watercolor over pencil, 16 in pencil, and 2 in pen and ink over pencil, originally bound in black leather-textured fabric over board, reinforced with brown leather corners and with a leather spine. 35.8 x 28.4 cm. Paginated in black ink in upper right corners of rectos. Annotated on inside front cover in Charles Prendergast's hand in black pencil: 36(?) Sketches by / Maurice Prendergast, the number 36(?) erased and replaced with 44 in blue pencil; added below that in blue pencil in the same hand: Collection of / Charles Prendergast / Westport. Conn (Collection of Charles Prendergast Westport. Conn and Sketches by Maurice Prendergast gone over in blue ballpoint pen and Mrs. added in blue ballpoint pen after Collection of, probably by Eugénie Prendergast).[1]

The sketchbook has been dismantled and the pages are now mounted separately. The binding had already deteriorated to a great degree when Robert Lehman acquired the book in 1961. The cover shows evidence of mold growth in the past, and the spine has been reinforced, probably by Charles Prendergast, with a strip of gray muslin that is colored black where it overlaps the front and back covers and is decorated on the spine with five sets of painted red and black horizontal lines. Traces of the original leather spine remain beneath the muslin.[2] The binding was sewn (and may also have been glued); the ends of the bindings can be seen under the endpaper and correspond to the binding holes (five holes, about 5.4–6.6 cm apart) on the pages. The white paper lining the inside of both the front and back covers has browned considerably, as have the outer edges of the pages removed from the binding.[3] There is not enough evidence to determine whether the sketchbook is complete, but there is internal evidence to suggest that most if not all of the pages are numbered in their original sequence. In a few cases, the artist must have closed the sketchbook before the watercolor was dry, as spots of color have been blotted with the versos of the adjacent pages. On other watercolors the water caused the paper to cockle, and where there is unevenness in the paper the pigment from the recto of the following folio has been abraded and offprinted onto the verso of the adjoining page where it has cockled. This is most likely to have occurred while the sketchbook was still bound. Such offprints appear on the versos of pages 1–10, 12, 13, 15–22, 24–31, 35, 36, 39–43.

When Prendergast returned to Boston from Paris in September 1894, he took steps to promote interest in his watercolors and to show them in Boston exhibitions, but he also started to contribute his designs to the city's thriving printing and publishing enterprises. Between 1895 and 1897 he illustrated several books and designed book covers and advertising posters for Boston publishers.[4]

It is likely that Prendergast used this sketchbook, with its range of expressive figural studies, decorative costume details, and composed scenes of life in the streets and parks of Boston, as a presentation piece, to show pub-

lishers and other potential clients his ability as a draftsman, illustrator, and colorist. Certain pages, such as 31r and 33v, are clearly ideas for advertisements. The watercolor on 5r and the pencil sketch on 32v are designs for a poster, most likely stimulated by the Columbia bicycle poster competition of 1896.[5] Many of the themes of the sketchbook, especially women displaying both themselves and products to others, echo throughout Prendergast's commercial work, notably the 138 illustrations he completed for James M. Barrie's My Lady Nicotine: A Study in Smoke, published by the Joseph Knight Company in Boston in 1896 (see Figs. 4.7, 4.11, 4.15, 4.18, 4.24).[6] Yet the sketchbook also has elements that are decidedly not promotional. For example, the pages are not uniformly finished, many compositions having been abandoned after the initial pencil sketch, and one page (37v) was used as a ledger for financial transactions involving Prendergast and the Boston painter Hubert P. Whitmarsh in early 1897.[7]

Prendergast also experimented in the sketchbook with designs for monotypes. On several of its pages are studies for or after plates that suggest the significant role sketching played in his monotype production during the late nineties. The pencil drawing of a harbor scene on 2v is a study for The Old Shipyard (Fig. 4.4).[8] The pose of the girl in Crescent Beach (Fig. 4.8)[9] is similar to that of

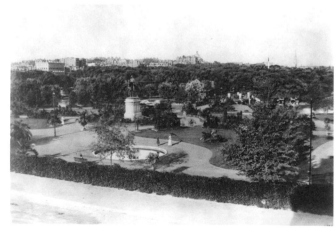

Fig. 4.1 The Public Garden, Boston, panorama from Arlington Street, 1894. Photograph courtesy of the Bostonian Society, Old State House, Boston

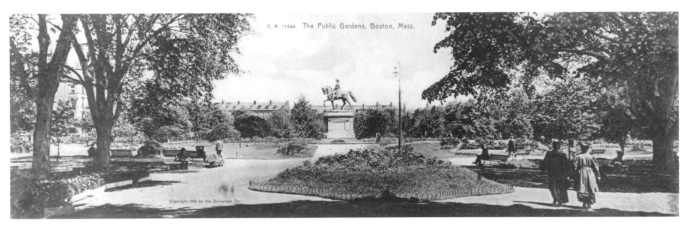

Fig. 4.2 The Public Garden, Boston, 1905. Photograph by Rotograph Co., courtesy of the Bostonian Society, Old State House, Boston

the figure in the foreground of the pencil sketch on 12r. The watercolor on 22r and the pencil sketch on 24r are related to *At a Fountain in the Public Garden* (Fig. 4.12).[10] The sketch on 33r may be a preparatory drawing for the monotype *Bareback Rider* (Fig. 4.16),[11] and a similar figure also appears in the watercolor *The White Horse and Circus Rider* (Fig. 4.17).[12] The scene on 40r is composed much like several of Prendergast's monotypes, of which *Street Scene* (Fig. 4.22) and *Afternoon* (Fig. 4.23) are examples.[13]

This sketchbook was never exhibited during Maurice Prendergast's lifetime. When Charles Prendergast lent it to an exhibition in Andover in 1938, it was called simply "Sketchbook." It appears to have been first called the *Large Boston Public Garden Sketchbook*, by Wick, in

1960, when it was still in Eugénie Prendergast's collection.[14] The only sites in the sketchbook that can be definitely identified are a fountain in the Public Garden (see 22r, 24r; Fig. 4.13)[15] and the Tremont Street and Huntington Avenue streetcars (see 16r, 17r). Nonetheless, the settings for many of the other sketches could well be the Public Garden, with its "stately trees and broad walks," as they were described in an 1889 guide to Boston (see Figs. 4.1, 4.2).[16] One of Prendergast's independent watercolors, *The Public Garden (Boston)* (Fig. 4.3),[17] depicts a fountain sculpture of Venus (which no longer exists) in the Public Garden, but the sculptural monuments in Boston's preeminent city park in the mid-1890s seem not to have been what interested him most. These drawings are evidence that the park appealed

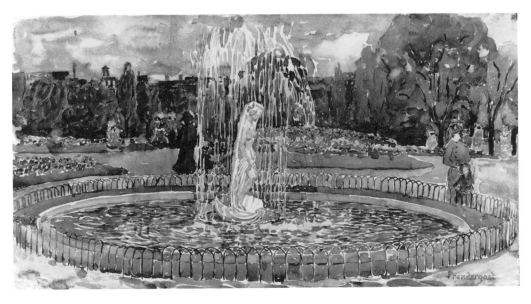

Fig. 4.3 Maurice Prendergast, *The Public Garden (Boston)*. Watercolor over pencil, ca. 1900–1901. Collection of Mr. and Mrs. Harry Spiro, New York. Photograph courtesy of Coe Kerr Gallery, New York

to him less as a designed landscape than as a setting for human, particularly feminine, activity.

Women or girls appear on every page of the *Large Boston Public Garden Sketchbook* but 32r, a flower and butterfly study. Prendergast sketched women and girls on the streets and in the parks of his city, observing and recording the differences in dress, carriage, and activities that distinguished the social classes. A number of the redheaded women, from their dress and demeanor, seem to be working women and may have been part of Boston's prominent Irish population. Many pages depict the close relationship between women and infants, whether their own or temporarily in their care. Prendergast must have felt at home in Boston's parks, for all his subjects, even the few little girls whose evident curiosity shows they were aware of his presence, are unselfconscious about the artist's scrutiny.

When men are present in these drawings they are relegated to a subsidiary, though psychologically important, position. Each of the several sketches Prendergast made at night, for example, is a street scene in which the central figure of a woman seems aware of the faceless crowd of top-hatted men who follow or observe her. Of all the drawings in the sketchbook, these night scenes are the most expressive of psychological tension. They are also of interest because some of them depict an obviously lively evening street life around the kind of outdoor cafés that are much more readily associated with Paris than with Boston in the 1890s. They raise the possibility that this book does not depict Boston exclusively but includes drawings in which Prendergast combined observation with memory, as he did in many other works.

Transportation is another important theme of the sketchbook. Women ride bicycles in the poster designs on 5r and 32v, which are aimed at selling bicycles by touting the freedom the new sport had to offer to female consumers. Women push infants in elaborate perambulators in other sketches, and older children maneuver tricycles through the park. Two women converse by a carriage on 27r in a scene that encapsulates Boston's past. And in the watercolors on 16r and 17r women are depicted with the more modern streetcars, their actual routes identified on their nameboards, that carried people back and forth from the expanding suburbs.

Prendergast was to sketch similar scenes in later sketchbooks, particularly the *Boston Watercolor Sketchbook* in the Museum of Fine Arts, Boston (see Figs. 4.5, 4.9, 4.10, 4.14, 4.21), which dates to about 1897–98 and contains drawings he made at Revere Beach (see Fig. 5.2) as well as in Boston's parks, including the then new Frank-

lin Park.[18] But the *Large Boston Public Garden Sketchbook* is the largest and most elaborate of these books.[19] Informed by his four-year experience in Paris and inspired by Boston of the mid-nineties, this rich collection of sketches not only provides evidence of his interest in the pleasures and complexities of a feminine world, which he observed with sustained sensitivity, and of his awareness of the many subtleties of the society in which he lived, but it also documents his increasing assurance with pencil and watercolor.

NOTES:

1. Charles Prendergast may also have added the signatures to pages 21r, 29r, and 31v. Clark, Mathews, and Owens (1990, p. 208) have noted that Charles "sometimes inscribed 'Prendergast' on oil paintings and watercolors by Maurice," and that "it is difficult to distinguish between the brothers' hands." It is possible that the monogram *MP* on page 30r is in neither brother's hand.

 A typewritten blue label that reads: *LARGE BOSTON PUBLIC GARDEN / SKETCHBOOK / ABOUT 1895–97 / LENT BY MRS. CHARLES PRENDERGAST / NOT IN CATALOGUE* has been removed from the inside front cover and is now in the Robert Lehman Collection files. The label was probably taped on the cover at the time of the exhibition that opened in Boston in 1960.

2. I am grateful to Margaret Holben Ellis for her advice on the condition of the sketchbook. The striping on the muslin strip used to reinforce the binding is similar to that on the spine of the *Boston Watercolor Sketchbook* in the Museum of Fine Arts, Boston (M. Prendergast 1960 [a facsimile]; Clark, Mathews, and Owens 1990, no. 1478). According to Wick (in his "Critical Note" to M. Prendergast 1960, p. 10), it was Charles Prendergast who "enlivened this sober envelope [the *Boston Watercolor Sketchbook*] by painting red and black stripes across the spine and splashing the inscription in red paint inside the front cover: *Sketches by Maurice Prendergast / 1899*." Although that sketchbook has sometimes been called the *1899 Sketchbook* based on Charles's annotation, the watercolors and pencil drawings it contains were most likely made in about 1897–98, or shortly after those in the *Large Boston Public Garden Sketchbook*. Maurice Prendergast left for Italy in midsummer 1898 and did not return to Boston until at least late November 1899.

3. Szabo (Oklahoma City–Memphis 1981–82, p. 14; M. Prendergast 1987, introduction, p. xviii) has said that the *Large Boston Public Garden Sketchbook* was among the works by Maurice Prendergast that survived a fire in Charles Prendergast's studio on Irving Place in New York in 1925 and that "some of its scorched and slightly water-stained edges still testify to this tragic event. The melted snow on the ground also penetrated the glue of the spine, loosening it and causing the pages to separate from the binding and from each other." The evidence of past mold growth on the cover and the disintegration of the binding are indeed

signs of water damage. There are no evident water stains on any of the pages, however, and the discoloration on the pages and the lining of the covers is quite even and is more likely to be the result of the deterioration of the paper itself than of scorching.

There are two somewhat different versions of the story of the fire. According to the account Basso published in the *New Yorker* in 1946 (pt. 2, p. 37), based on an interview with Charles, a few weeks after Charles moved into the studio on Irving Place, "the building had a fire. He had taken all his brother's unsold work with him. He couldn't do anything about saving Maurice's oils, . . . but he bundled up all the water colors and put them near a window. . . . A fireman . . . found him standing by the window, and led him from the building, his arms full of water colors. After the fire was under control, Charles went back to the studio and found that only a few of his brother's oils were damaged. . . . [As he] was making his way back down the stairs, a big glass window on the stairway was shattered by the force of the water and one of his hands was badly cut." When Wick recounted the tale in 1960, perhaps based on what Charles's widow, Eugénie Prendergast, had told him, he said that the fire broke out "in the early hours of the morning with snow on the ground. . . . Charles in a frantic effort to rescue the contents of the studio shattered the window glass and flung his most precious possessions out into the backyard, severely cutting his hand in the act. Many things were damaged or destroyed, but Charles succeeded in throwing clear a number of Maurice's portfolios of water colors, several small oil panels, some badly scorched, and a group of his sketchbooks." The facts were evidently clouded from the start. Basso went on to report that "the next day a newspaper said that he [Charles] had gone back into the building to rescue his cat. 'Shucks!' Prendergast says. 'I didn't even *have* a cat.'"

4. See Clark, Mathews, and Owens 1990, pp. 638–43.
5. This was suggested to me in 1985 by W. Anthony Gengarelly, professor of American studies at North Adams State College, North Adams, Massachusetts, who has done exten-

sive work on Prendergast's graphic career (see Gengarelly 1989). On the Columbia bicycle poster competition, see also Kiehl 1987, p. 20.
6. See Clark, Mathews, and Owens 1990, no. 1773, which reproduces some of the illustrations.
7. Whitmarsh is listed as a painter in oils in the *Boston City Directory* from 1891 to 1898.
8. Clark, Mathews, and Owens 1990, no. 1757, ill.
9. Ibid., no. 1644, ill.
10. Ibid., no. 1645, ill.
11. Ibid., no. 1596, ill. The relationship between the sketch and the monotype was first noted by Langdale in New York 1979, p. 73.
12. Clark, Mathews, and Owens 1990, no. 593, ill.
13. Ibid., nos. 1624, 1623, ill.
14. Wick in M. Prendergast 1960, p. 12.
15. See Friends of the Public Garden and Common 1988, pp. 61–62.
16. *King's Hand-Book of Boston*, 9th ed. (Boston, 1889), p. 102.
17. Clark, Mathews, and Owens 1990, no. 770, ill.
18. See note 2 above.
19. For a list of the eighty-eight sketchbooks by Prendergast that have survived, see No. 3, note 3.

PROVENANCE: Charles Prendergast, 1924; his widow, Eugénie Prendergast, 1948; Robert Lehman, 1961.

EXHIBITED: Andover (Mass.) 1938, no. 122; Boston (and other cities) 1960–61 (at Boston only; not in catalogue); New York 1966–67, nos. 1–44; Oklahoma City–Memphis 1981–82, nos. 1–44; New York 1982, nos. 1–44; Williamstown (Mass.) 1985, no. 25; New York 1987.

LITERATURE: Wick in M. Prendergast 1960, p. 12; Szabo 1975, p. 105, figs. 197, 198 (11r, 21r); New York 1979, pp. 73, 133; Berman 1982, ill. (5r, 34v–35r, 16r, 28r); Glavin 1982, p. 68, ill. (21r); Langdale 1984, p. 33; M. Prendergast 1987; Clark 1990, pp. 25–31, figs. 1–8 (1r, 19r, 16r, 27r, 5r, 41r, 44r, 18r); Clark, Mathews, and Owens 1990, no. 1477; Parkhurst 1990, pp. 76–77.

No. 4, inside front cover

1r. A woman reading a book. Watercolor over pencil; bordered in pencil and watercolor. Though the vase of red flowers on the table implies an indoor setting, this woman's veiled hat and open parasol and the green of the background suggest that she is reading out-of-doors. The setting might be an outdoor tearoom. Prendergast penciled HARD on the book, most likely to indicate that the woman is reading one of Thomas Hardy's contemporary novels, perhaps *Tess of the d'Urbervilles: A Pure Woman, Faithfully Presented*, which was published first in London and then in New York in 1891, or *Jude the Obscure*, which was serialized in *Harper's New Monthly Magazine* in 1894–95 and published in New York in 1895. Prendergast painted blue borders like this on almost all the watercolors in this sketchbook as well as on many of his single-sheet sketches from 1891–94, when he was in Paris.

1v. Blank.

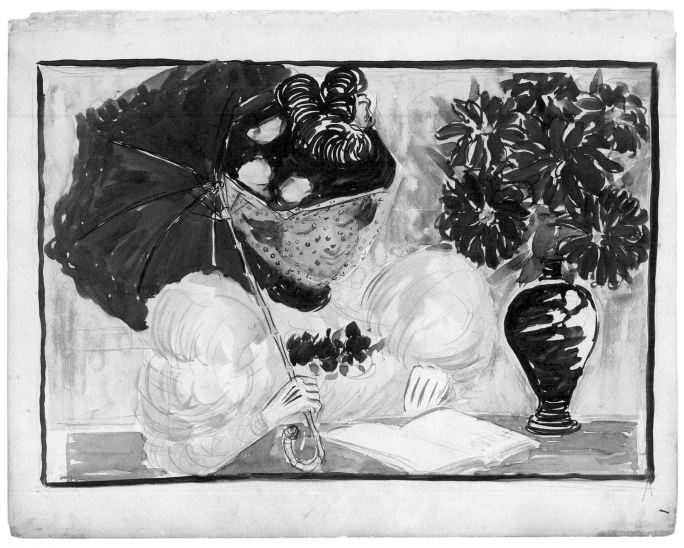

No. 4, 1r

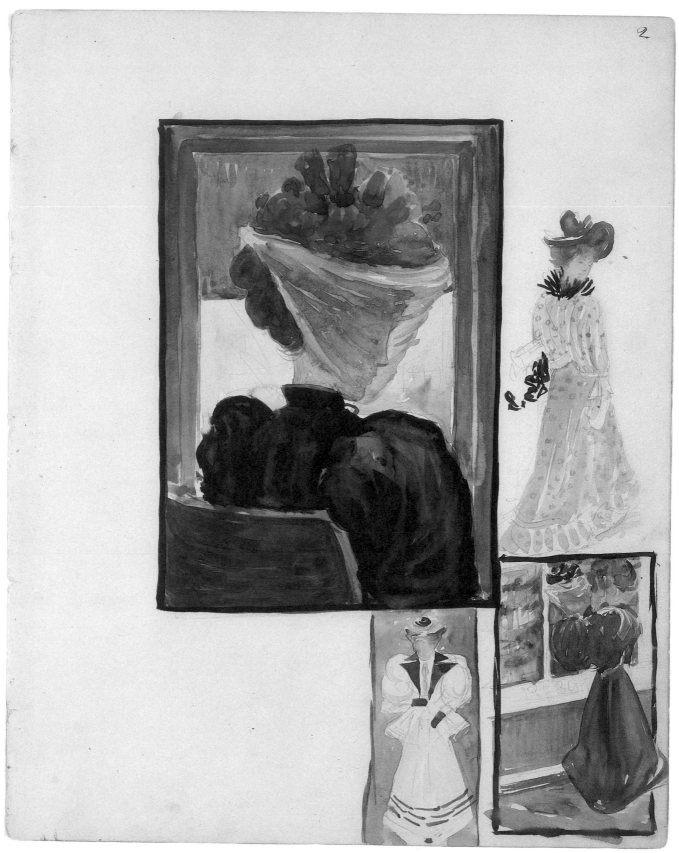

No. 4, 2r

2r. Four vignettes of fashionably dressed women. Watercolor over pencil; three vignettes bordered in pencil and watercolor. As he has here, Prendergast occasionally combined several vignettes of women on a single monotype plate. Three of the vignettes on this page depict women on the street, two of them wearing veiled hats, one peering into a shop window. The fourth shows the bust of a woman whom Prendergast observed as she sat framed in a window, her eyes downcast demurely beneath her veil. This is one of many drawings in the sketchbook that incorporate lettering. If the name could be identified, the letters (*RIB*[?]) penciled on the window ledge in the vignette at the lower right might provide a clue to the shop's location.

2v. Study for *The Old Shipyard*. Pencil; bordered. Langdale (New York 1979, p. 133) first noted that this drawing is a study for the monotype *The Old Shipyard* (Fig. 4.4), which is titled, signed, and dated 1901 in the plate. It is one of several harbor scenes, most likely in Boston, that Prendergast did in the late 1890s. Boston's historic waterfront was at the time about to be modernized. *King's How to See Boston* of 1895 (pp. 201–2) advised readers that "plans are now under way for the city to buy all the wharves, and replace them with handsome and commodious municipal docks."

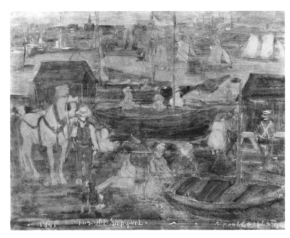

Fig. 4.4 Maurice Prendergast, *The Old Shipyard*. Monotype, 1901. Collection of Cornelia and Meredith Long. Photograph by Helga Photo Studio, Upper Montclair, New Jersey

No. 4, 2v

3

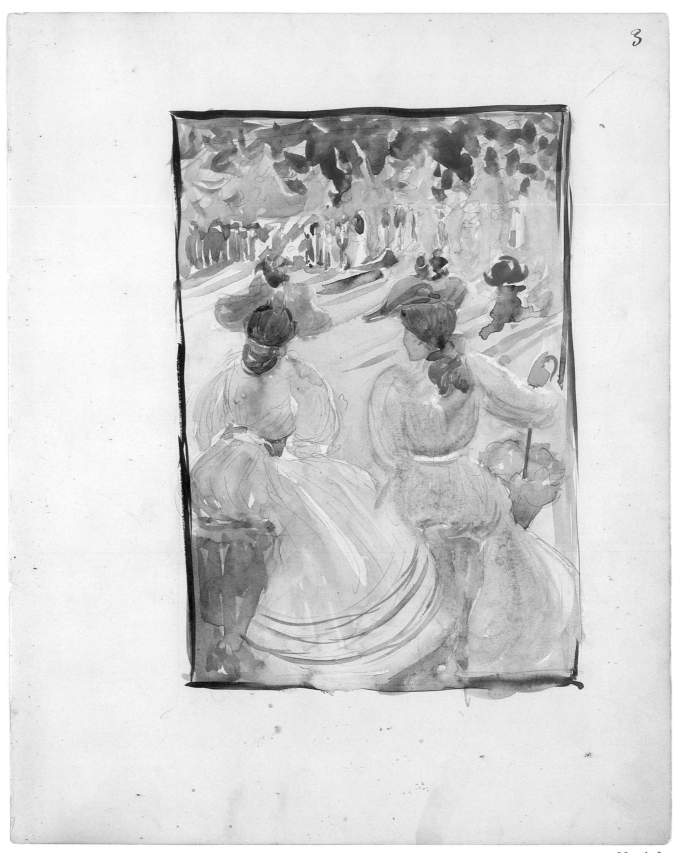

No. 4, 3r

No. 4, 3v

3r. Two women sitting in a park. Watercolor over pencil; bordered in pencil and watercolor. Like many other sketches in the book, this summer scene of two women sitting in a sunny park is set against a background row of figures, with decorative tree branches painted along the top edge of the paper.

3v. Women at the shore. Pencil. The exuberance and force of this loose sketch of a group of women, one of them drawn in some detail, the others only schematically rendered, make it quite different from the other drawings and underdrawings in the sketchbook. It may have been drawn later than the others. The setting could be Revere Beach, or possibly the South Shore.

4r. A woman reading in the park. Watercolor over pencil; bordered in pencil. While he was in Paris in 1891–94, Prendergast painted women sitting in parks, usually on typically Parisian chairs. Unlike her Parisian counterparts, this American woman sits on a bench, most likely in the Boston Common or the Public Garden, and she is engrossed in the book she holds in her gloved hand. Prendergast used the same basic palette of blue, yellow, green, and red for many other watercolors in this sketchbook (see Parkhurst 1990).

4v. Blank.

5r. Design for a bicycle poster. Watercolor over pencil; bordered in pencil and watercolor. At least four posters designed by Prendergast, for books published by W. A. Wilde and Co. and the Joseph Knight Company of Boston, were printed between 1895 and 1897, while he was working on the *Large Boston Public Garden Sketchbook* (see Clark, Mathews, and Owens 1990, nos. 1766, 1768, 1770, 1772, ill.). Gengarelly proposed to me in 1985 that this drawing, which appears never to have been published, was most likely an idea for the competition the Pope Manufacturing Company of Hartford, Connecticut, held in 1896 for a poster advertising their Columbia bicycle. Actually a poster within a poster (see the penciled lettering – *COLUMB / BICYC* – at the lower left), Prendergast's design shows a well-dressed urban woman, whose features are only implied beneath her elaborately veiled and flowered hat, stooping slightly as she walks by a poster displaying a woman riding a bicycle. The advertisement suggests that the frail pedestrian ought to exchange her restrictive skirts and boa for the more liberated outfit of the healthy, smiling woman in the poster and take up the new fad of bicycling. See also 32v and 40v.

4

No. 4, 4r

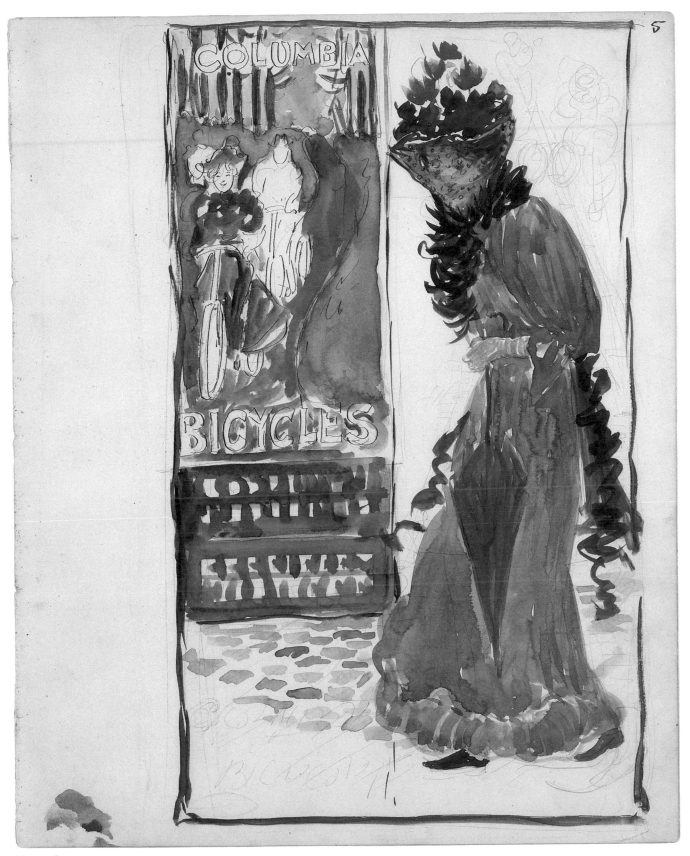

No. 4, 5r

No. 4, 5v

5v. A woman walking. Pencil. The active pencil lines effectively create the illusion of movement in this drawing of a woman walking with one foot thrust forward, her face turned to show a profile with a pointed nose like Prendergast gave so many of the women he drew and painted. This sketch, with its repetition of abstracted contours, recalls drawings in Prendergast's later sketchbooks but is unusual for this one; it differs dramatically, for example, from the more descriptive image on 38v.

6r. Two women conversing on the street. Watercolor over pencil; bordered in pencil and watercolor. Prendergast has emphasized the contrast between the dark blue dress and simple, veiled hat of the woman facing the viewer and the more flamboyant attire of her companion, who wears a dress in bright red and pale yellow and an elaborately flowered and veiled hat and carries a white parasol whose tip breaks the image's painted border. As they stop to talk, the two women stand out against the somber gray-violet of the suits of the men in the street behind them.

6v. Blank.

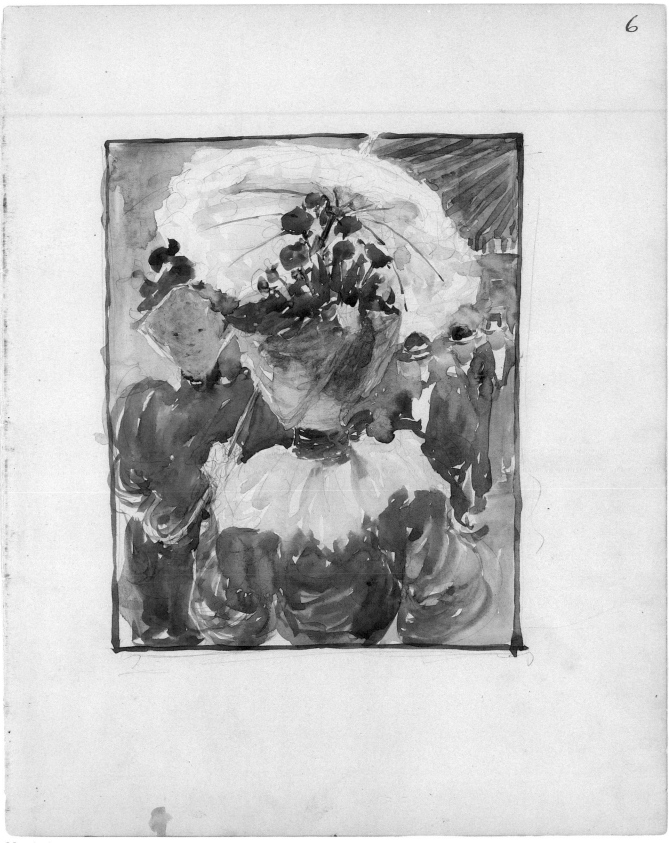

No. 4, 6r

7

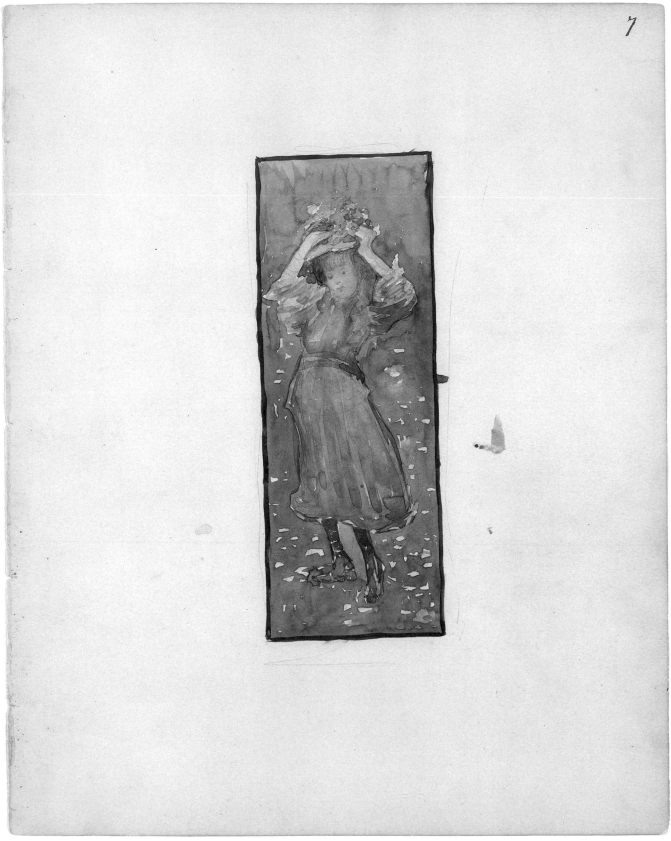

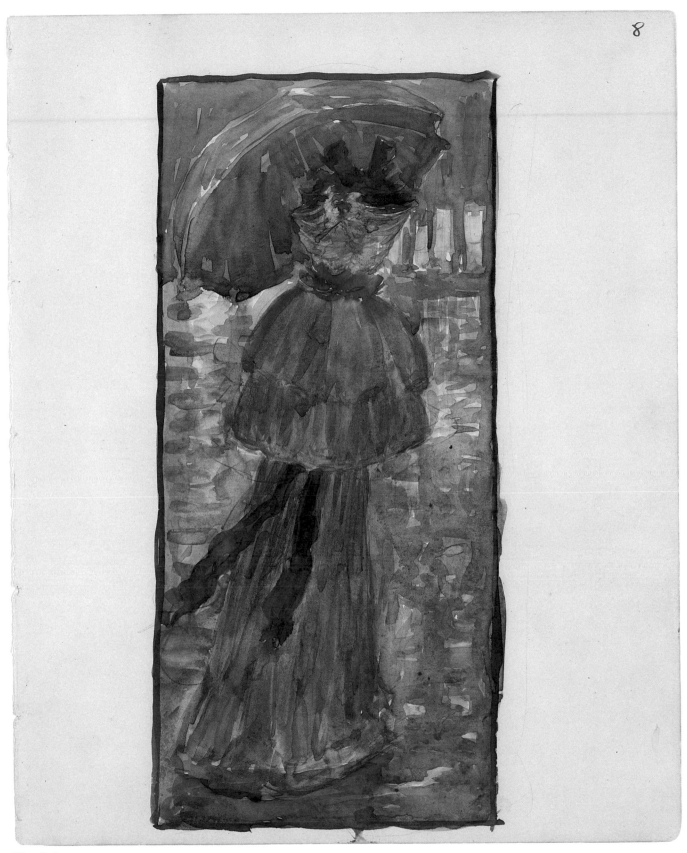

No. 4, 8r

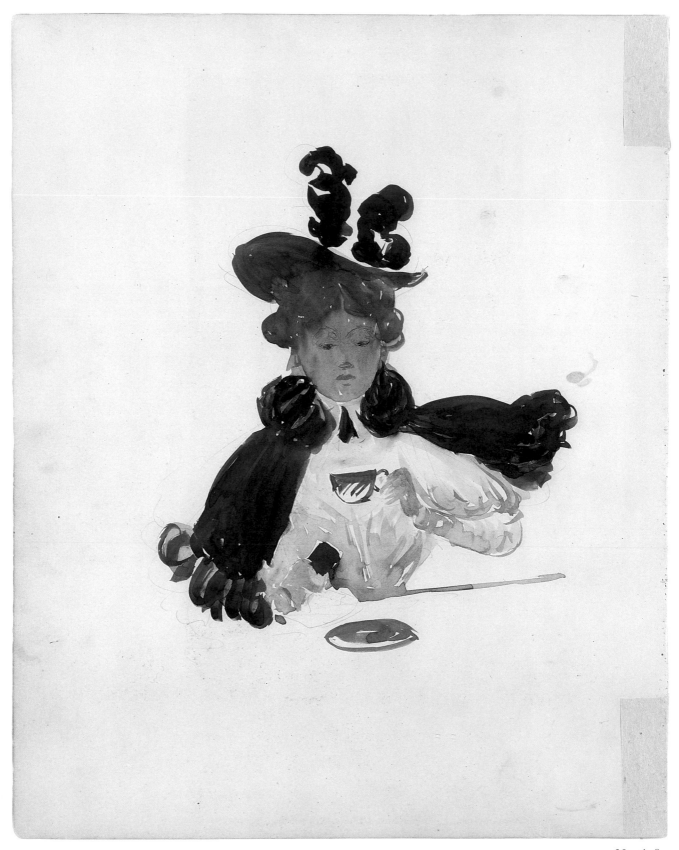

No. 4, 8v

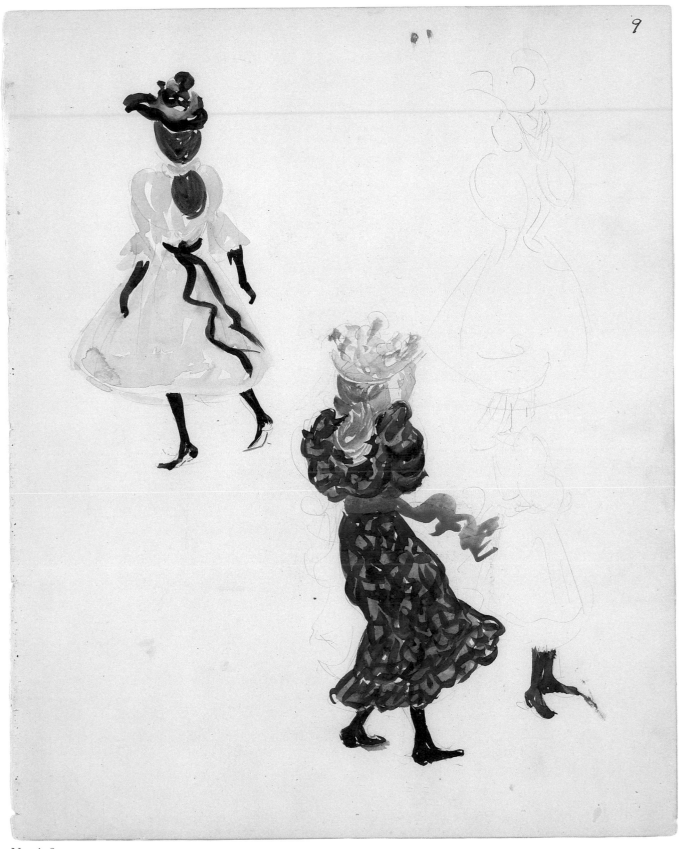

No. 4, 9r

7r. A young girl holding her hat. Watercolor over pencil; bordered in pencil and watercolor. The sway of her body and the tilt of her head as she reaches up to hold on to or straighten her flowered hat suggest that this girl on the edge of womanhood deliberately struck a coquettish pose for the artist.

7v. Blank.

8r. A woman walking in the rain under an umbrella. Watercolor over pencil; bordered in pencil and watercolor. A dark, rainy day or evening like those he sometimes chose for his Parisian scenes provided Prendergast with an opportunity to paint this woman in dark pink making her way, sashes flying, across wet pavement shimmering with blue, green, yellow, and purple reflections.

8v. A woman drinking tea. Watercolor over pencil. This graphically effective painting of a woman drinking tea, or perhaps chocolate, with a serious expression may be an idea for an illustration. Although Prendergast has uncharacteristically isolated her from a painted setting, the woman is probably sitting in a public tearoom. Her attire suggests she may be a working woman. See also 20r, 31r, and 43r.

9r. Young girls in hats and sashed dresses. Watercolor over pencil. This page of vignettes of girls shows Prendergast's method of quickly sketching in pencil and then working up the drawing with watercolor. He has evoked a windy day with the posture of the girl in the foreground, the flow of her sash, and her gesture of reaching up to secure her hat. The sketchbook was closed when the paint on this drawing was still wet, leaving a splotch of yellow on the opposite page.

9v. Blank.

10r. A young girl and a woman gazing out to sea. Watercolor over pencil; bordered in pencil and watercolor. These two compositions, each contained by painted blue lines broken only by one parasol's tip, show figures seen from behind gazing out to sea from a promenade bordered by railings, a theme Prendergast often chose for watercolors and monotypes in the late 1890s. Related subjects can be found in the *Boston Watercolor Sketchbook* in the Museum of Fine Arts, Boston (M. Prendergast 1960, pp. 7, 35 [Fig. 4.5], 52).

10v. Blank.

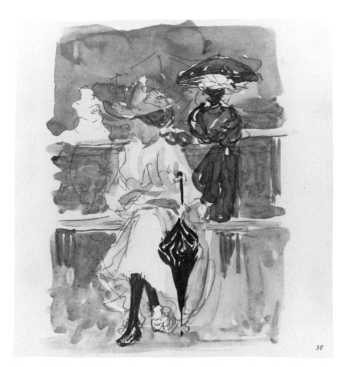

Fig. 4.5 Maurice Prendergast, *Boston Watercolor Sketchbook*, p. 35. Watercolor over pencil, ca. 1897–98. Museum of Fine Arts, Boston, Gift of Mrs. Charles Prendergast in honor of Perry T. Rathbone. Reproduced from facsimile

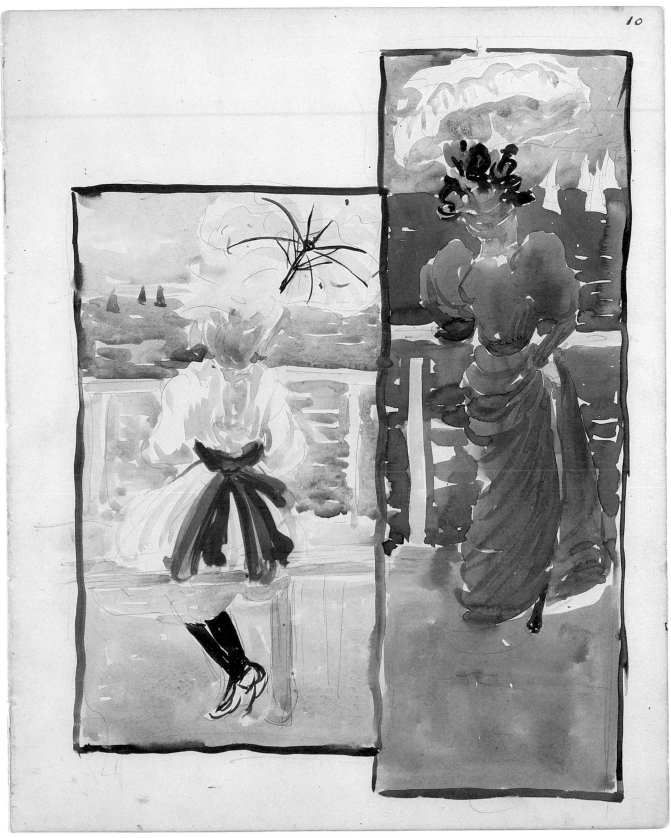

No. 4, 10r

11

No. 4, 11r

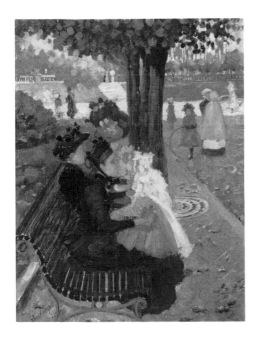

11r. A man and two women sitting in the park. Watercolor over pencil; bordered in pencil. As he did the figures in the small oil painting *The Tuileries Gardens, Paris* (Fig. 4.6) of about 1892–94 (Clark, Mathews, and Owens 1990, no. 9, ill.), Prendergast observed these people seated on a bench along a garden path from a slightly elevated viewpoint. His skill in expressing mood through posture and countenance is especially evident in the relaxed, wistful young woman (who sits, unlike most of Prendergast's women, doing nothing) and the hunched, resigned older man. See also No. 3, 65v.

11v. Trees or clouds of smoke. Pencil; bordered. This faint sketch may schematically delineate rising smoke, as in some of Prendergast's drawings for *My Lady Nicotine* (see Fig. 4.7).

Fig. 4.6 Maurice Prendergast, *The Tuileries Gardens, Paris.* Oil on canvas, ca. 1892–94. Terra Museum of American Art, Chicago, Daniel J. Terra Collection

Fig. 4.7 Maurice Prendergast, illustration for *My Lady Nicotine*. Ca. 1895. Reproduced from J. M. Barrie, *My Lady Nicotine: A Study in Smoke* (Boston: Joseph Knight Company, 1896), p. 115; collection of Carol Clark

No. 4, 11v

12

No. 4, 12r

Fig. 4.8 Maurice Prendergast, *Crescent Beach*. Monotype, ca. 1895–97. Terra Museum of American Art, Chicago, Daniel J. Terra Collection

12r. Two women and a girl on a boardwalk. Pencil; bordered. Prendergast freely reused figures or other motifs in different contexts. He depicted girls seated like this and seen from the side in the monotype *Crescent Beach* (Fig. 4.8) and in the *Boston Watercolor Sketchbook* in the Museum of Fine Arts, Boston (M. Prendergast 1960, p. 57 [Fig. 4.9]). In those two works the girl is seen against the curve of Crescent Beach, a section of Revere Beach on Boston's North Shore. Here the background contains two women standing with the girl on a balustraded promenade overlooking a harbor.

12v. Blank.

13r. Night scene with three women in blue. Watercolor over pencil; bordered in pencil and watercolor. Lanterns eerily illuminate the evening in this night scene, one of several in the sketchbook. While the lamps signify a festive occasion, the rushing figures and the contrast of orange and blue convey a more anxious mood, and perhaps the threat of rain. The blue paint, the same blue Prendergast used often in his watercolors of the 1890s, left patches of undispersed pigment as it dried and produced the granular surface seen here and on other pages of the sketchbook. There is less pencil underdrawing and a looser application of watercolor on this page than on any of the others except 34v and 35r.

Fig. 4.9 Maurice Prendergast, *Boston Watercolor Sketchbook*, p. 57. Watercolor over pencil, ca. 1897–98. Museum of Fine Arts, Boston, Gift of Mrs. Charles Prendergast in honor of Perry T. Rathbone. Reproduced from facsimile

82

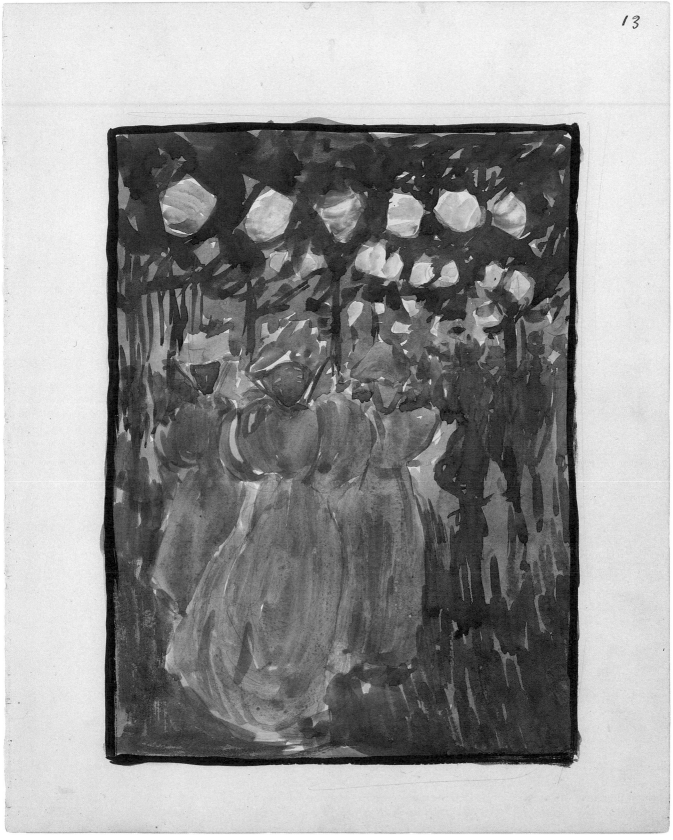

No. 4, 13r

14

No. 4, 14r

No. 4, 15r

13v. Blank.

14r. A woman in a veiled hat. Watercolor over pencil; bordered in watercolor. Prendergast again chose an evening setting for this individualized portrait of a woman dressed in dark clothes, her face obscured by her veiled hat in a tour de force of thin violet overpaint. The slight turn of her body and the expression of her blue eyes suggest that the artist and his mysterious subject knew each other.

14v. Blank.

15r. A woman in a veiled hat decorated with poppies. Watercolor over pencil. Prendergast formalized this half-length portrait by presenting a woman directly from the front and by composing her of two triangles, one from the waist to the puffed sleeves, the other from the chin to the hat brim, all topped by the poppies that sprout from her hat. Her face is hard and expressionless, without the animation and ease of the portrait on 14r.

15v. Blank.

16r. The streetcar on Tremont Street. Watercolor over pencil; bordered in pencil and watercolor. Inscribed on the streetcar: *TREMONT STREET / STREET / E MONT / EE*. Prendergast's subject here is the system of streetcars that linked the growing suburbs south and west of Boston to the city's center. He has clearly identified the Tremont line, which ran to Roxbury, his home in 1895 and 1896. A streetcar approaching the Boston Common appears in the *Boston Watercolor Sketchbook* in the Museum of Fine Arts, Boston (M. Prendergast 1960, pp. 46–47 [Fig. 4.10]). The woman in the foreground here waits quietly while another woman, in a flurry of quickly drawn pencil lines and lightly applied brushstrokes, runs to catch the car. Her pose resembles those of the cancan dancers Prendergast painted in Paris, and the streetcar riders play the role of attentive audience. Note that the original pencil drawing extended the image farther to the right, where there are traces of framing lines and a faint sketch of a woman.

16v. Blank.

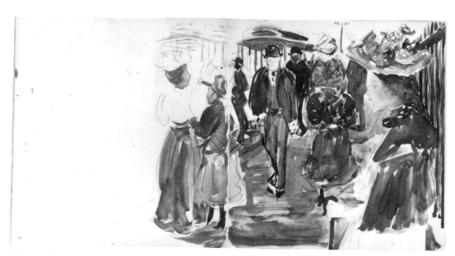

Fig. 4.10 Maurice Prendergast, *Boston Watercolor Sketchbook*, pp. 46–47. Watercolor over pencil, ca. 1897–98. Museum of Fine Arts, Boston, Gift of Mrs. Charles Prendergast in honor of Perry T. Rathbone. Reproduced from facsimile

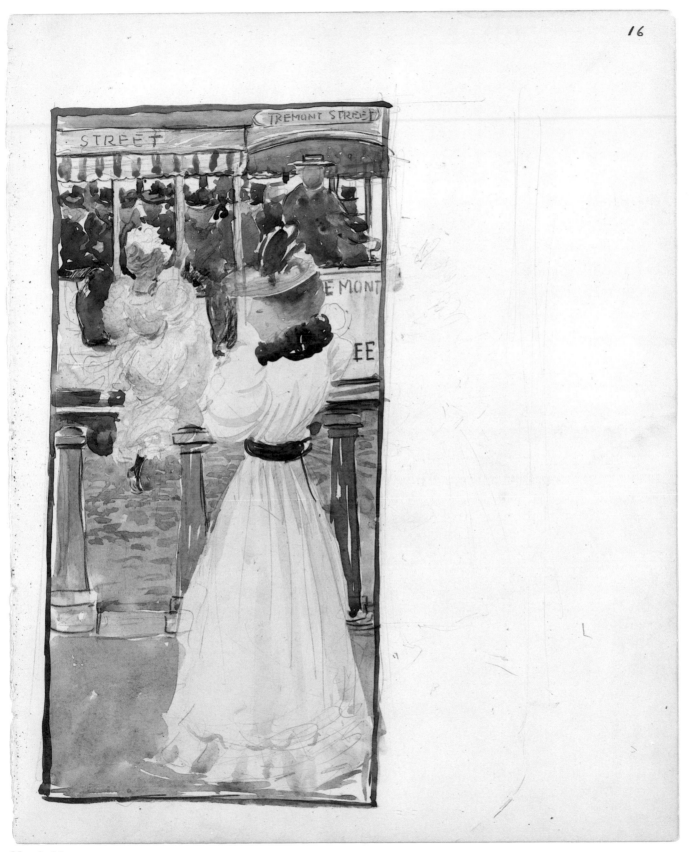

No. 4, 16r

17

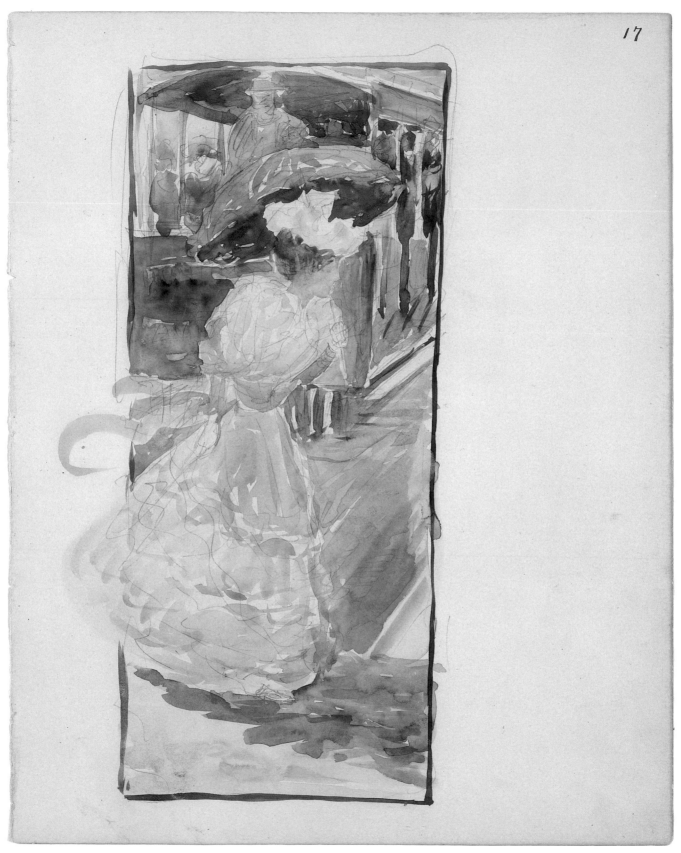

19

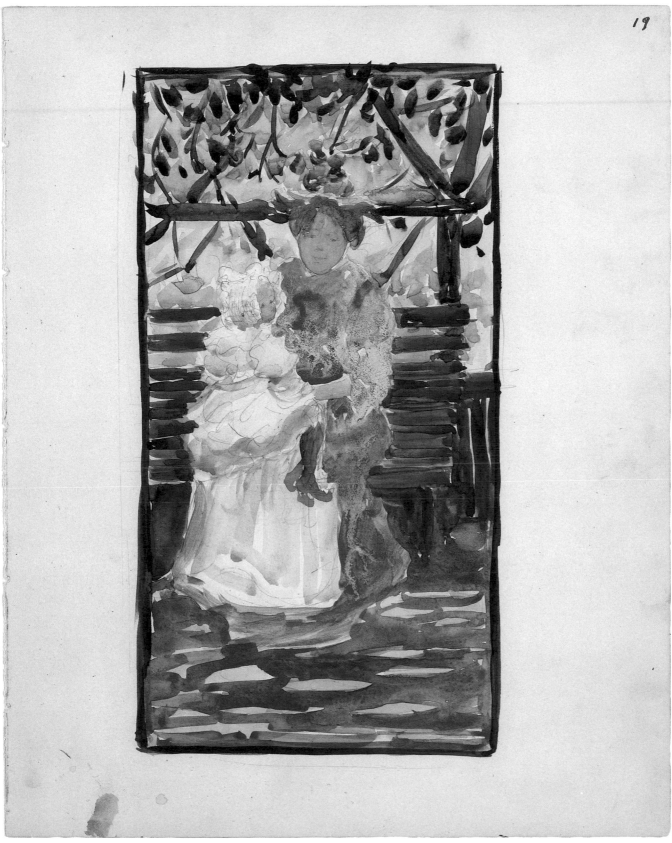

No. 4, 19r

No. 4, 18r

Seeing that he made a " paper " of it, I suppose he is justified in touching up the incidental details. He says, for instance, that we were told the story of the ghost which is said to haunt the house, just before going to bed. As far as I remember, it was only mentioned at luncheon, and then sceptically. Instead of there being snow falling outside and an eerie wind wailing through the skeleton trees, the night was still and muggy. Lastly, I did not know, until the journal reached my hands, that he was put

Fig. 4.11 Maurice Prendergast, illustration for *My Lady Nicotine*. Ca. 1895. Reproduced from J. M. Barrie, *My Lady Nicotine: A Study in Smoke* (Boston: Joseph Knight Company, 1896), p. 195; collection of Carol Clark

17r. The Huntington Avenue streetcar. Watercolor over pencil; bordered in pencil and watercolor. The trailing sashes of a woman crossing in front of a streetcar break the painted frame and enliven this composition. Barely discernible on the front of the car are the letters *HUNT / AVE*, which identify the Huntington Avenue line. Prendergast had moved to Huntington Avenue by 1897.

17v. Blank.

18r. A nude woman with red hair. Watercolor over pencil; bordered in pencil and watercolor. This half-length view of a nude woman whose loose red hair falls across her face as she looks over her shoulder at the viewer is the most incongruous page of the sketchbook. Other redheaded nudes appear in Prendergast's later work in oil, but this is as close as he came to representing woman as seductress. More overtly sexual than any of the many others he portrayed in the 1890s, this woman recalls the (albeit clothed and much more stylized) long-haired sirens in his sketches of men's smoking fantasies for *My Lady Nicotine* (see Fig. 4.11). She is reminiscent of Edvard Munch's contemporary images of women, which Prendergast probably saw when he was in Europe.

18v. Blank.

19r. A nanny with her charge. Watercolor over pencil; bordered in pencil and watercolor. On a sun-drenched park bench in obviously lovely weather, a well-dressed nurse in an unveiled hat and a white apron holds the child who is in her care. The woman's sweet expression, round face, and uncorseted body also suggest her position in Boston society.

19v. Blank.

20

No. 4, 20r

No. 4, 21r

20r. Head of a woman in a plumed hat. Watercolor over pencil. Prendergast's subject appears to be the same woman seen drinking tea on 8v, here even farther removed from the context of a tearoom.

20v. Blank.

21r. Mothers and children in the park. Watercolor over pencil; bordered in pencil and watercolor. Signed or, more probably, annotated by Charles Prendergast in pencil lower left: *M Prendergast*. This delicately colored sketch of a mother tending her baby in its carriage as an older girl, herself poised between infancy and adulthood, watches her is one of the largest and most fully realized in the book. William Merritt Chase, his slightly older contemporary, painted scenes in pastel or oil of mothers and children in Prospect and Central parks in New York that may have been an inspiration to Prendergast, whose approach to the subject is similar.

21v. Blank.

22r. A fountain in the Public Garden. Watercolor over pencil; bordered in pencil and watercolor. This fully worked up watercolor sketch of girls perched on the rim of a fountain is a study for the monotype *At a Fountain in the Public Garden* (Fig. 4.12). The monotype had until recently been called *Frog Pond* (a title it seems to have acquired in 1964, when it was purchased by Vose Galleries, Boston), but the site is not the Frog Pond in the Boston Common but rather one of the two small fountain basins, both in the shape of a cross pattée, between the lake and the Charles Street side of the Public Garden (Fig. 4.13). A pencil sketch of the same subject is found on 24r. Prendergast also drew or painted the ponds and fountains and the children attracted to them in the Tuileries and Central Park.

22v. Blank.

Fig. 4.12 Maurice Prendergast, *At a Fountain in the Public Garden*. Monotype, ca. 1895–97. Worcester Art Museum, Worcester, Massachusetts, Gift of Frank L. and Louise C. Harrington

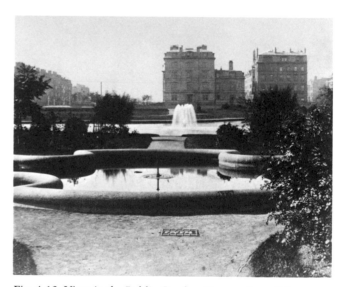

Fig. 4.13 View in the Public Garden, Boston, late 1860s or early 1870s. The house at the center, on Arlington Street, was the home of the artist Sarah Choate Sears and her husband, J. Montgomery Sears. Sarah Sears is said to have financed Prendergast's trip to Italy in 1898–99 and to have acquired many of his Italian watercolors. Photograph from a stereograph (no. 548) by John P. Soule, Boston, courtesy of the Bostonian Society, Old State House, Boston

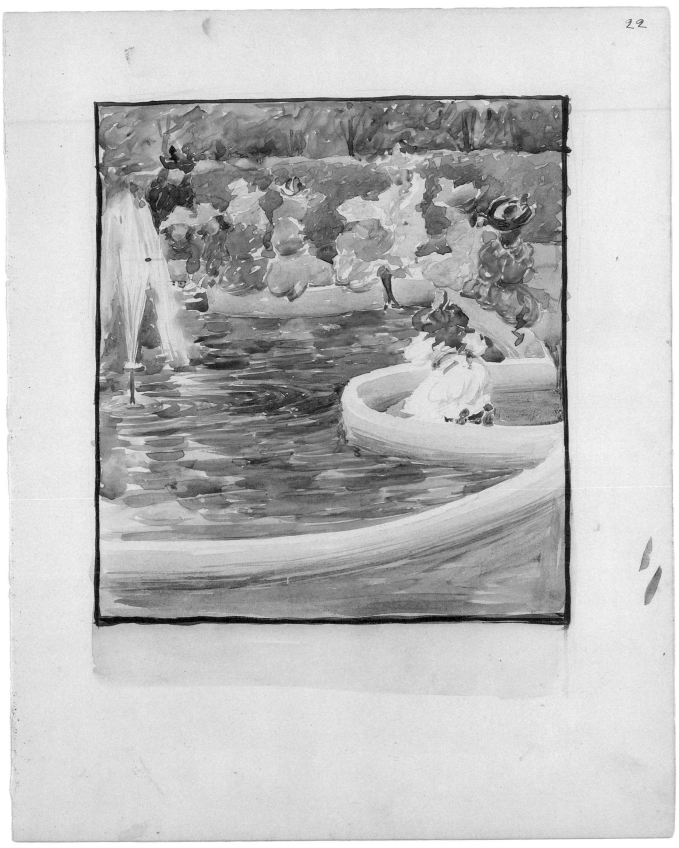

No. 4, 22r

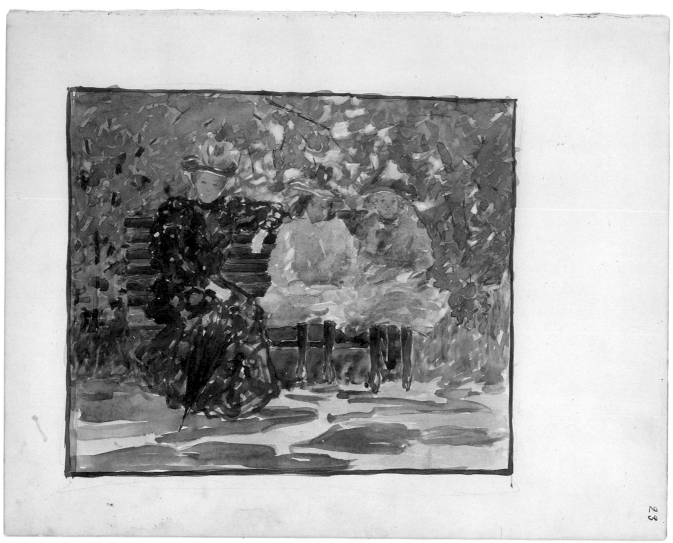

No. 4, 23r

24

No. 4, 24r

23r. A woman and two girls sitting in the park. Watercolor over pencil; bordered in pencil and watercolor. This is one of the few posed studies in the sketchbook. The woman casually resting her arm on the back of a park bench and the two girls, perhaps her daughters, sitting next to her dangling their legs look out with mild curiosity at the artist who observed and recorded them. That Prendergast used white paint, rather than the white of the paper left in reserve, to render the light in the trees in the background is unusual.

23v. Blank.

24r. A fountain in the Public Garden. Pencil. Like the watercolor on 22r, this sketch relates to the monotype *At a Fountain in the Public Garden* (Fig. 4.12). Prendergast apparently abandoned this drawing, which is larger in scale, in favor of the more contained composition of the fully worked watercolor sketch.

24v. Blank.

25

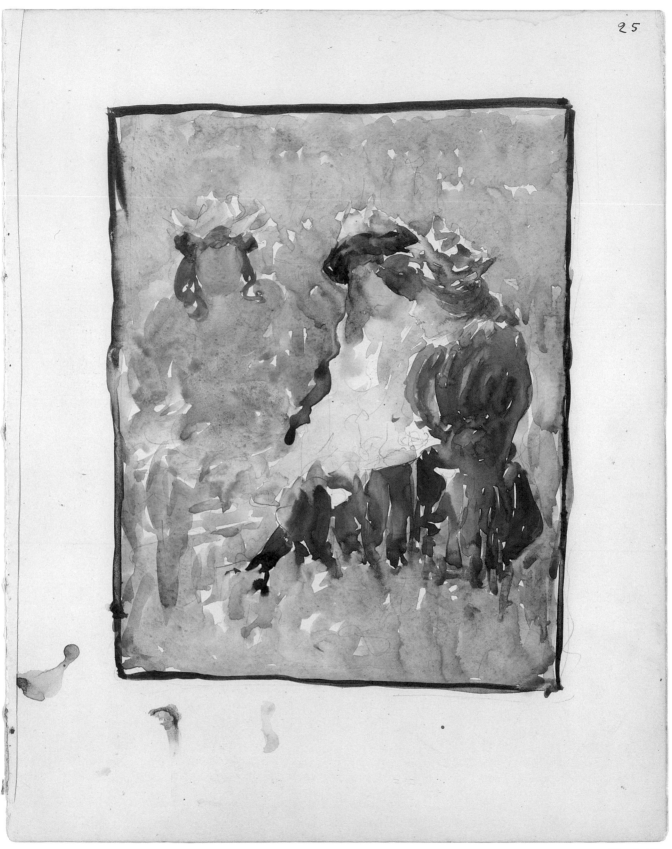

No. 4, 25r

No. 4, 25v

Fig. 4.14 Maurice Prendergast, *Boston Water-color Sketchbook*, p. 19. Watercolor over pencil, ca. 1897–98. Museum of Fine Arts, Boston, Gift of Mrs. Charles Prendergast in honor of Perry T. Rathbone. Reproduced from facsimile

25r. Three girls sitting on the grass. Watercolor over pencil; bordered in pencil and watercolor. This drawing is closely related to some of the sketches in the *Boston Watercolor Sketchbook* in the Museum of Fine Arts, Boston (M. Prendergast 1960, particularly pp. 5, 19 [Fig. 4.14], 53). The watercolor in this broadly painted sketch was applied very wetly and the artist included few details.

25v. A reclining woman reading a book. Pencil; bordered. Women reclining, sometimes reading, in intimate domestic settings was a popular subject with the French Impressionists, notably Pierre Auguste Renoir, and with painters of the Boston school, especially Edmund Tarbell. This is one of the few drawings in the sketchbook set specifically indoors, yet this pert, attentive woman exudes little of the listlessness, fragility, and languid ease that characterize the women painted by Tarbell or Thomas Dewing. She seems to be more contemporary than those symbols of timeless languor and to relate most closely to the Gibson girls created by Charles Dana Gibson. See also 38r.

26

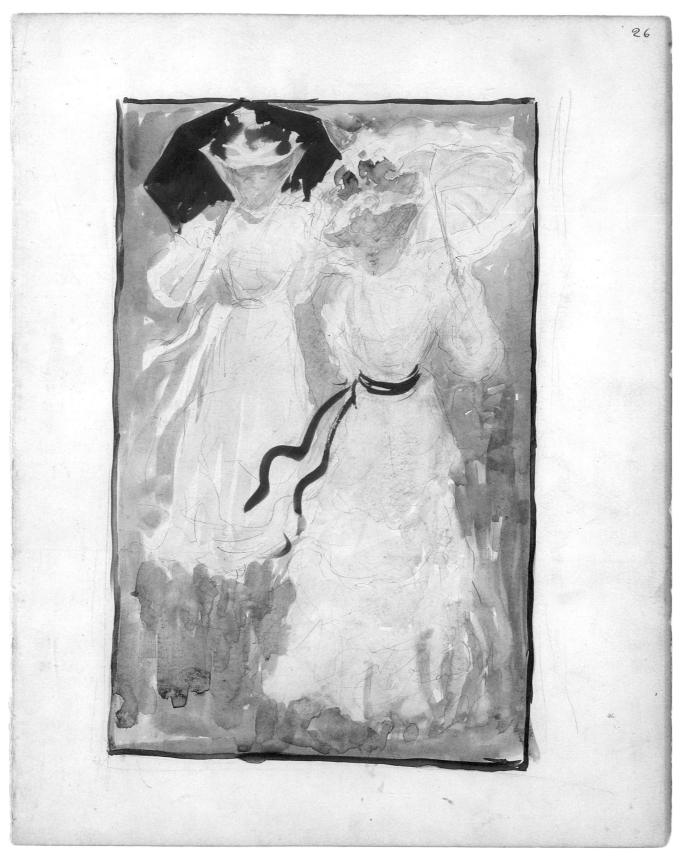

No. 4, 26r

27

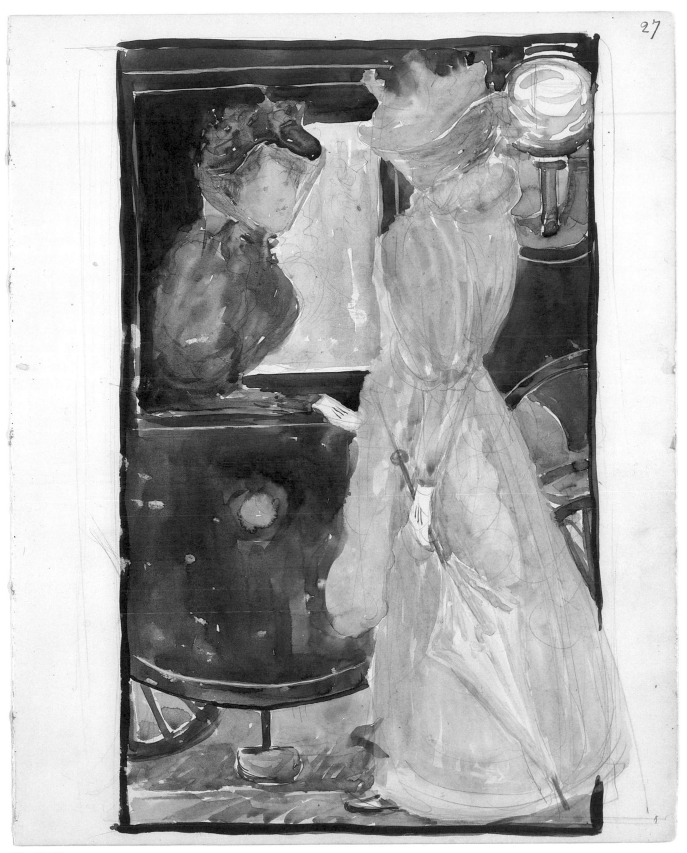

No. 4, 27r

No. 4, 27v

26r. Two women crossing a field. Watercolor over pencil; bordered in pencil and watercolor. The two women, dressed in pale blue and pale pink, protect themselves with parasols as they cross a field glaring yellow in the brilliant summer sun. The color of the field is reflected in splashes of yellow light on the dresses and the white parasol.

26v. Blank.

27r. A woman stopping to converse with an acquaintance riding in a carriage. Watercolor over pencil; bordered in watercolor and pencil. Prendergast might have noticed these obviously upper-class women on Beacon Hill or along the recently developed Commonwealth Avenue. The brass running lamp that signifies the approach of evening helps set the mood of quiet companionship at the close of the day. The pedestrian, her skirt still swaying behind her outside the painted border, seems just to have stepped up to the carriage. See also 27v.

27v. Two women, one standing, the other sitting in a carriage. Pencil; bordered. This is the same scene Prendergast sketched on 27r, but in this version the standing woman has turned to face the viewer, which breaks the quiet, intimate mood by implying the presence of an observer who has interrupted the conversation.

28r. A girl riding a tricycle in the park. Watercolor over pencil; bordered in pencil and watercolor. Prendergast depicted bicycles, streetcars, carriages, and baby carriages on the streets and in the parks of Boston. Here he presented another mode of transportation, a child's tricycle on a park promenade. Watched by a younger child who turns sideways to observe the action, a girl energetically pedals in our direction, away from the perambulator of her youth and the watchful eye of her mother.

28v. Blank.

28

No. 4, 28r

29

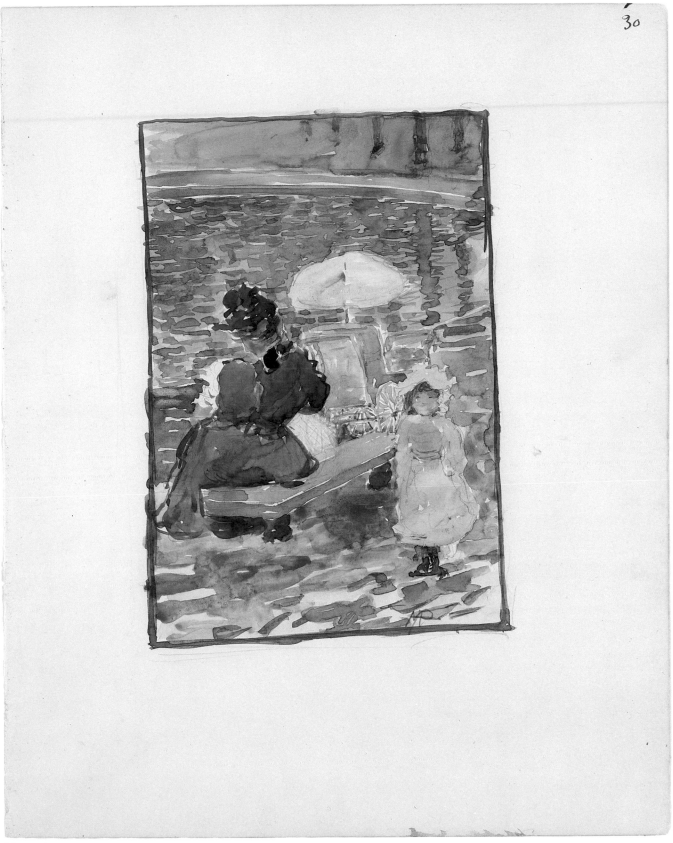

No. 4, 30r

29r. A mother pushing her baby in a perambulator, with her daughter at her side. Watercolor over pencil; bordered in pencil and watercolor. Signed or, more probably, annotated by Charles Prendergast in pencil lower right: *M. Prendergast*. Babies, on mothers' laps or unseen in carriages, figure often in Prendergast's watercolors. In this sketch of great immediacy the baby, sitting in his pram under a large white umbrella that isolates and emphasizes him, takes the lead role. His mother, carrying her own parasol and busily pushing the pram along an avenue of trees, turns to speak to her older daughter, who looks away and walks in the other direction – suggesting a domestic incident of the kind Prendergast must have observed dozens of times each day in the park. Prendergast rarely depicted complete families, and here too there is no suggestion that the man sporting a derby and strolling with a walking stick is part of the group in the foreground.

29v. Blank.

30r. A mother sitting at the edge of a pond with her baby and young daughter. Watercolor over pencil; bordered in pencil and watercolor. Annotated in an unidentified hand in pencil lower right: *MP* (monogram). Probably at the edge of the lake or one of the fountains in the Public Garden, Prendergast is observed by a child whose mother is absorbed with the care of the infant she has taken from its parasoled carriage to hold as she sits on a low bench.

30v. Blank.

31r. Design for an advertisement for a tearoom. Pen and brush and black ink over pencil; bordered in pen and black ink over pencil. Right corners torn. Like other sketches in the book, this is probably a design for an advertisement. The blank signboard between the woman in a dotted dress, a boa, and a veiled hat who carries a steaming cup and the border of flowers would have been suitable for advertising a tearoom's name and menu or hours. Images of women drinking tea or chocolate in public restaurants appear on two other pages of this sketchbook (8v and 43r), and Prendergast chose sidewalk cafés as settings for several of the watercolors he painted in Paris in 1891–94 and for an illustration in *My Lady Nicotine* (p. 212). Many of the illustrations in *My Lady Nicotine* feature disks like the one in the background here (see Fig. 4.15).

31v. A young girl sitting on a wall next to a baby in a carriage. Watercolor over pencil (upside down on the page); bordered in pencil and watercolor. Signed or, more probably, annotated by Charles Prendergast in pencil lower right: *M Prendergast*. Children were more likely than their preoccupied mothers to be aware of Prendergast's presence, and he in turn was sensitive to their special unselfconscious curiosity. Here a pigtailed child sitting on a low wall looks up from watching her young sibling, who likewise seems aware that they are being observed.

32r. Flowers and butterflies. Watercolor over pencil; bordered in pencil and watercolor. This is the only sheet in the sketchbook without figures. It shows an exuberant, decorative design of butterflies and flowers whose petals and tendrils spill out along all four edges of the defined borders of the composition.

Fig. 4.15 Maurice Prendergast, illustration for *My Lady Nicotine*. Ca. 1895. Reproduced from J. M. Barrie, *My Lady Nicotine: A Study in Smoke* (Boston: Joseph Knight Company, 1896), p. 246; collection of Carol Clark

31

No. 4, 31r

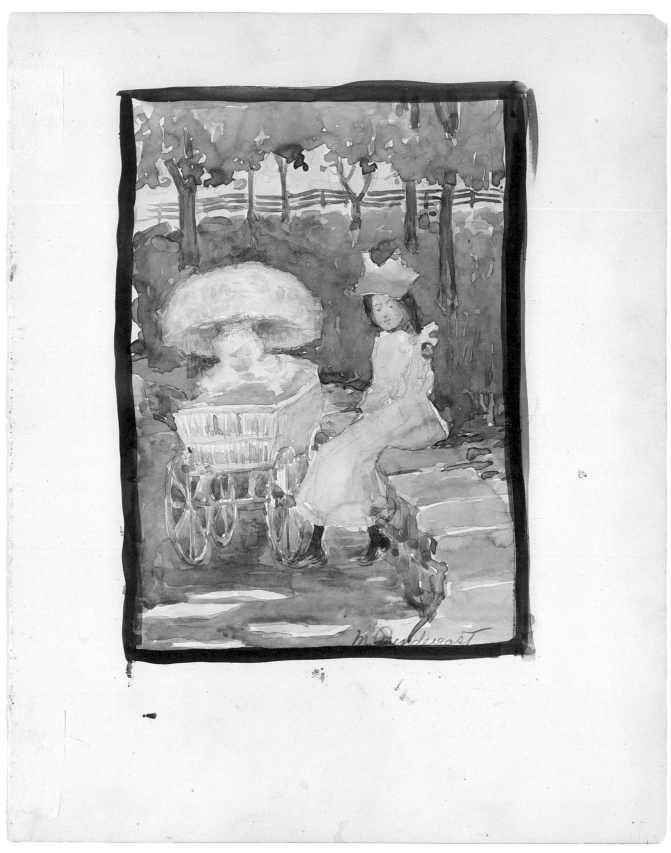

No. 4, 32r

No. 4, 32v

32v. Design for a bicycle poster. Pencil; bordered. *COLUMBIA* lightly sketched across top. Another design for a Columbia bicycle poster, most likely for the competition held in 1896 (see 5r and 40v), this drawing shows a woman seen from the side pedaling vigorously as she participates in the new healthful fad that signaled greater freedom for women.

33r. A bareback rider. Pencil; bordered. Because Prendergast titled a large monotype *Nouveau Cirque* (Terra Museum of American Art, Chicago; Clark, Mathews, and Owens 1990, no. 1594, ill.), his circus series quite naturally has been assumed to be set in Paris (see Langdale 1984, p. 150). However, the existence of this sketch in a notebook used in Boston and the appearance of the date 1895 in the plate of at least two circus

monotypes, both titled *Circus Scene with Horse*, one in the Terra Museum of American Art, the other in a private collection (Clark, Mathews, and Owens 1990, nos. 1590, 1591, ill.), suggest that he worked on the subject, whether from memory or freshly observed at an American circus, after his return to Boston in the autumn of 1894. As Langdale first noted in 1984 (p. 73), this sketch of a bareback rider who is dressed in a tutu and stands, one leg bent, atop a horse appears to be a preparatory study, appropriately in reverse, for the monotype *Bareback Rider* in the Cleveland Museum of Art (Fig. 4.16). It is also closely related to a slightly smaller watercolor over pencil drawing, *The White Horse and Circus Rider* (Fig. 4.17). The watercolor makes clear that Prendergast intended the slight figure to the left of the horse in this sketch to be the ringmaster.

Fig. 4.16 Maurice Prendergast, *Bareback Rider.* Monotype, ca. 1895. Cleveland Museum of Art, Purchased from the Dudley P. Allen Fund

Fig. 4.17 Maurice Prendergast, *The White Horse and Circus Rider.* Watercolor over pencil, ca. 1893–95. Collection of Mrs. Charles Prendergast. Photograph by E. Irving Blomstrann, courtesy of the Prendergast Archive and Study Center, Williams College Museum of Art, Williamstown, Massachusetts

No. 4, 33r

No. 4, 33v

33v. Design for an advertisement. Pencil; bordered. This drawing is further evidence of the relationship of this sketchbook to Prendergast's commercial career. Five women, two of them more fully defined with hats and smiling faces, seem to link arms as they hold up round signs, each marked with a different letter, in what is clearly a design for an advertisement for something called BOVOX. A similar chain of women, linked by a smokelike sash rather than arms, opens the first chapter of *My Lady Nicotine* (Fig. 4.18). See also 42v.

34r. Blank.

34v–35r. A crowd watching fireworks. Watercolor over pencil. This study of light and reflections is the only drawing in the sketchbook that extends across two pages (still attached to each other). Prendergast rendered the light effects with technical mastery, applying thin washes of color and then blotting the paper for even greater luminosity to create impressions we could liken to abstract art.

MY LADY NICOTINE.

CHAPTER I.

MATRIMONY AND SMOKING COMPARED.

THE circumstances in which I gave up smoking were these:

I was a mere bachelor, drifting toward what I now see to be a tragic middle age. I had become so accustomed to smoke issuing from my mouth that I felt incomplete without it; indeed, the time came when I could refrain from smoking if doing nothing else, but hardly during the hours of toil. To lay aside my pipe was to find myself soon afterward wandering restlessly round my table. No blind beggar was ever more abjectly led by his dog, or more loath to cut the string.

Fig. 4.18 Maurice Prendergast, illustration for *My Lady Nicotine*. Ca. 1895. Reproduced from J. M. Barrie, *My Lady Nicotine: A Study in Smoke* (Boston: Joseph Knight Company, 1896), p. 1; collection of Carol Clark

No. 4, 34v–35r

No. 4, 35v

35v. A woman walking toward the right. Pencil. This woman in a full skirt and carrying a muff has the pointed, upturned nose that is characteristic of Prendergast's profile sketches.

36r. A woman with red hair wearing a green plumed hat. Watercolor over pencil; bordered in pencil and watercolor. Foliage broken by spots of sunlight provides the background for this sensitive portrait of a young redheaded woman whose serious countenance is matched by the subdued earth tones in which Prendergast painted her. The plume of her hat echoes the hues and shapes of the backdrop of thick foliage.

36v. Blank.

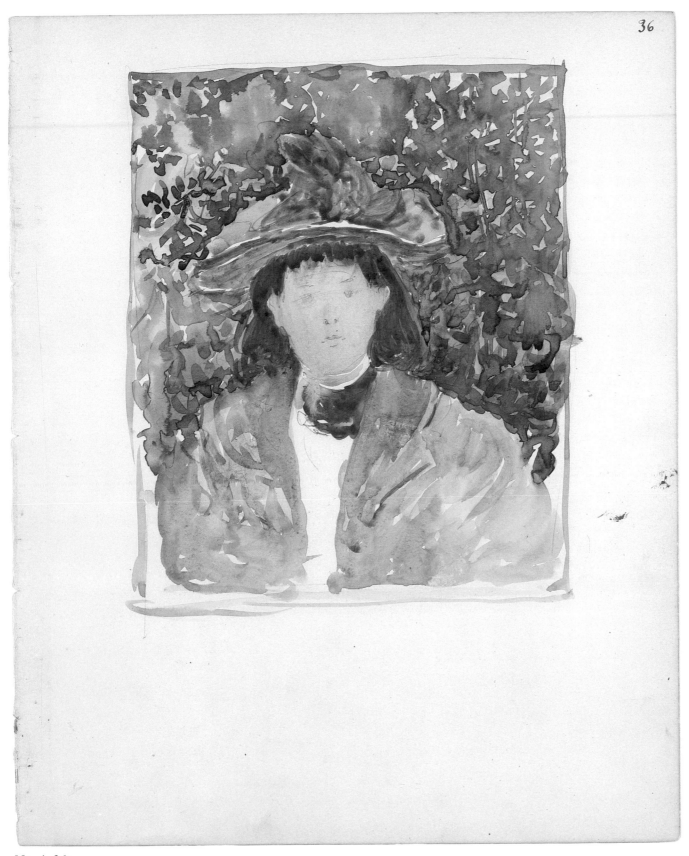

No. 4, 36r

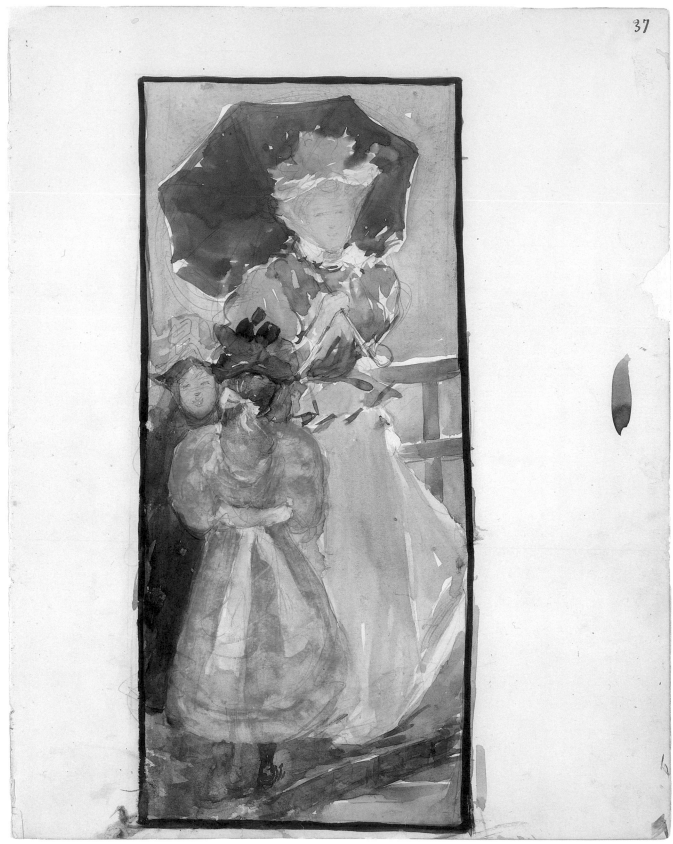

No. 4, 37r

No. 4, 37v

Fig. 4.19 Reconstruction of No. 4, page 37v, with fragments removed from 38r (see also Fig. 4.20)

37r. Two young girls and a woman with a parasol. Watercolor over pencil; bordered in pencil and watercolor. In a striking vertical format, Prendergast recorded these two girls having a lively conversation while a woman, perhaps the mother of one of them, looks on. The three beautifully dressed females might have been standing by a railing at the water's edge on a spring day, the wind ruffling their skirts. Prendergast painted this homage to femininity in his usual palette of red, yellow, green, and blue, with rare touches of opaque white. See also 39r.

37v. Annotated in two columns ruled in ink, on the left (*Mr Prendergast* at top of column and *0 00* at bottom in pencil, remainder in pen and ink): *Mr. H. P. Whitmarsh % / Jan 30 Paid Mr Prendergast 5 00 / Feb 6 " 10 00 / " 13 " 7 00 / " 20 " 7 00 / " 27 " 7 00 / [Mar]ch 6 " 7 00 / 13 " 7 00 / [2]0 " 7 00 / [2]7 " 7 00 / [April 3] " 7 00 / [" 10] Did not draw 0 00 / [" 17] " " " 0 00*; on the

right (*Mr Whitmarsh* and the line through *B.* at top of column and *10 0* at bottom in pencil, remainder in pen and ink): *Mr M. B. Prendergast % / April 9 Paid Mr Whitmarsh 10 00 / " 17 " " " 10 0*. Various losses along top, left, and bottom edges made up with rag paper. During conservation treatment of the sketchbook in the 1980s, fragments of the edges of this page that had been (purposely?) adhered to the facing page (38r) were removed and mounted separately (Figs. 4.19, 4.20). The date February 1897 is written on two fragments from the top of the sheet. This evidence of financial transactions between Prendergast and the Boston painter Hubert P. Whitmarsh, or between them and a third party, perhaps an agent, might eventually provide a clue to understanding more about Prendergast's career in the years after his return to Boston in 1894. Strangely enough, the accounts appear to have been written by neither Charles nor Maurice Prendergast.

No. 4, 38r

Fig. 4.20 No. 4, page 38r, before re-
moval of fragments of 37v that had
adhered to it (see also Fig. 4.19)

No. 4, 38v

38r. A reclining woman. Pencil. This young woman reclining amid a flow of penciled drapery conveys by her insouciant expression and alluring pose a kind of intimacy quite different from that of the reclining woman who reads on 25v. A rocking chair with bentwood braces in a serpentine similar to that seen here appears in *My Lady Nicotine* (p. 70). See also 37v.

38v. A woman walking with a parasol. Pen and black ink over pencil; bordered in pencil. Prendergast went over this pencil drawing with pen and black ink to emphasize the determined walk of a woman who holds up her skirt for one booted leg to step out of the bounds he drew for her. This descriptive drawing differs markedly from the summary figure on 5v.

39

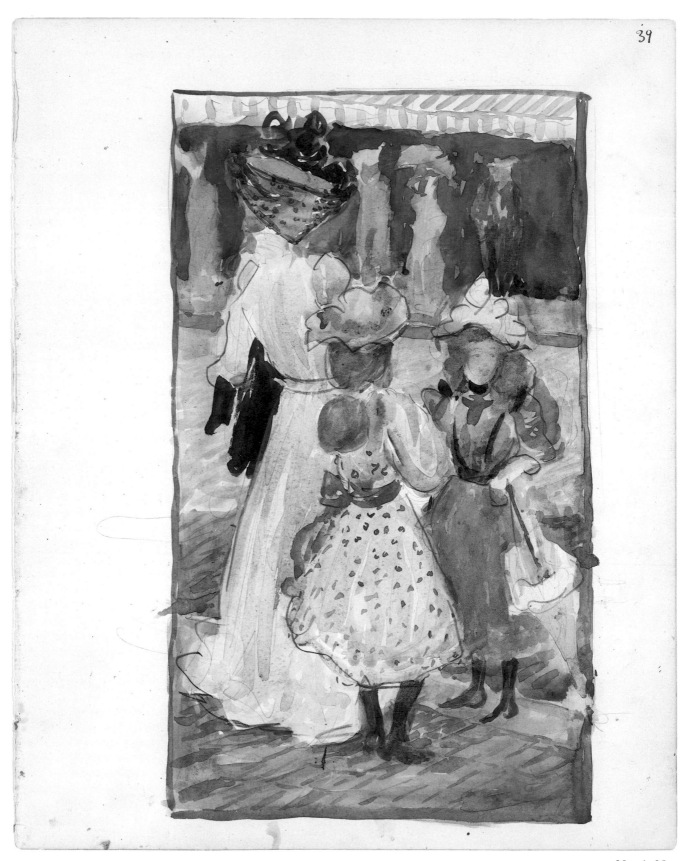

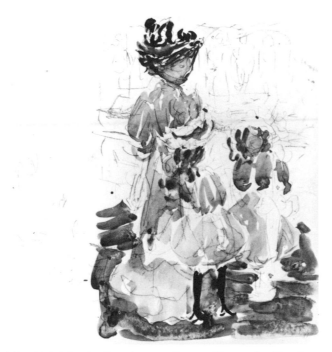

Fig. 4.21 Maurice Prendergast, *Boston Watercolor Sketch-book*, p. 11. Watercolor over pencil, ca. 1897–98. Museum of Fine Arts, Boston, Gift of Mrs. Charles Prendergast in honor of Perry T. Rathbone. Reproduced from facsimile

39r. Two girls and a woman in a veiled hat. Watercolor over pencil; bordered in pencil and watercolor. Here, as on 37r, a woman oversees the animated exchange between two young girls, but in a more definitely urban atmosphere, without the fresh breeze off the water. As he did in other watercolors, Prendergast enlivened the setting by painting a festive striped awning along the top edge of the sheet. The dark lines applied with a stiff brush to reinforce the contours give this drawing a heavier, less delicate look than the other pages of the sketch-book. A similar group of figures appears in the *Boston Water-color Sketchbook* in the Museum of Fine Arts, Boston (M. Prendergast 1960, p. 11 [Fig. 4.21]).

39v. Blank.

40

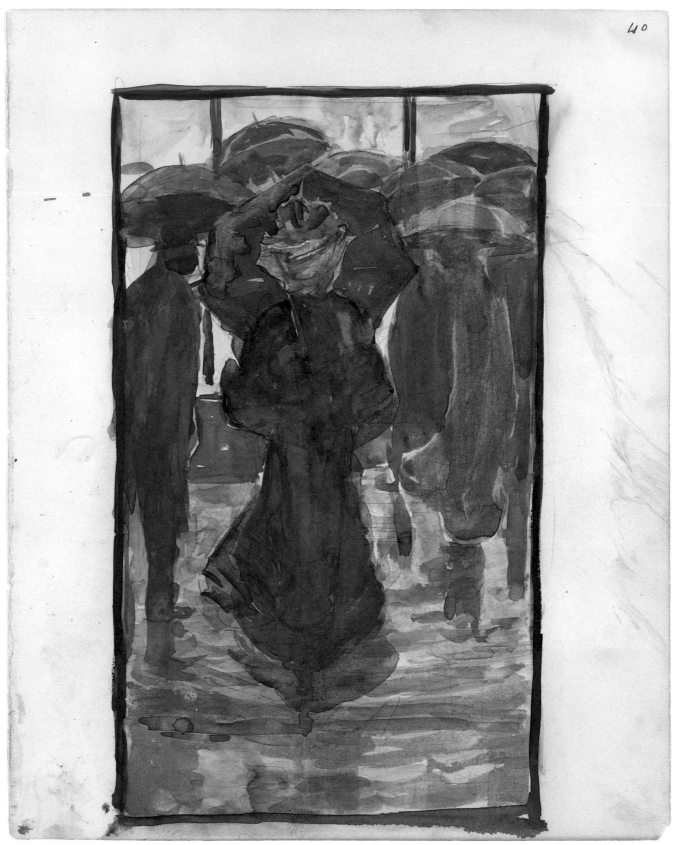

No. 4, 40r

40r. Night scene with figures carrying umbrellas. Watercolor over pencil; bordered in pencil and watercolor. Lower right corner torn off. As on 8r, the setting is a rainy evening on a city street, but here the bright lights of a store window dramatically illuminate the scene from the back and cast the figures into dark blue shadows. The bright red umbrella that frames her veiled face and glimpse of yellow hair accentuates the central figure. Prendergast chose a similar shallow space in a street bounded by shop fronts with insistently vertical window moldings for some of his monotypes, for example *Street Scene* (Fig. 4.22) and *Afternoon* (Fig. 4.23). See also 42r.

Fig. 4.22 Maurice Prendergast, *Street Scene*. Monotype, ca. 1895–1900. Terra Museum of American Art, Chicago, Daniel J. Terra Collection

Fig. 4.23 Maurice Prendergast, *Afternoon*. Monotype, ca. 1895–1900. Corcoran Gallery of Art, Washington, D.C., Museum Purchase, Mary E. Maxwell Fund

No. 4, 40v

40v. A woman walking with a parasol. Pencil; bordered. The slight sketch to the left is probably another idea for the Columbia bicycle poster competition (see 5r and 32v).

41r. Night scene with two women with parasols and a crowd of men in top hats. Watercolor over pencil; bordered in pencil and watercolor. Various trials with brush and green water-color in right margin. Here the evening has taken on a hurried, even frantic character. The sprightly central figure pulls up her skirt daintily to extend one foot and holds her parasol high as she rushes toward us in front of an anonymous crowd of darkly dressed figures – seven top-hatted men and one woman. The contrast of complementary yellow and blue behind the pale green central figure (the same pale green was used along the edges of the coats and hats of some of the men) heightens the image's visual intensity.

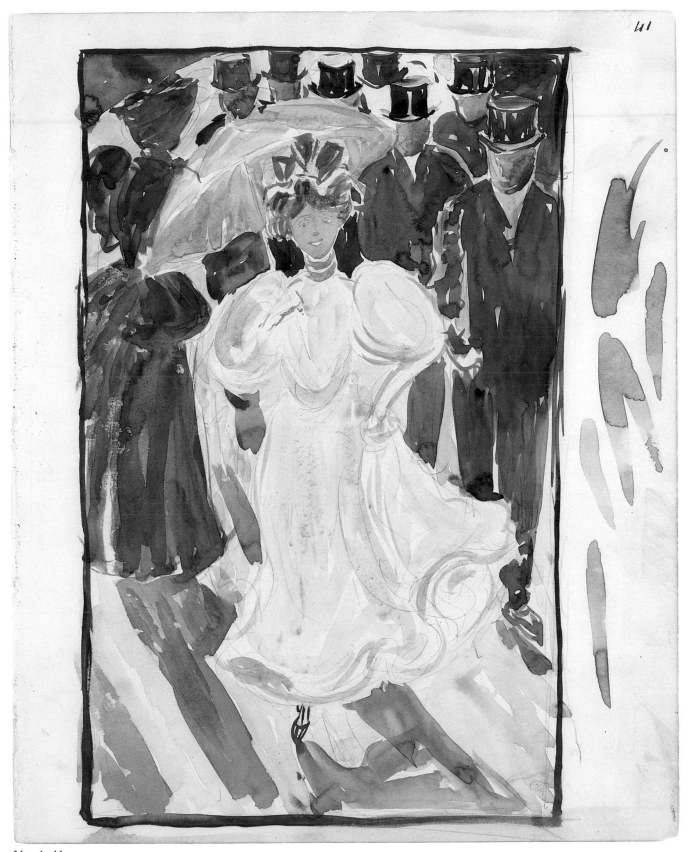

No. 4, 41r

No. 4, 41v

41v. A woman sitting facing right and the head of a woman. Pencil. Prendergast sketched this young woman from the side, sitting on a park bench and protected by a parasol, and then sketched her face, tilted and with a faint smile, from the front.

42r. Night scene with a woman walking and men in top hats in the background. Watercolor over pencil; bordered in pencil and watercolor. A three-part shop window like that in 40r forms a backdrop for this evening street scene, which features a woman in rose-violet in front of a group of several top-hatted men and one woman, but the dull reddish brown that has been substituted for the green of 40r gives this sketch a totally different character.

42

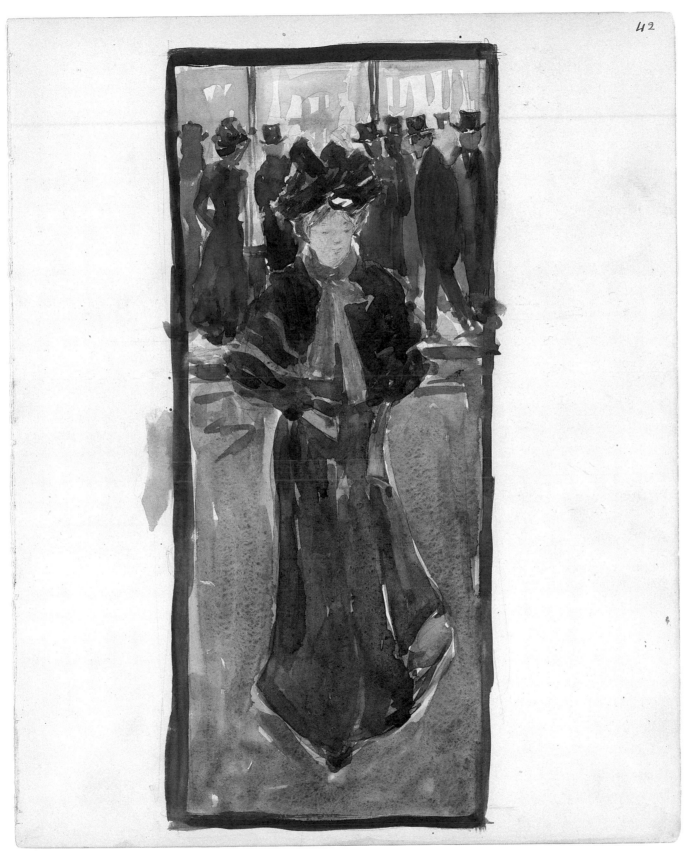

No. 4, 42r

No. 4, 42v

42v. A seated woman trying on a hat. Pencil. This young woman trying on a hat and looking coyly at the viewer, perhaps through a shop window, resembles the figures in the advertisement on 33v.

43r. A woman drinking from a cup. Watercolor over pencil; bordered in pencil and watercolor. In a sketch with the same subject as the advertisement on 31r and the watercolor on 8v, this redheaded woman, seen in profile, raises a cup to her lips as her downcast eyes reflect solitary thought rather than the conviviality of a shared meal.

43v. Blank.

43

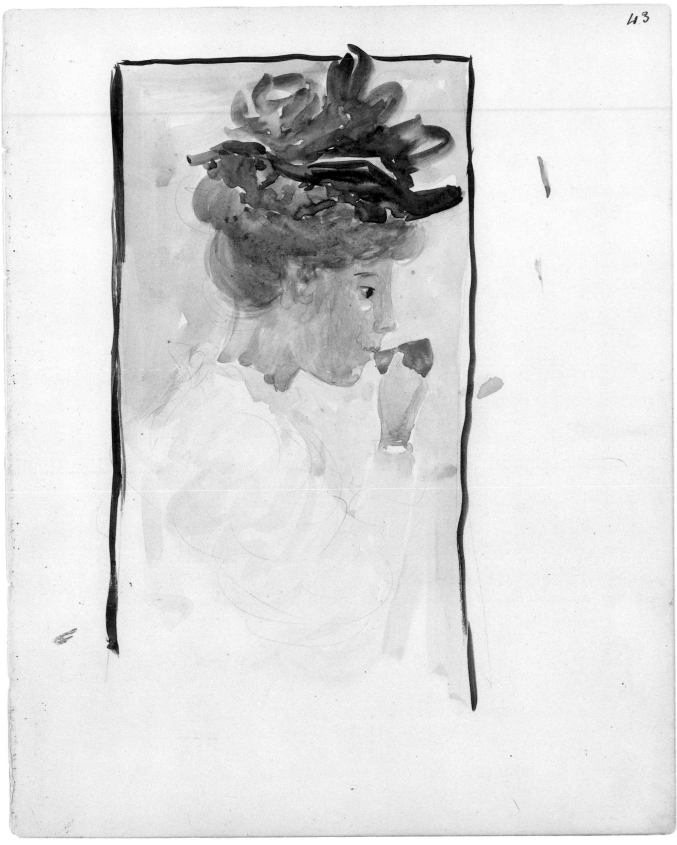

No. 4, 43r

44

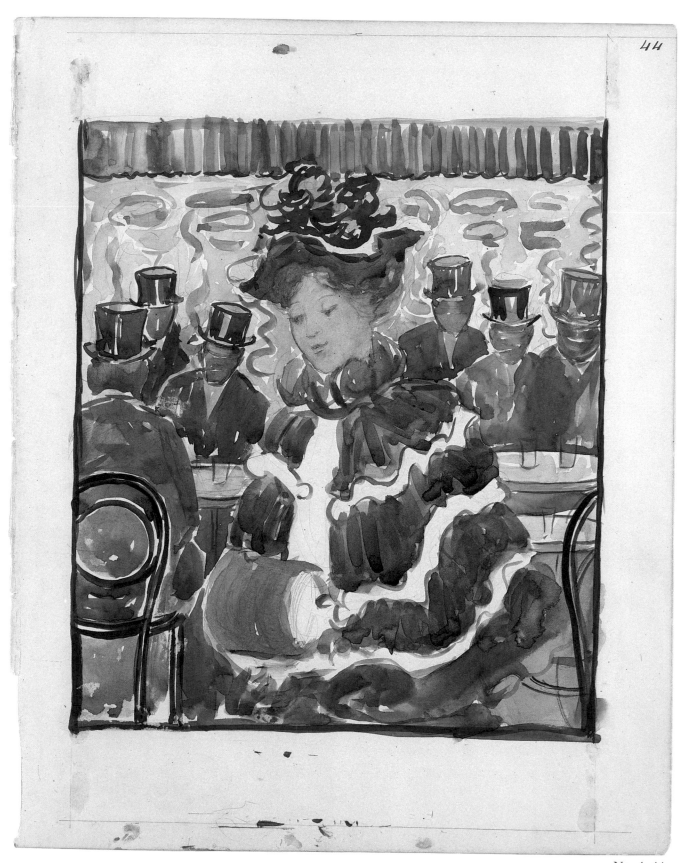

No. 4, 44r

44r. A woman passing a café. Watercolor over pencil; bordered with a straightedge in pencil and freehand in watercolor. The final watercolor of the sketchbook is among the strongest in design and the most effective in conveying mood. Prendergast again used the technique, seen on 41r, of introducing green into the dark blue costumes. And, like many of Prendergast's other works, the page is topped with the striped valance of an awning. The faceless men present as background in other sketches have now become an audience for the young woman who crosses in front of the outdoor café. Her downcast eyes imply an innocence that was often associated in late nineteenth-century literature, art, and advertising with the idealized American woman, who was deemed less experienced than her European counterpart. To judge from her muff, the evening is cool. Smoke from the men's cigars curls decoratively up at the level of the woman's head, evoking the associated masculine pleasures of smoking and sexual fantasy, which Prendergast made graphically clear in his illustrations for *My Lady Nicotine* by creating enticing women quite literally from smoke (see Fig. 4.24).

44v. Blank.

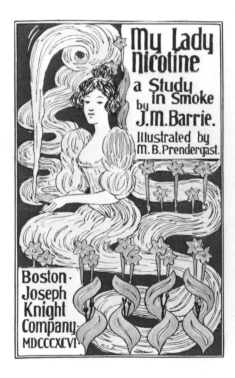

Fig. 4.24 Maurice Prendergast, illustration for *My Lady Nicotine*. Ca. 1895. Reproduced from J. M. Barrie, *My Lady Nicotine: A Study in Smoke* (Boston: Joseph Knight Company, 1896), title page; collection of Carol Clark

5. Swings, Revere Beach, ca. 1896–97

1975.1.921

Watercolor over pencil. 35.5 x 25.3 cm. Signed in black ink lower left: *Prendergast.*[1] Annotated on the verso at upper center in Charles Prendergast's hand: *Swings* (in pencil) / *REVERE. BEACH* / *1897* (in black crayon). Tack holes at all four corners.

In Boston between his return from France in the autumn of 1894 and his departure for Italy in the summer of 1898, Prendergast produced a major body of work in watercolor, a medium he had begun to master in Paris. With these fluid and vibrant watercolors, he attracted patrons, began his exhibiting career, and won the attention of critics.

His subjects were Boston's new leisure sites – South Boston Pier, Franklin Park, and the seaside resorts along the shore north and south of the city. Among his favorite haunts was Revere Beach, where he could blend into the crowd and sketch middle-class pleasure-seekers. Prendergast discovered Revere Beach, on the North Shore five miles outside the city, at a peculiar and fortuitous moment in its history. Since 1875, when the Boston, Revere Beach, and Lynn Narrow Gauge Railroad made it easily accessible to the city, the resort had been growing more and more overcrowded and seedy. "One of the most graceful stretches of ocean beach on the Atlantic coast," Edwin M. Bacon wrote in 1898 in *Walks and Rides in the Country Round About Boston*, Revere Beach had been "up to the close of the season of 1896 ... a place of low-browed, cheap, unlovely structures, in a crowded row on either side of the tracks, with narrow promenade, protected from them by wire fences. It was picturesque, if shabby, and, packed with its unconventional summer population, not uninteresting to the social philosopher." In the years following the Massachusetts Parks Act of 1893, work began to clear the old buildings at Revere Beach, and by 1897 the Metropolitan Park Commission had created, under Charles Eliot's direction, a new "public ocean park, with promenade and pleasure-driveway," that was the first of its kind in the United States.[2]

When he sketched this view of Revere Beach in 1896 or 1897, Prendergast shifted his gaze from the ocean to concentrate on the beach crowded with children digging in the sand and playing on the swings under their parents' attentive supervision. The colorfully dressed women and girls sporting elaborate flowered hats are meticulously outfitted for their weekend holiday at what is clearly a densely populated suburban resort. The swings, or swingboats, that obstruct the view to the sea also serve

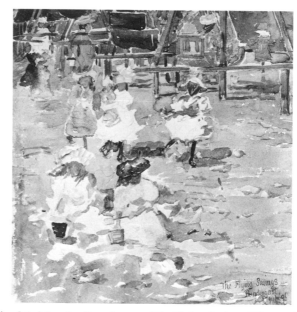

Fig. 5.1 Maurice Prendergast, *The Flying Swings*. Watercolor over pencil, 1896. Collection of Marcia Fuller French. Photograph by Linda Lorenz, courtesy of the Amon Carter Museum, Fort Worth, Texas

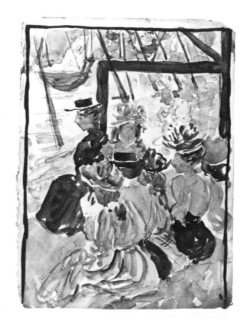

Fig. 5.2 Maurice Prendergast, *Boston Watercolor Sketchbook*, p. 58. Watercolor over pencil, ca. 1897–98. Museum of Fine Arts, Boston, Gift of Mrs. Charles Prendergast in honor of Perry T. Rathbone. Reproduced from facsimile

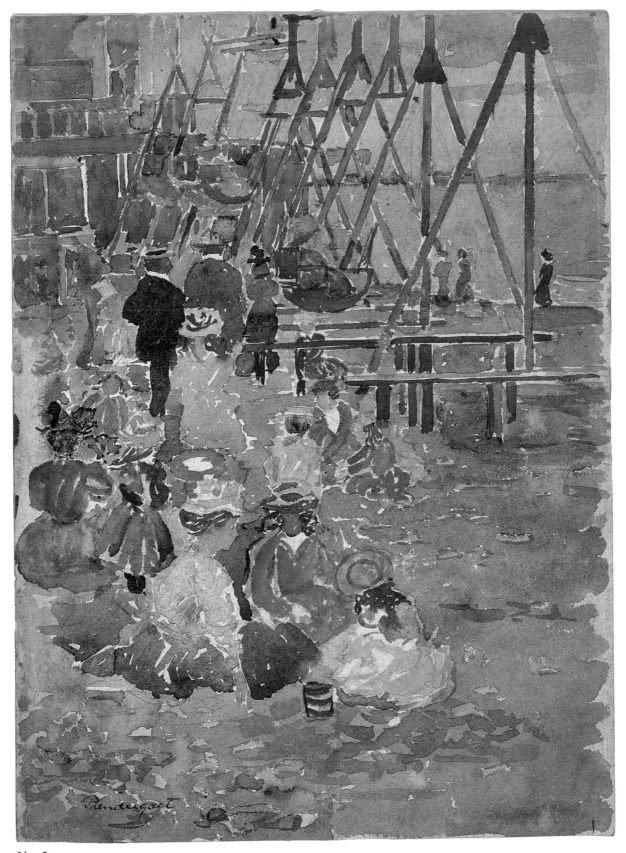

No. 5

as an abstract, geometric counterpoint to the natural forms of the figures and play the same key organizational role in the composition as do the prominent piers in others of Prendergast's beach scenes.

Prendergast painted watercolors of Revere Beach that show the sweep of sandy beach and the vistas out to sea, but he was just as fascinated by the seaside architecture that at the time still fringed the bathing areas and by the other "structures" of seashore pleasure – bathing rafts and swingboats. The Lehman watercolor is one of four Revere Beach scenes in which Prendergast included swingboats. It is closest to *The Flying Swings* of 1896 (Fig. 5.1),[3] whose title, prominently lettered in red on the sheet, affirms the pictorial importance he attached to these structures that were as much a source of visual stimulation for an artist as they were a source of pleasure for beachgoers.

There are many related sketches in the *Boston Watercolor Sketchbook* in the Museum of Fine Arts, Boston (see Fig. 5.2), that Prendergast also painted sometime before his departure for Italy in 1898.[4]

NOTES:

1. This is probably Maurice Prendergast's signature, but see No. 4, note 1.
2. Bacon 1898, pp. 15–16. See also Newton 1971, pp. 318–36; Garland 1978, pp. 157–75; Garland 1981, p. 16; Zaitzevsky 1982, pp. 118–23; and Mathews 1990, p. 14.
3. Clark, Mathews, and Owens 1990, no. 628, ill. For the two other beach scenes with swings, see ibid., nos. 626, 627, ill.
4. M. Prendergast 1960, especially p. 58. On the sketchbook, see also No. 4, notes 2, 18, and Figs. 4.5, 4.9, 4.10, 4.14, 4.21.

PROVENANCE: Charles Prendergast, 1924; his widow, Eugénie Prendergast, 1948; Robert Lehman, March 1961.

EXHIBITED: New York 1976–77, no. 48; New York 1982, no. 47.

LITERATURE: Oklahoma City–Memphis 1981–82, p. 13, fig. 4; Szabo in M. Prendergast 1987, p. xvi; Clark, Mathews, and Owens 1990, no. 625, ill.

6. Late Afternoon, Summer, ca. 1900–1905

1975.1.919

Watercolor and pastel over pencil; bordered in pencil along lower edge. 52.2 x 41 cm. Laid down on board. Signed (or annotated by Charles Prendergast?) in pink pastel lower right: *Prendergast*. Small tears along left, top, and right edges; tack holes at all four corners and at upper center.

Many of the watercolors and oils Prendergast painted between 1900 and 1905 record scenes at crepuscule, as he and his contemporaries often called it. In *Late Afternoon, Summer* (which was titled *Late Afternoon* in 1950 when it was exhibited for the first time and has also been called *Afternoon on the Beach*) he evoked a moment when the late afternoon sun, still bright enough to require a parasol, was fading into cool, darkening twilight at Nahant, one of his favorite sites in these years.

Three large figures – a woman standing facing us while another woman seated on a bench and a young girl with pigtails look out at the activity on the water and the pier in the distance – fill the foreground of *Late Afternoon, Summer*. After the success of his watercolors of the Boston shore and Italy of the late 1890s, Prendergast began to experiment with compositions in which larger figures are more boldly drawn with pencil and paint. The fluid blending of figures and setting that characterized his earlier works gave way to more distinct shapes as he introduced pastel into his watercolors, which gave them a dense, textural quality and greater intensity of color. The

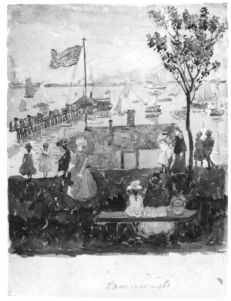

Fig. 6.1 Maurice Prendergast, *Excursionists, Nahant*. Watercolor, pencil, and gouache, ca. 1896–97. The Metropolitan Museum of Art, New York, The Lesley and Emma Sheafer Collection, Bequest of Emma A. Sheafer, 1973 (1974.356.2)

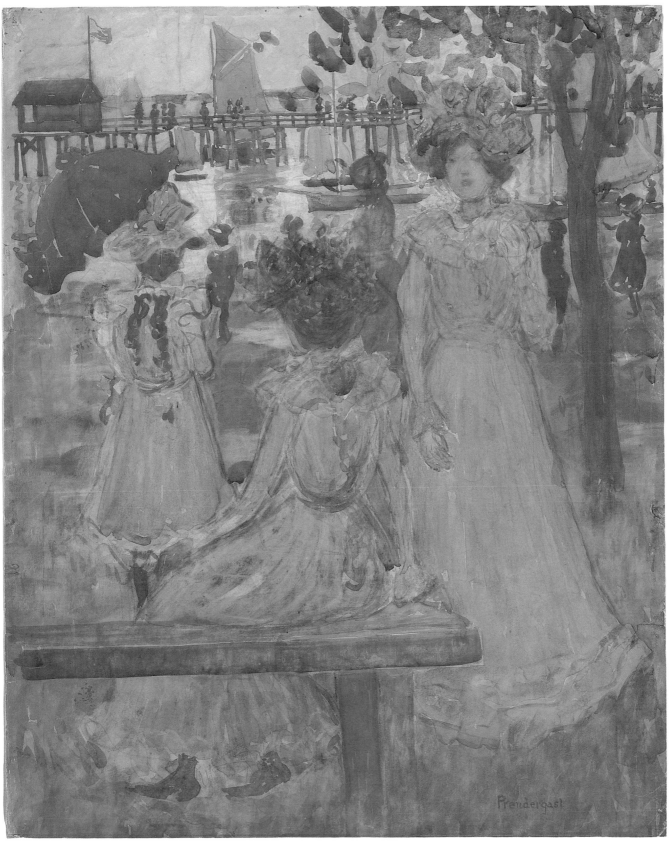

No. 6

Fig. 6.2 Maurice Prendergast, *The Pier.*
Watercolor over pencil, ca. 1900–1905.
Williams College Museum of Art,
Williamstown, Massachusetts, Gift of
Mrs. Charles Prendergast

atmosphere of these works is also strangely silent, and we know that during these years Prendergast suffered from worsening deafness.

Excursionists, Nahant in the Metropolitan Museum (Fig. 6.1) is an earlier treatment of this subject, dating from about 1896–97.[1] Another version more closely related to the Lehman watercolor and from the same period, *The Pier* (Fig. 6.2), shows Prendergast's experiments with various figural arrangements.[2] He must have loved the wit and decorative potential of little girls' pigtails; in the *Boston Watercolor Sketchbook* (Museum of Fine Arts, Boston) he sketched several girls on the beach who wore their hair in pigtails.[3]

NOTES:
1. Clark, Mathews, and Owens 1990, no. 650, ill.
2. Ibid., no. 827, ill.
3. M. Prendergast 1960, p. 72. On the sketchbook, see also No. 4, notes 2, 18, and Figs. 4.5, 4.9, 4.10, 4.14, 4.21, 5.2.

PROVENANCE: Charles Prendergast, 1924; his widow, Eugénie Prendergast, 1948; [Kraushaar Galleries, New York, by 1950]; Joseph Katz, Baltimore, 1957; his descendants, 1958; [Victor Spark, New York, 1959]; [Lock Galleries, New York, 1960]; Robert Lehman, June 1960.

EXHIBITED: New York 1950, no. 21 (as *Late Afternoon*); New York 1966–67, no. 132 (as *Afternoon on the Beach*); New York 1976–77, no. 49; New York 1982, no. 48.

LITERATURE: Clark, Mathews, and Owens 1990, no. 826, ill.

7. Low Tide, Beachmont, ca. 1900–1905

1975.1.920
Watercolor over pencil. 39 x 55.9 cm. Laid down. Signed in black ink lower right: *Prendergast*.[1] Embossed stamp lower left (Fig. 7.1): *R. W. S.* (with a crown to the left) / *1804 5*.[A] *PALL MALL* (the stamp of the Royal Society of Painters in Water Colours).[2] Vertical crease 23.5 cm from right edge; vertical fold about .5 cm from left edge, left corners torn along the line of the fold; tack holes at right corners.

As he did in *Late Afternoon, Summer* (No. 6), Prendergast created the figures in *Low Tide, Beachmont* with bold outlines as well as patches of color. As a result, both watercolors became flatter and more abstract and as much decorative as naturalistic. *Low Tide, Beachmont* is a study in circular forms made from rocks, billowing skirts, hats, and parasols. The figures, not just drawn in paint but defined by blocks of color, blend into the surrounding rocks. The angle of the pier creates a striking division between the rocks and figures in the foreground and the water beyond, and it further animates the composition by suggesting a rushing movement from right foreground to left middle ground.

Fig. 7.1 Rubbing of the stamp of the Royal Society of Painters in Water Colours on No. 7 (actual size)

Fig. 7.2 Maurice Prendergast, *Low Tide, Beachmont.*
Watercolor over pencil, ca. 1900–1905. Worcester Art Museum, Worcester, Massachusetts

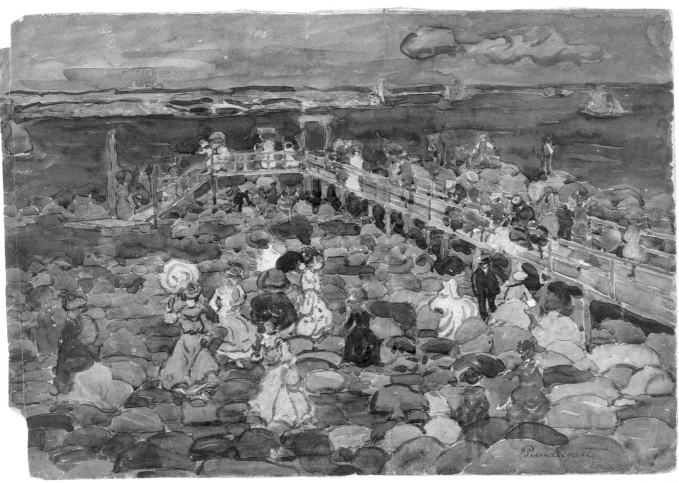

No. 7

From about 1900 to 1905 Prendergast also experimented with new pictorial compositions in a number of other watercolors set at Boston's shore resorts (see Fig. 7.2).[3] The Lehman watercolor is distinguished from the others by the forceful diagonal of the pier.

Like many of Prendergast's works, this watercolor was titled after his death. Eugénie Prendergast may have called it *Low Tide, Beachmont* when she sold it to Robert Lehman in 1961. The locale it depicts appears to be not Beachmont, however, but a spot along Boston's South Shore near Hull, perhaps what is called Stony Beach. The lighthouse in the background could well be on one of the Boston Harbor islands.[4]

NOTES:
1. This is probably Maurice Prendergast's hand, but see No. 4, note 1.
2. The Royal Society of Painters in Water Colours (monogram R.W.S.) was founded in 1804; its address is listed in the 1879 and 1911 Baedeker's as 5A Pall Mall, London. J. Barcham Green and Son of Hayle Mill, Maidstone, England, origi-

nally began making this paper in about 1900 for the London paper merchants the Old Watercolour Paper and Arts Company, Ltd., which was founded in 1895 by J. W. North (the paper is sometimes called "OW" paper). According to Peter Bower of the Tate Gallery, London, "the object of the company was to make the finest quality handmade papers using only 100% linen rag for the furnish and with great attention paid to the sizing and finishing of the sheets." After some preliminary trials, Hayle Mill "proved capable of producing paper that would meet the exacting requirements of the Royal Society of Painters in Watercolour, whose guarantee stamp was to appear in each sheet" (Bower, letter to the author, 8 October 1991).

So far as I know, this is the only watercolor for which Prendergast used paper with the R.W.S. stamp. I am greatly indebted to Peter Bower and to James Gibb, the Old Water-Colour Society's Club, Bankside Gallery, London; Leslie Paisley, Williamstown Regional Art Conservation Laboratory, Williamstown, Massachusetts; Marjorie Cohn, conservator and curator of prints, Fogg Art Museum, Cambridge, Massachusetts; and John Krill, paper conservator, Winterthur Museum, Winterthur, Delaware, for helping me with research on the stamp. See also Cohn in Cambridge (Mass.) 1977, p. 20, and Hardie 1966–68, vol. 1, p. 27, n. 1; vol. 3, p. 138.

No. 8, recto

I am grateful to Margaret Holben Ellis for taking the rubbing of the stamp and for examining the drawing; she sees no watermark in the paper.

3. Clark, Mathews, and Owens 1990, no. 823, ill., also titled *Low Tide, Beachmont*, is one example.

4. I am grateful to Peter McCauley of Revere Beach for suggesting this location to me (telephone conversation, 18 October 1991) and for sharing with me his extensive knowledge of the Boston shores.

PROVENANCE: Charles Prendergast, 1924; his widow, Eugénie Prendergast, 1948; Robert Lehman, March 1961.

EXHIBITED: New York 1966–67, no. 125; New York 1976–77, no. 47; New York 1982, no. 46; New York 1985–86.

LITERATURE: Oklahoma City–Memphis 1981–82, p. 13, fig. 3; Szabo in M. Prendergast 1987, p. xvi; Clark, Mathews, and Owens 1990, no. 847, ill.

8. Standing Nude Woman and Studies of a Hand, a Leg, and Feet, ca. 1912–15

1975.1.922

Pencil. 30.7 x 24 cm. Tear about .5 x 5.9 cm along left lower edge made up; some stains.

Verso: Standing nude woman seen from the back. Pencil.

Most of Prendergast's pencil sketches are part of his eighty-eight extant sketchbooks (many of which have missing pages that have been either lost or separately preserved).[1] This drawing is one of a small group of independent pencil sketches that date from the early 1910s. Most of these are studies of figures, some nude, some draped, many dancing in poses inspired by ancient and modern sources.[2]

No. 8, verso

The drawings on the recto and verso of the Lehman sheet were probably made during a session with a professional model. The line is sure and confident, the work of an accomplished artist who had drawn the nude or clothed figure hundreds of times and was continuing his efforts to understand the anatomy of the human body and its many expressive movements.

Prendergast's renewed interest in the structure and expression of the body coincided in his oils with greater freedom of movement, even though his figures were increasingly subordinated to painted pattern.

NOTES:
1. For the locations of the sketchbooks, see No. 3, note 3.
2. See Clark, Mathews, and Owens 1990, nos. 1446–62, and see also Gengarelly 1990.

PROVENANCE: Charles Prendergast, 1924; his widow, Eugénie Prendergast, 1948; Robert Lehman, January 1962.

EXHIBITED: Boston (and other cities) 1960–61, no. 147; New York 1976–77, no. 50; New York 1982, no. 49.

LITERATURE: Oklahoma City–Memphis 1981–82, p. 13, fig. 2 (verso); Clark, Mathews, and Owens 1990, no. 1451, ill. (recto).

Charles Prendergast

Saint Johns, Newfoundland, 1863–Norwalk,
Connecticut, 1948

When in 1912 Charles Prendergast began to carve, gesso, gild, and paint panels, he already had enjoyed a successful career as a designer and producer of frames, most of which were sold through Carrig-Rohane, the firm he established with Hermann Dudley Murphy in 1903. He continued to make frames throughout his long career.[1]

The personal lives and careers of Charles and his older brother, Maurice (see Nos. 3–8), were closely intertwined: Maurice collaborated on the choice of designs for and the carving of frames, and from about 1912 to 1917 the two worked especially closely on a series of decorative panels, the most striking of which is *The Spirit of the Hunt* (ca. 1917; collection of Mr. and Mrs. Jon Landau).

As a result of their collaborative effort in the 1910s both brothers' work took a new direction, which Maurice explored mostly in watercolor and Charles primarily on painted and gilded panels. Their paintings evoked a fantasy world inspired by exotic sources as varied as Persian miniatures, Sienese trecento painting, and Etruscan frescoes, which Charles knew from museums and reproductions and from the photographs the brothers collected and kept in the studios they shared. Charles also traveled in Europe, at least three times with his brother, with whom he studied at Colarossi's studio in Paris about 1891. Their visit to Italy in 1911 precipitated his first experiments with painted panels. "It's like a dream, that Venice, a perfect dream," he said.[2]

An especially lucrative frame commission enabled the brothers to move to New York in 1914. There they continued their association with the group of independent artists called The Eight, and Charles became especially close to William Glackens (see Nos. 14, 15). Charles's work began appearing in independent exhibitions in New York in 1915, and in 1916 he was elected the first vice president of the Society of Independent Artists. He was made an associate of the National Academy of Design in 1939. His borrowings from selected traditions of the past allied him with the Arts and Crafts Movement as well as with other contemporary painters. His panels and decorative objects (screens, chests, and figures) were bought by many of the same collectors – especially Lillie Bliss, John Quinn, and Albert C. Barnes – who patronized Maurice and his European contemporaries.

As he had nurtured his brother's career until Maurice's death in 1924, so Charles maintained the works

Maurice had entrusted to him as he continued to work as an artist-craftsman for another quarter century. In 1925 he married Eugénie Van Kemmel, and in 1929 they moved to Westport, Connecticut. After about 1932, which he called the beginning of his "modern" period,[3] he discovered the modern world's own festive pageants at New York's Central Park Zoo and the World's Fair of 1939, as well as at the country fairs and resorts he visited with his wife.

NOTES:
1. One of Prendergast's frames is in the Robert Lehman Collection and will be included in the volume on frames to be published in this series.
2. Quoted in Basso 1946, pt. 2, p. 32.
3. See ibid., p. 31.

LITERATURE: Basso 1946; Boston–New Brunswick (N.J.)–Washington, D.C. 1968–69; Williamstown (Mass.) 1988–89; Anderson 1990; Clark, Mathews, and Owens 1990; Derby 1990.

9. Allegory, ca. 1927–28

1975.1.918

Watercolor over pencil. 25.8 x 33.8 cm. Page from a sketchbook; left edge perforated. Backed with rag paper. Signed in blue ink lower right: *C Prendergast*. Lower left corner torn; small tears along edges; some abrasion along lower edge.

This watercolor dates from what Charles Prendergast called his "transitional" period (between "Oriental," or "celestial," and "modern").[1] Like his paintings on panel and glass from the late twenties and early thirties, it presents a harmonious world removed from earthly strife, perhaps the "golden age of art" he prophesied in an article he wrote for *House Beautiful* in 1909.

Most of Prendergast's watercolors, which survive in twelve sketchbooks[2] and as independent sheets from sketchpads, are studies for panel paintings. *Allegory* may be a study for the panel *Hill Town* (Fig. 9.1), which Lillie Bliss bought in 1928.[3] The buildings in *Allegory* were inspired by the hill towns of southern France, which he visited with his wife in 1927. They are set, however, in an imaginary landscape with a palm, a fruit tree, and

No. 9

Fig. 9.1 Charles Prendergast, *Hill Town*. Tempera, pencil, and gold leaf on incised, gessoed panel, ca. 1928. Addison Gallery of American Art, Phillips Academy, Andover, Massachusetts, Bequest of Miss L. P. Bliss

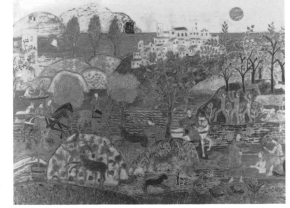

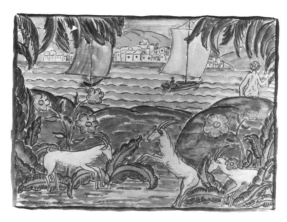

Fig. 9.2 Charles Prendergast, *Beach Scene with Prancing Goats*. Watercolor over pencil and pen and ink, ca. 1927–29. Williams College Museum of Art, Williamstown, Massachusetts, Gift of Arthur T. Norman

sunflowers where a nude woman bathes in an inlet filled with fish and horned goats swim between the two banks. *Beach Scene with Prancing Goats* (Fig. 9.2) has a similar landscape and may have come from the same sketchpad.[4]

NOTES:
1. See Basso 1946, pt. 2, pp. 30–31.
2. Six of the sketchbooks are in the Museum of Fine Arts, Boston (Clark, Mathews, and Owens 1990, nos. 2409–13, 2419), and six are in the Williams College Museum of Art, Williamstown, Massachusetts (ibid., nos. 1214–18, 1220).
3. Ibid., no. 2260, ill.
4. Ibid., no. 2362, ill.

PROVENANCE: Eugénie Prendergast, the artist's widow, 1948; [Davis Galleries, New York]; Robert Lehman, 1961(?).

EXHIBITED: New York 1976–77, no. 51; New York 1982, no. 50; Williamstown (Mass.) 1989–90, no. 33.

LITERATURE: Oklahoma City–Memphis 1981–82, p. 14, fig. 6; Clark, Mathews, and Owens 1990, no. 2363, colorpl. 93.

Robert Henri
Cincinnati 1865–New York 1929

Robert Henri was born Robert Henry Cozad in Cincinnati. When he was about nine years old his family moved west, and although he returned to Cincinnati to attend school he spent much of his youth in Cozad, the town his father, John Jackson Cozad, founded in Nebraska, and in Denver. In 1882 John Cozad shot one of his employees in a fight in Cozad and was charged with murder. Although he was later cleared of the murder charge, when the Cozads moved back to the East a year later they kept the names they had assumed to avoid the scandal; Robert took the name Robert Earle Henri, his brother John became Frank L. Southrn, and his parents called themselves Mr. and Mrs. Richard Henry Lee.

In 1886 Henri moved to Philadelphia and enrolled at the Pennsylvania Academy of the Fine Arts. Thomas Eakins had resigned as director of the academy a few months earlier, but his influence remained. In part through Thomas Anshutz, who was Eakins's former student and assistant and had taken over his classes, during the two years Henri spent at the academy he developed what was to be a lifelong respect for Eakins's work and ideas. From 1888 to 1891 Henri studied in Paris, first at the Académie Julian and then at the Ecole des Beaux-Arts, and also spent time in Brittany, on the Mediterranean coast, and in Italy. Although he remained committed to the importance of the art of his time, Henri's admiration for the old masters, especially Velázquez, Rembrandt, and Hals, was strengthened during this trip and his subsequent sojourns in Europe, particularly in 1895–97, 1898–1900, and 1906.

When he returned to Philadelphia in 1891, Henri took classes at the Pennsylvania Academy, and in 1892 he began teaching at the Philadelphia School of Design for Women. He also organized informal weekly art classes in his studio that were attended by a number of talented young newspaper artist-reporters, notably Everett Shinn, John Sloan, William Glackens, and George Luks (see Nos. 11–15). With his move to New York in 1900, Henri became the leader of a group of independent artists, which included his Philadelphia friends, who rebelled against the hegemony of the National Academy of Design (of which he became a member in 1906). Their efforts as a group — which has come to be known as The Eight — resulted in an important exhibition at the gallery of William Macbeth in New York in 1908. Henri also was a leading force behind the Exhibition of Independent Art-

ists in 1910 and the exhibitions at the MacDowell Club between 1911 and 1919.[1]

An inspiring teacher, Henri taught classes at the New York School of Art (1902–9), his own school (1909–12), the Modern School of the Ferrer Center (1911–16), and the Art Students League (1915–27). His philosophy of art education had wide-ranging influence, especially after the publication in 1923 of *The Art Spirit*, a collection of letters, notes, and talks that express his belief in the unity of art and humanity, or, as he later wrote, "the life that flows beneath these superficial things."[2]

As an artist, Henri is best remembered for his dark, naturalistic landscapes and cityscapes from the early 1900s and for the portraits and figure studies he painted throughout his career. Like others of his day, he was attracted to pseudoscientific theories of art, particularly those of Hardesty Maratta and Jay Hambidge. By the time he exhibited three paintings and two drawings at the Armory Show in 1913, Henri's style had come under the influence of these advocates of formulaic approaches to color and design, whose theories he reconciled to his own philosophy of artistic freedom.

With his second wife, the artist Marjorie Organ (see No. 20), whom he married in 1908 (his first wife, Linda Craige, also an artist, died in 1905), Henri participated fully in the cultural life of New York, secure in his position as a champion of artistic independence and as a leader of a series of organized revolts that marked the beginning of the twentieth century in American art.

NOTES:
1. On the Macbeth Gallery and the independent exhibitions of the early 1900s, see Milroy 1991 and Owens 1991.
2. Henri diary, 25 August 1926, quoted in Homer (1969) 1988, p. 176.

LITERATURE: Perlman (1962) 1988; Homer (1969) 1988; Wilmington 1984; Perlman 1991.

10. Sketchbook: Spain, 1906

1975.1.910
37 pages, with 21 drawings in pencil and 22 in pen and black ink, bound in beige fabric over board. 9.9 x 15 cm. Paginated in pencil in upper right corners of rectos. Inscribed in pencil on front cover: *Henri / Spain 1906 / H* (the final *H* gone over in red crayon[?]). On the inside back cover, a label in the shape of a palette: *VIUDA DE MACARRÓN / c. j r(?) / 1,40 / 2 Jovellanos 2 MADRID* (the name and address printed, the letters and numbers in pen and ink); annotated in pencil above the label and partially obscured by it: *c. 140*; inscribed in pen and black ink below the label: *Madrid. / Segovia / Pozuolo.* (joined by bracket to) *Aug & / Sept / 1906*. Pages removed after 3v, 8v, 12v, 14v, 15v, 21v, 25v, 27v, 29v, and 33v; two pages removed after 19v; three pages removed after 32v.

In the summer of 1906, seven months after the death of his first wife, Linda Craige, Henri visited Spain for the second time. From his diary and his correspondence with his family and friends we know about his life that summer in great detail.[1]

In April Henri had arranged with Douglas John Connah, director of the New York School of Art, to take a group of the school's students to Madrid for the summer for a salary of $250 per month, plus $300 for expenses.[2] Before he left New York he closed his studio and stored his pictures. He was "preparing to open another Chapter of Life," his friend John Sloan wrote in his diary. "It seems very sad to be leaving the old studio, where we have had such pleasant evenings, where Mrs. Henri died."[3] Henri may have regarded the trip as a memorial to Linda as well as part of a process of healing and renewal of his own life after her death. Less than a week after he arrived in Madrid he wrote to his parents that he was thinking a great deal about Linda and the six weeks they spent there in the summer of 1900.[4]

"It seems a long time since I left New York," he wrote home on 10 June,[5] just five days after he sailed from

Boston on the S.S. *Romanic* (White Star Line) in the company of nineteen students, among whom was the twenty-three-year-old Walter Pach,[6] and an assistant, Louis Gaspard Monté of Columbia University Teachers' College.[7] They landed at Gibraltar on 14 June and took ten days to travel up to Madrid, stopping at Algeciras, Seville, Granada, and Cordova. Throughout the journey Henri admired the landscape and the architecture, especially the Alhambra. Nothing he knew of, he wrote to his parents from Granada, was "quite as romantically beautiful."[8] Henri and his class arrived in Madrid on 23 June, just a day before his friends William and Edith Glackens happily departed for Paris after an unsatisfactory stay in Spain that had been further spoiled by illness. They had developed a particular distaste for Madrid, which they regarded as nothing but a "little cheap Paris."[9]

Unlike the Glackenses, Henri enthusiastically embraced every aspect of life in Madrid. Throughout his stay he took daily Spanish lessons so he could better enjoy his time in the capital. He was charmed by his hostess, Signora Carmona, with whom Whistler, Sargent, and many other artists had stayed, and found "all places intensely interesting in their remains as well as in their present life."[10] During his first week in Madrid he began to teach classes in the studio, and he and the students worked out-of-doors and in the galleries of the Prado, where he had studied the works of Velázquez, Ribera, and Goya six years earlier. He also frequented the cafés and theaters. He admired Spanish dancers, hired a Gypsy he met at dinner in the woods one evening to sit for him in his studio, and celebrated his forty-first birthday on 24 June by attending a bullfight.[11] Those first days set the pattern for the six weeks of summer school.

On about 14 July Henri traveled to Toledo — "one of the most picturesque and antique towns in the world" — to see the cathedral and the paintings of El Greco. "With Velasquez and Goya," he wrote to his parents, El Greco "is one of the greatest figures of Spain."[12] Henri's particular kind of modernism was founded on a belief that study of the old masters is essential to any artist's education. In another of his letters home he said in describing Henry Jacquier, a French artist he met in Madrid, that "the fault of the modern french school is rather that the value of the great old masters is lost sight of as an influence for the younger artists."[13]

Henri also made at least one trip to the Escorial, about 21 July, where he was taken with Goya's tapestries. He wrote about the tapestries on a postcard he sent to John Sloan, who was a talented printmaker and shared his fascination with Goya. No less than five of the postcards

Henri sent to Sloan and his wife, Dolly, that summer reproduce works by Goya.[14] Sloan, however, was less than enthusiastic about his friend's cards. "Have heard from Henri only in this way," he wrote in his diary on 9 August. "Rather dislike the postcard fad. Would rather have had a letter from a friend than a damaged photograph of a street in the town they stop in, or a canceled ink stained reproduction of a painting."[15] Henri did later send the Sloans at least two letters from Spain, and the gift he presented Sloan on 22 October — sets of prints of Goya's engravings *Los caprichos, Los desastres de la guerra,* and *Los proverbios* — was doubtless more to his liking.[16]

Like so many tourists of his time, Henri was enthralled with the spectacle and risk of the bullfight. (The introduction to the 1908 Baedeker's for Spain and Portugal [p. xxxiii] warned tourists that "the love of gain and advertisement is superseding professional honour [*vergüenza torera*], and the advent of female bull-fighters, hypnotists, and toreros in motor-cars is degrading the bull-fight into a vulgar, sensational spectacle," but nowhere in his diary or letters does Henri mention anything of the sort.) He was equally curious about the matadors themselves. On 25 July he met Felix Asiego, who, unlike most other bullfighters, was from "one of the best familys of Malaga" and had "a great fancy for Americans — a desire to learn english and come to America."[17] Although Asiego's injuries often forced him to postpone his modeling sessions, Henri completed two portraits of the matador, a full-length portrait he sent back to New York for exhibition and another, smaller one he presented to his sitter in appreciation of their friendship. He followed the same practice when he painted portraits of Asiego's friend Don Clemente Gordillo Alvarez de Sotomayor, a lieutenant in the Spanish army, and Milagros Moreno, a dancer known as La Reina Mora. Henri was proud of his reputation as "El Maestro" among his friends in Madrid: "They are all quite of the opinion that to be painted by me is a matter of great importance and there is never any doubt as to the quality of the work."[18]

Henri had more time to work on these portraits and to cultivate his Spanish friendships after most of his students left for Paris on 9 and 11 August.[19] He had time as well to sit in cafés with Helen Niles and Louise Pope, two students from his painting class who had remained in Madrid, and, of course, to attend bullfights. Less than a week after the class ended he escaped Madrid for three days in Segovia. "Just taking a look at the old town and cooling off from the heat of Madrid for a day or two" was the message he penned on the scenic postcard he

sent to the Sloans.[20] He noted in his diary that he made small panel sketches during his three-day stay,[21] and he also recorded his impressions of the landscape around Segovia in the Lehman sketchbook.[22]

Henri may also have made some of these sketches in a town called Pozuelo. He wrote *Pozuolo* on the inside back cover of the sketchbook, and on 3 September 1906 he wrote in his diary that he had been "at Pozuello fete" to watch Asiego fight in the bullring.[23] He was probably referring to the town about ten kilometers west of Madrid that modern maps call Pozuelo de Alarcón and that the 1908 Baedeker's calls simply Pozuelo, a "smiling oasis among oak- and pine-clad hills."

The sketchbook, which he purchased at the Madrid artists' supply store Macarrón, also chronicles Henri's daily life as an artist in Madrid. Like other artists' sketchbooks, it includes names and addresses he wished to remember, as well as his responses to architecture and landscape and especially to the people he encountered. All the drawings, in heavy, dark pencil or in pen and ink, record the observations of a sensitive artist cum tourist in Spain. Some are biting caricatures (two of himself); others are sketches after works by the Spanish painters he admired throughout his career. Two satirical sketches (17r and 18r) show women visitors to the Prado first admiring a Murillo and then retreating in horror from Goya's *Naked Maja*. The absurdity of some Americans' objection to nudity in art was on Henri's mind at the time, for he wrote to his parents in August decrying Anthony Comstock's recent confiscation of an Art Students League pamphlet that reproduced student sketches from the life class.[24]

Henri saw his summer in Spain as a good season of work but thought that only the passage of time would determine how valuable the work had been. "It is all too new and near to me here," he wrote from Madrid a few days before he left.[25] He retraced his steps to Gibraltar, sailed on 8 October on the *Königin Luise*, and arrived in New York ten days later, ready to reclaim his paintings from storage and resume his life.

NOTES:

1. Henri's diary of the trip is reproduced in the Robert Henri papers in the Archives of American Art, Smithsonian Institution, Washington, D.C. (roll 885). His correspondence with his parents, Mr. and Mrs. Richard H. Lee, is preserved in the Beinecke Rare Book and Manuscript Library at Yale University, New Haven, and his correspondence with John and Dolly Sloan is among the John Sloan papers in the Helen Farr Sloan Library, Delaware Art Museum, Wilmington. There are brief discussions of the trip in Homer (1969) 1988, pp. 122–25, and in Perlman 1991, pp. 69–71, and portraits and small panels Henri painted in Spain are reproduced in Homer and in Wilmington 1984. I am grateful to Janet J. Le Clair, William Innes Homer, and Rowland Elzea for their generous assistance in preparing this entry.

2. Henri diary, 27 April 1906.

3. Sloan diary, 21 May and 1 June 1906, quoted in Sloan 1965, pp. 37–39.

4. Henri to his parents, 29 June 1906. On the Henris' trip to Spain in 1900, see Homer (1969) 1988, pp. 97–98, and Perlman 1991, p. 41.

5. Henri to his parents, 10 June 1906, "within sight of the Azores."

6. Henri diary, 5 June 1906.

7. Perlman (1991, p. 69) identifies the assistant.

8. Henri to his parents, 20 June 1906.

9. I. Glackens (1957) 1983, pp. 67–69.

10. Henri to his parents, 29 June 1906.

11. Ibid., and Henri diary, 24 June 1906.

12. Henri to his parents, 16 July 1906.

13. Henri to his parents, 2 September 1906. Henri also mentions Jacquier (1878–1921) in his diary entry for 2 September. Both Henri and Bénézit spell Jacquier's Christian name Henry.

14. Nine postcards from Henri are preserved in the John Sloan papers in the Delaware Art Museum. I am grateful to Rowland Elzea for bringing them to my attention.

15. Sloan diary, 9 August 1906, quoted in Sloan 1965, p. 50.

16. Sloan diary, 22 October 1906, quoted in Sloan 1965, pp. 72–73.

17. Henri to his parents, 25 July 1906.

18. Henri to his parents, 23 September 1906.

19. Henri diary, 4, 5, and 11 August 1906.

20. Henri to Sloan, 17 August 1906.

21. Henri diary, 16 August 1906.

22. Robert Lehman acquired the sketchbook, along with eleven drawings by Henri (which are no longer in the collection) and a sketchbook by Marjorie Organ (No. 20), from Hirschl and Adler on 13 February 1962 (bill of sale in Robert Lehman Collection files, listing eight ink drawings by title, three unidentified drawings, and the two sketchbooks).

23. Henri diary, 3 September 1906. On 4 September, Henri noted that he had "painted memory of bulfight by boys at Pozuello."

24. Henri to his parents, 23 August 1906.

25. Fragment of letter from Henri to his parents, probably about 1 October 1906.

PROVENANCE: Probably Marjorie Organ Henri, 1929; probably her sister, Violet Organ, 1930; probably her nephew, John C. Le Clair, 1959; [Hirschl and Adler Galleries, New York]; Robert Lehman, February 1962.

No. 10, front cover

No. 10, 1r

1r. Buildings and people. Pencil.

1v. Blank.

2r. People in a street. Pencil.

2v. Blank.

3r. Buildings. Pencil.

3v. Blank.

Page removed between 3v and 4r.

4r. Two priests standing before a curtained door
(a confessional?). Pencil.

4v. Blank.

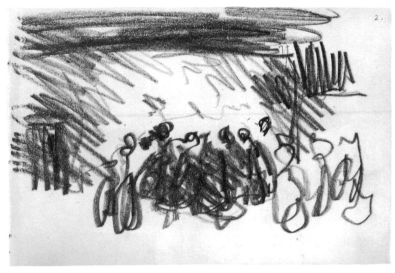

No. 10, 2r

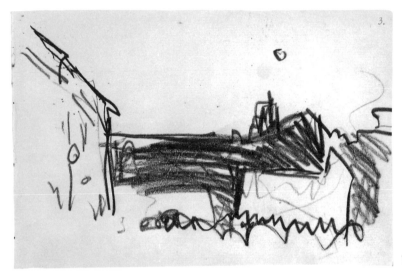

No. 10, 3r

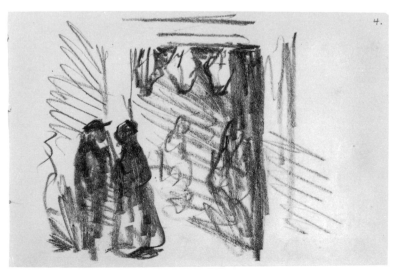

No. 10, 4r

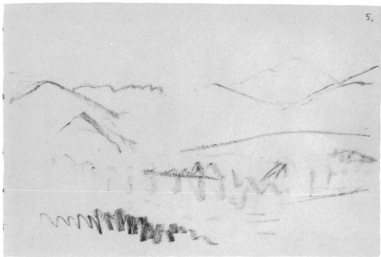

No. 10, 5r

5r. Slight sketch of mountains. Pencil. This is probably a view near Segovia.

5v. Blank.

6r. A woman and child looking out over a town with a mountain in the background. Pencil. The town is probably Segovia.

6v–7r. A walled city. Pencil. This is probably a view of Segovia.

7v. Blank.

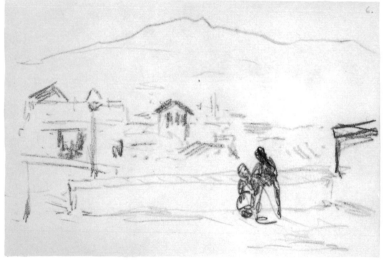

No. 10, 6r

No. 10, 6v–7r

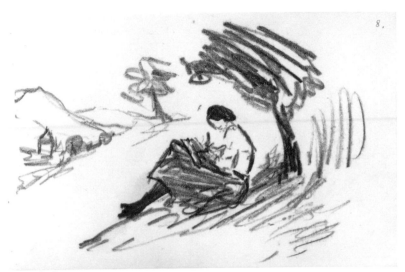

No. 10, 8r

Fig. 10.1 Robert Henri, 1907. Photograph courtesy of Bennard B. Perlman

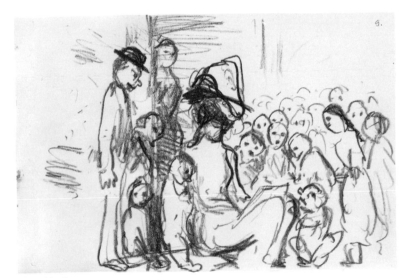

No. 10, 9r

8r. A woman sitting under a tree sketching. Pencil. This sketch, too, was probably made somewhere near Segovia.

8v. Blank.

Page removed between 8v and 9r.

9r. Grotesques in the manner of Goya, one with the head of a bird, surrounded by a crowd. Pencil.

9v. Blank.

10r. Caricature of a man walking with a cane. Pencil. This is probably a self-portrait (see Fig. 10.1).

10v. Blank.

No. 10, 10r

No. 10, 11r

11r. Caricature of a gigantic man sketching in a landscape as tiny people look up at him. Pencil. The giant is probably Henri (see Fig. 10.1).

11v. Blank.

12r. A man and two women looking into a shop window as another woman peers at them from a doorway. Pencil.

12v. Blank.

Page removed between 12v and 13r.

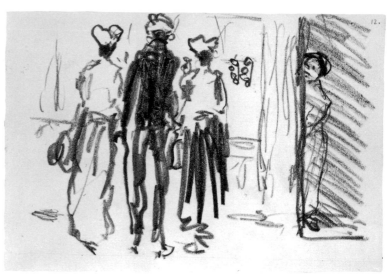

No. 10, 12r

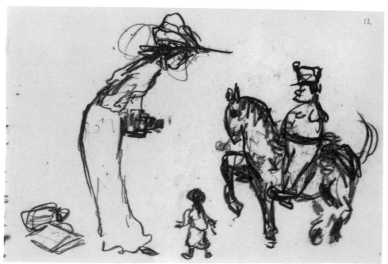

No. 10, 13r

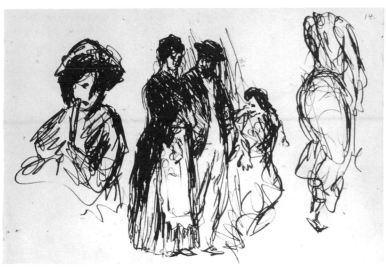

No. 10, 14r

13r. A soldier on a prancing horse, a tiny child, and a seemingly gigantic woman who appears to be taking a picture. Pencil.

13v. Blank.

14r. A man and a woman with an urchin (a pickpocket?) beside them, a bust of a woman, and a headless figure of a woman seen from behind. Pen and black ink.

14v. Blank.

Page removed between 14v and 15r.

15r. A woman seated on a park bench with one child in her lap and another standing beside her. Pen and black ink.

15v. Blank.

Page removed between 15v and 16r.

16r. An old man and a child meeting two women wearing aprons; two head studies. Pen and black ink.

16v. Blank.

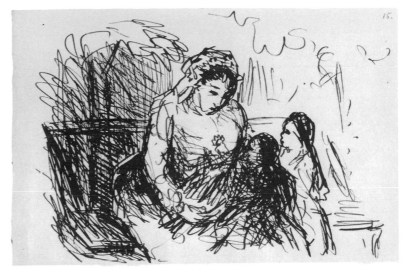

No. 10, 15r

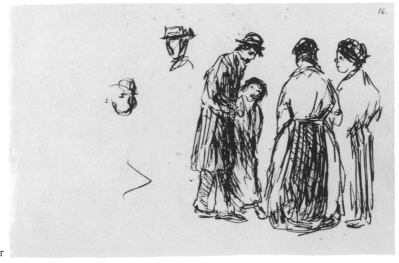

No. 10, 16r

No. 10, 17r

No. 10, 18r

17r. Three women visitors to the Prado reading guidebooks as they look at a painting by Murillo, apparently an Immaculate Conception with putti who seem to be laughing at the women. Pen and black ink. Inscribed in black ink at center: *MURILLO*. See 18r.

17v. Blank.

18r. The same women as on 17r, rushing away from Goya's *Naked Maja*. Pen and black ink. Inscribed in black ink at left center: *GOYA*.

18v. Blank.

19r. Three women tourists reading guidebooks in front of the Roman aqueduct at Segovia as a beggar with a crutch tries unsuccessfully to gain their attention. Pen and black ink. These may be the same three women sketched on 17r and 18r.

19v. Blank.

Two pages removed between 19v and 20r.

No. 10, 19r

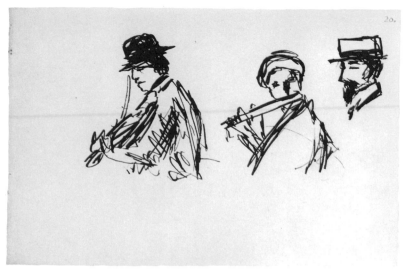

No. 10, 20r

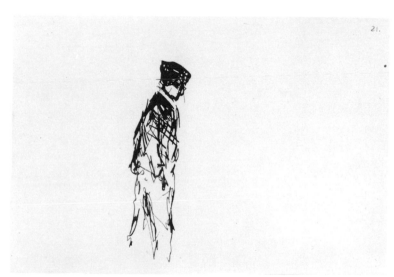

No. 10, 21r

20r. Busts of a violinist and a flutist and the head of a bearded man. Pen and black ink.

20v. Blank.

21r. A man walking toward the right. Pen and black ink.

21v. Blank.

Page removed between 21v and 22r.

22r. Head of a woman and three seated(?) figures. Pen and black ink.

22v. Blank.

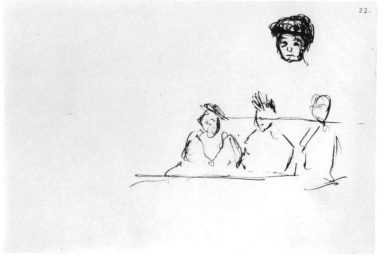

No. 10, 22r

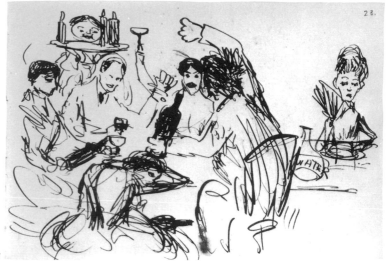

No. 10, 23r

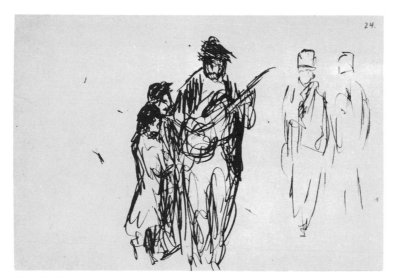

No. 10, 24r

23r. A rowdy dinner party. Pen and black ink. Note the woman in the foreground who has collapsed with her head on the table and the older woman sitting disdainfully apart at the right with a carafe labeled *WATER* in front of her.

23v. Blank.

24r. Two men approaching a street guitar player and two children. Pen and black ink.

24v. Facade of a building with large Corinthian pilasters framing a pedimented door with a window above it. Pen and black ink. See 25r and 26r.

25r. People in the street in front of a building. Pen and black ink. Cut along two-thirds of left edge (ca. .5 cm from binding). The building seems to be the same as that on 24v and 26r.

25v. Blank.

Page removed between 25v and 26r.

26r. People in the street in front of a building. Pen and black ink. The same building is sketched on 24v and 25r.

26v. Indecipherable sketch. Pen and black ink.

No. 10, 24v

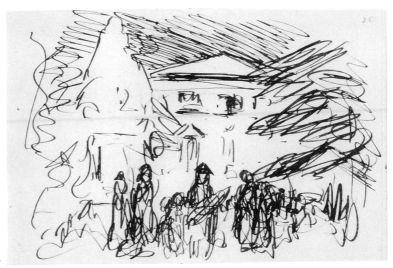

No. 10, 25r

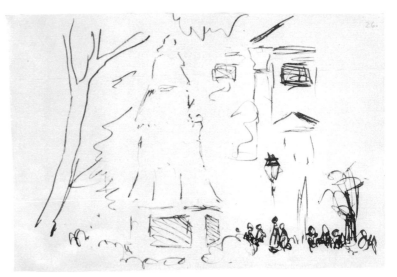

No. 10, 26r

No. 10, 26v

No. 10, 27r

No. 10, 27v

No. 10, 28r

27r. People in the street in front of buildings. Pen and black ink.

27v. Cliffs by the sea and a waterfall. Pen and black ink. Inscribed across top in pen and black ink: *Black head / white head / gull rock*.

Page removed between 27v and 28r.

28r. A bass player and a standing man (a flutist?). Pencil.

28v. Caricature of a man embracing a voluptuous nude woman. Pen and black ink.

29r. Caricature of a man talking to a voluptuous nude woman. Pen and black ink.

29v. A woman sitting in a chair and the same woman sitting at a table. Pen and black ink.

Page removed between 29v and 30r.

No. 10, 28v

No. 10, 29r

No. 10, 29v

157

No. 10, 30r

No. 10, 30v

30r. Four sketches, two naturalistic, two caricatural, of a woman's profile. Pen and black ink.

30v. A streetlight(?). Pencil.

31r. Buildings. Pencil. Inscribed across top in pencil: *red gray red yel.*

31v. Indecipherable sketch. Pencil. This sketch might be related to the buildings on 32r.

32r. Buildings. Pencil.

32v. Buildings. Pencil. Inscribed in pencil: *tile / red / W / blue sign / white; white / yel* (or *red*?) *W W black*(?); *yel / W / red / green.*

Three pages removed between 32v and 33r.

No. 10, 31r

No. 10, 31v

No. 10, 32r

No. 10, 32v

No. 10, 33r

No. 10, 34r

No. 10, 33v

No. 10, 34v

No. 10, 35r

33r. View of rooftops and spires. Pen and black ink.

33v. Inscribed in pen and black ink: *Yo he dicho* / *I have said* / *yo . . .* [crossed out] *dije* / *I have said (very past)* / *Yo digo* / *Yo diré* / *Usted. dijo* / *Usted he dicho* / *Usted dice* / *Usted dirá.*

Page removed between 33v and 34r.

34r. Indecipherable sketch. Pencil.

34v. Annotated in pencil: *Don Clemente Gordillo* / *Oficial del Ejercito* / *Español Ejercito* (*Ejercito* added in another hand [probably Henri's])/ *Fernando Garcia Gonzalez.* Gordillo was a lieutenant in the Spanish army whose portrait Henri painted. Henri wrote to his parents on 23 August 1906 that Gordillo's friend Gonzalez "is in one of the big banks here also speaks french and speaks it very well." See also 35r.

35r. Annotated in pencil: *D. Clemente Gordillo* / *Oficial del Regimiento de* / *Lanceros de Prince* / *del Ejercito Español.* (*Prince* added in another hand [probably Henri's]) / *Lieutenant of the Regiment of Lancers* / *of the Prince of the Spanish* / *army.* (all in another hand, and *the Prince* in darker pencil, perhaps in yet another hand).

No. 10, 35v–36r

35v–36r. Two caricatures of women and a map locating the Prado (square at top right) in relation to the Puerta del Sol (oval near bottom). Pencil. Annotated in pen and black ink: *D. Manuel Naranjo y / Rute.(?) / San Bartolomé / N° 7 y 9. – / Plaza de Santa / Ana. N° 2.*

36v. Annotated in pencil (upside down): *Carlota Martinez / Esperanza n° 12 – / 12 / (white shawl with / flowers)* (the second *12* and *(white shawl with flowers)* in another hand [probably Henri's]).

37r. Annotated in pencil: *Joaquin Decref / Instituto de Fisica / = Fernando VI-8. / Dr. Enrique Slocker / Plaza de las / Salesas 8 / Dr. Guitano(?) Sterling* (crossed out). Henri may have sought out these physicians for his friend Emily Sartain, who arrived in Madrid very ill (letter from Henri to his parents, 27 August 1906, and Henri diary, 4 and 12 September 1906).

37v. Inscribed in pencil: *Louse. owes. 7.00 / " cards, etc. 90 / " owes 1/3 of 2.00 for cab / Louse gave me to keep 100°° / H. owes. 1/3 of 2.00 cab / H owes for cards etc 260. / I have 10°° of* [word crossed out] *Helen / –cab at Segov - 3.30 / –Perls. – 72.50 / –Cash for lace H 2500 / –waiter tip 500 / –Bill 8100 / –Buss 300 / –cab 250 / 7250 / 5500 / 1750 / 27.* "Louse" and Helen must be Henri's students Louise Pope and Helen Niles, who stayed on in Madrid after the rest of the class had left.

No. 10, 36v

No. 10, 37r

No. 10, 37v

No. 10, inside back cover

George Benjamin Luks
Williamsport, Pennsylvania, 1866–New York 1933

George Luks was brought up in an educated, liberal family in northeastern Pennsylvania, but he invented a past, or pasts, for himself — as a boxer named "Chicago Whitey," for instance — that perhaps better suited the harsh realities of the world he depicted on canvas. For the subjects of his art Luks was attracted to the street world of New York. He moved to New York in 1896, after working as an artist-reporter for the *Philadelphia Press* and the *Evening Bulletin* in Philadelphia, where he met Robert Henri (see No. 10), John Sloan, Everett Shinn, and William Glackens (see Nos. 14, 15), the core of the group of artists known later as The Eight. Before that he had studied off and on at the Pennsylvania Academy of the Fine Arts and, in 1889, at the academy in Düsseldorf. He also traveled to Paris, London, and Madrid, and in 1895–96 he was in Havana covering the Cuban revolt as a staff artist for the *Evening Bulletin*.[1]

In New York Luks also worked as a newspaper and magazine artist. He drew the enormously popular comic strip "Hogan's Alley," better known as "The Yellow Kid," for Joseph Pulitzer's *World* after William Randolph Hearst lured Richard Felton Outcault, the strip's originator, to the *Journal*. (In 1896–97 the comic strip appeared in both papers, which the rest of the press called the "Yellow Kid journals," eventually dropping the "kid.") He continued to travel abroad, notably to France in 1902–3 and again in 1904, and came to admire European masters (among them Rembrandt, Hals, Velázquez, Goya, and Renoir), aspects of whose styles he incorporated into his own technique of quick and heavy brushwork to depict new subjects drawn from city life. His best works, such as *The Spielers* (Addison Gallery of American Art, Phillips Academy, Andover, Massachusetts) and *The Wrestlers* (Museum of Fine Arts, Boston) of 1905, are raw, roughly painted pictures whose vitality mirrors his experiences on New York's streets and at the city's new places of leisure. Among the clubs and restaurants Luks and his friends frequented in the early years of the century were Mouquin's and the Café Francis, and Luks was a member of the Friendly Sons of Saint Bacchus, who met regularly at Maria's on MacDougal Street in Greenwich Village.

Luks exhibited at the Society of American Artists in New York before it merged with the National Academy of Design in 1906. He was one of the six independent artists (all part of The Eight) represented in the show

Robert Henri mounted at the National Arts Club in 1904, and in 1908 he was included in The Eight's exhibition at the Macbeth Gallery.[2] Indeed, it was to protest the National Academy of Design jury's rejection of the painting Luks submitted in 1907, among other things, that Henri organized the exhibition at Macbeth's. After 1913, when his work appeared at the Armory Show and he had his first solo exhibition, at Kraushaar Galleries in New York, Luks began to enjoy commercial success, and he also taught intermittently. Yet he seems never to have shed his past of rowdy abandon, both actual and imagined, for he died in 1933 after being injured in a barroom brawl, under circumstances he could easily have invented or painted.

NOTES:
1. Luks is on the register of the Pennsylvania Academy of the Fine Arts for the school years 1882–83, 1883–84, and 1887–88 (conversation with Cheryl Leibold, archivist at the academy, 16 October 1990). Cuba (1987, p. 10) says that Luks attended the night antique class at the academy in April 1884 and also discusses his study and travels in Europe and his assignment in Cuba.
2. On William Macbeth and the independent exhibitions of the early 1900s, see Milroy 1991 and Owens 1991.

LITERATURE: I. Glackens (1957) 1983; Perlman (1962) 1988; Shinn 1966; Utica 1973; Wilkes-Barre 1987.

11. Artist with Portfolio, ca. 1902–4

1975.1.913

Black chalk. 16.7 x 10.9 cm. Page from a sketchbook; traces of four(?) binding holes along right edge. Signed in black chalk lower center: *George Luks*. Inscribed in black chalk lower left: *17*, and upper center: *not exaggerated*. Small tears along left and upper edges; upper left corner made up; right edge uneven.

Verso: A woman in an apron, a kitten playing with a spool of thread, and two dogs. Pencil (the woman) and black chalk (the animals). Signed in black chalk lower center: *George luks;* inscribed in black chalk lower right: *Paris*.

Luks drew tirelessly. As a young man he made his living as an illustrator and learned to choose a characteristic pose, like that of this artist clutching a portfolio, and

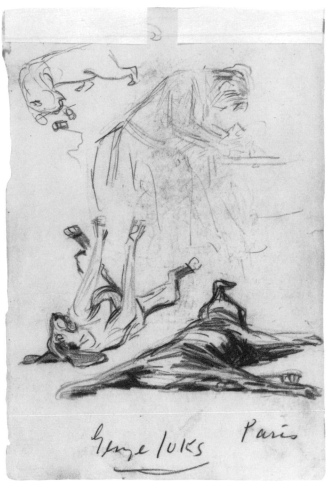

No. 11, recto

No. 11, verso

express it in a flurry of heavy, controlled lines. The charming sketches on the verso of a playful kitten and two dogs – one sleeping, the other scratching its back – reveal his special skill at depicting animals. Among his submissions to the 1913 Armory Show were ten studies he made at the Bronx Zoo in 1904.[1]

This drawing, inscribed *Paris* on the verso, and Nos. 12 and 13 may have been part of a sketchbook Luks carried on one of the two trips he made to France in 1902–3 and 1904.[2]

NOTES:
1. The sketches are reproduced in Andover 1990.
2. I appreciate Stanley Cuba's help in proposing a date for these three sketches (letter to the author, 12 June 1986). According-ing to a note in the Robert Lehman Collection files, Robert Lehman purchased No. 11 from Davis Galleries in March 1961. It is probable that Nos. 12 and 13 share the same provenance.

PROVENANCE: [Davis Galleries, New York]; Robert Lehman, March 1961.

No. 12, recto

No. 12, verso

12. Sketches of Children, ca. 1902–4

1975.1.914

Black chalk. 16.9 x 10.9 cm. Page from a sketchbook; traces of at least four binding holes along right edge. Partial watermark: *A N Paris / Mad*[]*and*. Torn and repaired along a diagonal line running 5.4 cm from lower edge at left to 2.6 cm from lower edge at right.

Verso: Standing boy in a cap. Black chalk. Numbered in pencil(?) upper left: 6/4, and along bottom edge: 4 x 6½ – 9 x 11¾ #[] (partially cropped).

The appeal of their portrayals of children, whether street urchins or well-dressed and privileged young like those shown in this sketch, contributed to the success of Luks and the artists of his circle. Robert Henri once said that "if one has a love of children as human beings, and realizes the greatness that is in them, no better subjects for painting can be found. The majority of people patronize children, look down on them rather than up to them, think they are 'cute,' 'sweet,' when in reality it is the

children that have not yet been buried under the masses of little habits, conventions and details which burden most grown-ups."[1] Luks understood children and captured their awkward, uninhibited poses. With his own childlike boasting and behavior, he may have felt even closer to them than to his adult contemporaries.

This drawing, like Nos. 11 and 13, may have been part of a sketchbook Luks carried during one of the two trips he made to France in 1902–3 and 1904.

NOTE:
1. Henri to C. C. Horn, 7 June 1927, quoted in Homer (1969) 1988, p. 207.

PROVENANCE: [Probably Davis Galleries, New York]; Robert Lehman, 1961(?).

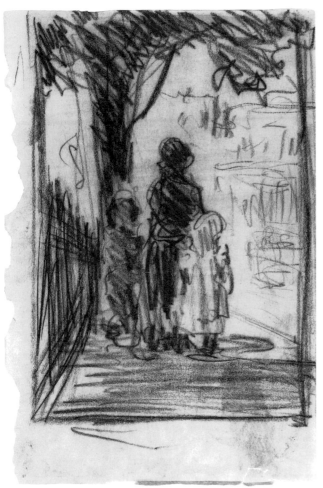

No. 13, recto

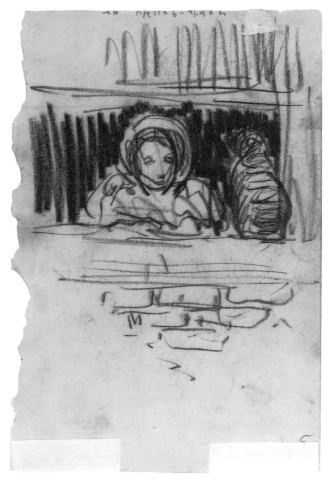

No. 13, verso

13. Three Figures Walking, ca. 1902–4

1975.1.915
Black chalk. 16.8 x 11 cm. Page from a sketchbook; left edge unevenly torn. Small tear toward the right at lower edge.

Verso: A woman and a cat (upside down). Black chalk. Numbered in pencil(?) upper left: 3/3, and in pencil along lower edge: 4 x 6½ – 9 x 11¾ #2.

Luks once claimed, "This world never had but two great painters...Frans Hals and George Luks!"[1] Despite his hyperbole Luks did share with Hals a knowledge of life on city streets.[2] Here – in a manner that is unpretentious and in the mode of seventeenth-century Dutch artists – he sketched a mother and her children on the sidewalk and, on the verso, a woman looking out a window at a cat perched on the sill. The verso may reflect his admiration for Rembrandt's many drawings of girls and women resting on window sills, such as *Saskia Looking Out of a Window* in the Museum Boymans-van Beuningen,

Rotterdam.[3] The subject was also popular with Luks's contemporaries: John Sloan, for instance, wrote in his diary in 1906 that he had painted a small panel of a "girl combing hair at a window, a cat on the leads [ledge?] below."[4]

Like Nos. 11 and 12, this sheet may have come from a sketchbook Luks used in France in 1902–3 or 1904.

NOTES:
1. Quoted in Shinn 1966, p. 1.
2. Henri, too, was inspired by Hals's choice of subject matter as well as by his style; see Homer (1969) 1988, p. 241. For a study of the revival of interest in Hals during the nineteenth and early twentieth centuries, see Jowell 1989.
3. Benesch 1973, no. 250, fig. 295.
4. Sloan diary, 21 June 1906, quoted in Sloan 1965, p. 43.

PROVENANCE: [Probably Davis Galleries, New York]; Robert Lehman, 1961(?).

William J. Glackens

Philadelphia 1870 – Westport, Connecticut, 1938

Early in his career, from 1891 to 1894, William Glackens was an artist-reporter for newspapers in Philadelphia, where he worked with John Sloan, George Luks (see Nos. 11–13), and Everett Shinn. He met James Preston (see Nos. 16–18) and Robert Henri (see No. 10) while attending evening classes at the Pennsylvania Academy of the Fine Arts. With Henri, their mentor, Glackens, Sloan, Luks, and Shinn formed the nucleus of the group who became known as The Eight after their exhibition in 1908 at the gallery of William Macbeth in New York.[1]

Following a year in Paris with Robert Henri, Glackens moved to New York in 1896 and supported his painting by drawing illustrations for various journals. He traveled to Cuba in 1898 to cover the Spanish-American War for *McClure's Magazine*. With the financial security afforded him by his 1904 marriage to fellow artist Edith Dimock, the stimulus of another European trip in 1906, and the affirmation of The Eight show, he concentrated on painting portraits and scenes set in the streets, parks, and cafés and at the beaches of New York. *Chez Mouquin* (1905; Art Institute of Chicago), *The Shoppers* (1907; Chrysler Museum, Norfolk, Virginia), *The Green Car* (1912; Metropolitan Museum of Art), and many of his other paintings depict contemporary life at the new places of leisure in the city. Although he was influenced by the work of French painters, Glackens's impressionism was a personal exploration, based on the principles he gleaned from his study of the works of Edouard Manet and, especially, Pierre Auguste Renoir. On a trip to Paris in 1912 during which he purchased paintings for his patron and former schoolmate Albert C. Barnes, who shared his enthusiasm for Manet and Renoir, he came to admire as well the bold, decorative work of Henri Matisse.

Glackens helped organize and participated in the Exhibition of Independent Artists in 1910 and the Armory Show in 1913, for which he was in charge of the selection of American works. In 1916 he was elected the first president of the Society of Independent Artists, whose motto, "No Jury – No Prizes," expressed liberal artists' continued outcry against the restrictive policies of the National Academy of Design (of which he was elected an associate in 1906 and a full member in 1933).

Glackens enjoyed friendships with many American artists of his time, especially Ernest Lawson and the Prendergast brothers, Maurice and Charles (see Nos. 3–9). It was the example of Lawson and Maurice Prendergast,

in particular, that encouraged Glackens to change his own style, a transformation first seen in the seascapes he painted in 1908–16 in Bellport, Long Island, where both the Glackenses and the Prestons spent many summers before and during World War I. During the last years of his life Glackens lived in France for long periods of time. There and in New York he continued his productive career until his sudden death in 1938 at the Westport, Connecticut, home of Charles and Eugénie Prendergast.

NOTE:

1. On William Macbeth and the independent exhibitions of the early 1900s, see Milroy 1991 and Owens 1991.

LITERATURE: Du Bois 1931; Shinn 1945; I. Glackens (1957) 1983; Perlman (1962) 1988; New Brunswick (N.J.) 1967; Washington, D.C. 1972; Wattenmaker 1972; Wilmington 1985; Wattenmaker 1988.

14. Edith Glackens Walking, ca. 1905–10

1975.1.909

Black chalk[1] on dark brown paper; corners of image outlined with a straightedge in black chalk about .2 cm from edges of sheet. 16.5 x 8.1 cm. Backed with rag paper. Signed in black chalk across bottom: *W. Glackens*. Edges uneven; small tears in the woman's skirt, along left edge, and at upper left corner.

Although Glackens gave up commercial graphic work about 1915 because he considered oil painting more important than drawing, he continues to be admired for his spontaneous, incisive, sympathetic, often witty drawings, many of which show a keen awareness of the work of French illustrators, notably Jean-Louis Forain and Théophile Steinlen. In a review of an exhibition of Glackens's work at the American Water Color Society in New York in 1910, the critic A. E. Gallatin remarked Glackens's "wonderfully expressive line" and his "genius for instantly seizing upon the essentials of human make-up."[2] And Everett Shinn wrote in 1945 that "it would be impossible to exaggerate the importance of Glackens' drawings in the development of his power both as illustrator and painter."[3]

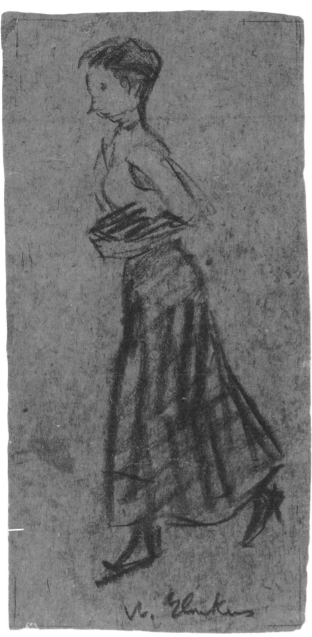

No. 14

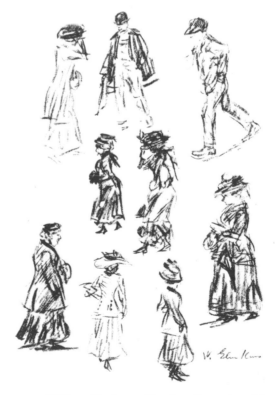

Fig. 14.1 William Glackens, *Sketches*. Reproduced from
A. E. Gallatin, "The Art of William Glackens: A Note,"
International Studio 40, no. 159 (May 1910), p. LXXI

Glackens's friend James Preston owned this drawing, which probably depicts Glackens's wife, Edith.[4] The subject and small size of both *Edith Glackens Walking* and *Two Women Walking* (No. 15) suggest that they might have been cut from larger sheets (but not the same sheet, as No. 15 appears to be on lighter brown paper) covered with figure studies. Among the four works Gallatin chose to illustrate his review in 1910 is a sheet of sketches of figures in the street that are much like the Lehman drawings (Fig. 14.1).[5] In these spontaneous drawings, done quickly from life, Glackens expressed attitude and movement in a collection of thick and thin lines that alone define shadowed form and lighted edges. From 1905 on Glackens's drawings reached, as Wattenmaker has put it, "a deeper level of expressiveness." His life sketches, "frequently organized into picturesque sequences on sheets of brown paper, constitute his most original contribution to the art of drawing; with them he was able to break away from the stereotypes of his sources, significantly to modify them, and to forge his own distinct and highly individual simplified statement and upon them, therefore, must rest his reputation as a creative draughtsman."[6]

Ira Glackens related that his father "never went out without a sketchbook in his pocket, and a stub of a certain kind of pencil intended for marking laundry packages.... These sketchbooks... were more valued by him than his paintings for they... were the records of a lifetime of observing humanity."[7] Like many of Glackens's drawings of this period, these two are on brown paper rather than a sketchbook page. "The wrapping paper found in grocery shops in the old days," his friend Shinn explained, "had a beautiful surface for drawing, especially for carbon and chalk."[8]

NOTES:
1. Helen Otis, conservator in charge of paper conservation at the Metropolitan Museum, examined Nos. 14 and 15 with me on 21 February 1986 and identified the medium as black chalk. Wattenmaker (1972, p. 56, n. 1) referred to the medium as crayon, specifically a Dixon no. 4 marking pencil, and Shinn (1945, pp. 27, 37) says Glackens used "charcoal and carbon pencil" and "chalk."
2. Gallatin 1910, p. LXVIII.
3. Shinn 1945, p. 37.
4. A Davis Galleries label that was affixed to an old backing removed from the drawing (Robert Lehman Collection files) notes that it was "purchased from James Preston" and gives its title as *Edith Glackens Walking* (but see No. 15, note 3). A note in the files indicates that Robert Lehman bought the drawing from Davis in January 1961.
5. Gallatin 1910, ill. p. LXXI. See also New Brunswick (N.J.) 1967, no. 51, ill.; Washington, D.C. 1972, nos. 14–18, ill.;

Wattenmaker 1972, figs. 61, 62, 64; and New York 1977, no. 5, ill. Cecily Langdale and Roy Davis provided information on this question in a letter to the author of 12 March 1986.
6. Wattenmaker 1972, pp. 55–56. I also wish to thank Richard Wattenmaker, who is preparing a study on Glackens, for his advice on this entry.
7. I. Glackens, "By Way of Background," in Washington, D.C. 1972, n.p.
8. Shinn 1945, p. 37.

PROVENANCE: James Preston, East Hampton, New York; [Davis Galleries, New York]; Robert Lehman, January 1961.

EXHIBITED: New Brunswick (N.J.) 1967, no. 48.

LITERATURE: Wattenmaker 1972, pp. 60, 64, fig. 63.

15. Two Women Walking, ca. 1905–10

1975.1.908

Black chalk[1] on brown paper. 20.7 x 13.1 cm. Backed with Japan paper. Annotated in Ira Glackens's hand in pencil lower left: *WG / per IG*.[2] Small horizontal tears 2 cm from lower edge at left and 1.6 cm from lower edge at right; upper right corner torn and replaced; various small holes filled in across upper 2 cm of sheet.

For a discussion of Glackens's drawings, see No. 14. The woman in the large hat at the left in this drawing may be Glackens's wife, Edith. Ira Glackens was unable to confirm the identity of any of the three women in Nos. 14 and 15.[3]

NOTES:
1. See No. 14, note 1.
2. A Davis Galleries label that has been removed from this drawing (Robert Lehman Collection files) notes that it is "initialed by Ira Glackens lower left" but says nothing about its provenance. Ira Glackens or James Preston (see No. 14, note 4) may once have owned the drawing. A note in the files says that Robert Lehman acquired it from Davis in January 1961.
3. I. Glackens, conversation with the author in Shepherdstown, West Virginia, 23 March 1986.

PROVENANCE: [Davis Galleries, New York]; Robert Lehman, January 1961.

EXHIBITED: New Brunswick (N.J.) 1967, no. 47.

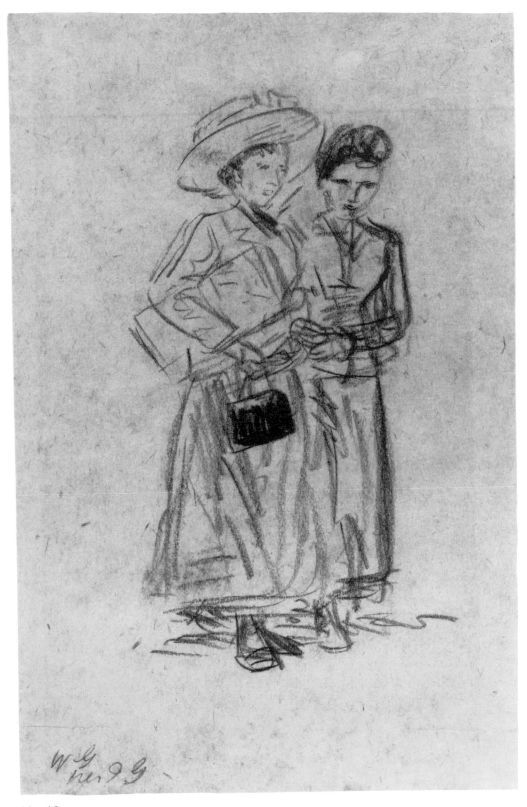

No. 15

James Moore Preston

Roxborough, Pennsylvania, 1873–East Hampton,
New York, 1962

Jimmy Preston, as he was known, was a fellow student
of William Glackens (see Nos. 14, 15) and Everett Shinn
at the Pennsylvania Academy of the Fine Arts in Phila-
delphia during the 1890s and so came to know George
Luks and Robert Henri as well (see Nos. 10–13). In 1895
he shared a studio with John Sloan and supported him-
self as an artist-reporter for the Philadelphia newspa-
pers. He spent 1898 in Paris, where he attended classes
at the atelier Colarossi. Henri and his first wife, Linda
Craige, were also in Paris that year, and May Wilson,
whom Preston would marry in 1903, was studying there.
By 1900 Preston had moved to New York, joining Luks,
Glackens, Henri, and May Wilson, who in 1901 shared a
studio with Edith Dimock, Glackens's future wife, in the
Sherwood Building, the artists' cooperative on West 57
Street where Henri was also renting space at the time.
After their marriage in 1903 the Prestons traveled fre-
quently to France and were part of the circle of artists
who frequented Mouquin's and the Café Francis in New
York. They were especially close to the Glackenses, who
often accompanied them to Europe and with whom they
summered in Bellport, Long Island, from 1911 to about
1917.

Preston was a landscape painter whose rural subjects
were often gentler than those of his Philadelphia and
New York friends who formed the core of the group later
called The Eight. He exhibited at the Pennsylvania Acad-
emy of the Fine Arts in the 1910s and was represented
by two landscapes at the International Exhibition of Mod-
ern Art (the Armory Show) in 1913. Preston's style
changed little over the years. In the 1920s he was suc-
cessful as an illustrator for both magazines and the ad-
vertising industry, as was May Wilson Preston, but by
1935, when the Prestons moved to East Hampton, he
had given up illustration to concentrate on painting. His
work was exhibited in one-artist shows in East Hampton
in 1948 and again in 1959, three years before he died.[1]

NOTE:

1. According to his obituary in the *New York Times* (17 Janu-
 ary 1962, p. 33, col. 2), Preston died at Southampton
 Hospital.

LITERATURE: I. Glackens (1957) 1983; New York 1964b; East
Hampton (N.Y.) 1968; Greensburg (Pa.)–New York 1990.

16. France, after about 1920

1975.1.969
Black chalk; corners of image outlined with a straightedge in
pencil .8–1.4 cm from edges of sheet. 22.1 x 27 cm. Signed
in black chalk lower right: *James Preston.*

Attesting to Preston's life in the art colonies of America
and France, this drawing and Nos. 17 and 18 present
stylized images of quiet, rural, often picturesque land-
scapes. *France* probably shows the same unidentified site
as two undated paintings, *Red Roofs* and *French Coun-
tryside* (Fig. 16.1).[1] Preston and his wife traveled to France
a number of times between 1909 and the outbreak of
World War I. They resumed their trips after the war, and
Preston spent 1926–29 painting with William Glackens
(see Nos. 14, 15) in Paris and nearby Isle Adam.[2]

NOTES:
1. Greensburg (Pa.)–New York 1990, nos. 35, 37, ill.
2. Boyle in ibid., introduction.

PROVENANCE: [Davis Galleries, New York]; Robert Lehman,
January 1961.

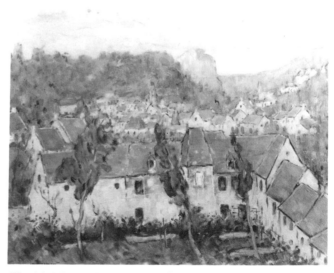

Fig. 16.1 James Preston, *French Countryside.* Oil on canvas.
Collection of Mr. and Mrs. John J. Stetzer. Photograph cour-
tesy of Altman/Burke Fine Art, New York

No. 16

No. 17

17. The Meadow, probably after 1935

1975.1.968

Black and some white chalk; borders of image marked off at the corners with a straightedge in black chalk about .2 cm from top edge, about .5 cm from left edge, and about .3 cm from bottom edge of sheet. 23.4 x 28.3 cm. Page from a sketchbook; top edge perforated. Backed with rag paper(?). Signed in black chalk lower right: *James Preston* (with an illegible inscription in white below). Tacked down at all four corners.

Comparing it with other works Preston is thought to have painted in East Hampton, Long Island, where he lived from 1935 until his death in 1962, suggests that *The Meadow* is a view of the fields surrounding the village, with its buildings in the background.[1] See also Nos. 16 and 18.

NOTE:

1. See, for example, *Easthampton View* (Greensburg [Pa.]–New York 1990, no. 27, ill.), the locale of which, according to Elisabeth Haveles (letter to the author, 7 November 1990), is identified on the verso of the canvas, possibly by either Preston or a member of his family.

PROVENANCE: [Davis Galleries, New York]; Robert Lehman, January 1961.

No. 18

18. East Hampton House, Autumn, probably after 1935

1975.1.970

Watercolor over black chalk on board; bordered with a straight-edge in pencil 1.1 cm from edge at top, left, and bottom, and three times, 1.5, 1.6, and 1.9 cm from edge, at right. 28.6 x 36.2 cm. Laid down on old backing now partly removed. Signed in pencil lower right: *James Preston*.

In its strong surface pattern of leaves obscuring an old house, *East Hampton House, Autumn* is reminiscent of Childe Hassam's etchings of the village, in particular *Lion Gardiner House, Easthampton* (1920).[1] Yet Preston's work is carried as much by colorful blotches of autumn leaves as by the linear webbing of house boards and vines. See also Nos. 16 and 17.[2]

NOTES:
1. Cortissoz 1925, no. 159, ill.
2. According to notes in the Robert Lehman Collection files, Robert Lehman acquired Nos. 16 and 17 from Davis Galleries in January 1961. No. 18 was most likely purchased at the same time. Both No. 16 and No. 18 bore Davis Galleries labels that have been removed and are in the files.

PROVENANCE: [Davis Galleries, New York]; Robert Lehman, 1961(?).

Elmer Livingston MacRae

New York 1875–Cos Cob, Connecticut, 1953

Elmer MacRae is best known for the key role he played in organizing the International Exhibition of Modern Art at the 69th Regiment Armory in New York in 1913. MacRae was a founding member and secretary-treasurer of the Pastellists, a group of artists who held four exhibitions in New York between 1910 and 1914 and then disbanded in 1915. The idea for the Armory Show seems first to have been discussed at the time of the Pastellists' second exhibition, which opened at the Folsom Galleries in New York in December 1911 and included pastels by MacRae, Mary Cassatt, Arthur B. Davies, William Glackens (see Nos. 14, 15), Robert Henri (see No. 10), Everett Shinn, and John H. Twachtman, with whom MacRae had studied at the Art Students League. MacRae, Davies, Glackens, and other Pastellists were among the artists who formed the Association of American Painters and Sculptors in 1911–12. The association, of which Davies was president, Walt Kuhn was secretary, and MacRae was treasurer, mounted the Armory Show a year later.

In the early 1900s MacRae was associated with the New York gallery of William Macbeth, who also exhibited the works of Henri, Glackens, and the other artists who have come to be known as The Eight (see Nos. 10–15). MacRae participated in all four of the Pastellists' exhibitions, and six of his pastels and four of his oil paintings were shown at the Armory Show in 1913. In 1915 he stopped working in both oil and pastel and began to create carved and decorated panels and screens, a group of which he exhibited at the Montross Gallery in New York in 1926.

MacRae's work was reintroduced to the public in 1959 and 1960, when Milch Galleries in New York showed a group of oils and pastels that had been discovered in 1958 in the barn behind his home in Cos Cob, Connecticut. MacRae was one of the many artists and writers who summered in Cos Cob at the Holley House, now called the Bush-Holley House, in the late 1890s. In 1900 he married the proprietors' daughter, Emma Constant Holley, and moved to Cos Cob. He lived in the Holley House until he died in 1953.[1] His wife sold the house, originally a colonial homestead, to the Historical Society of the Town of Greenwich in 1957, and it was during the society's restoration work that the paintings and drawings were found in the barn. Also uncovered in the barn was an orange crate filled with MacRae's papers con-cerning the Armory Show (treasurer's records and ledgers, diaries, personal letters, and press clippings), which were long thought to have been lost. The documents have been crucial for scholars attempting to reconstruct the circumstances of that decisive event and the roles of its various organizers.

NOTE:
1. MacRae obituary, *Greenwich Time*, 2 April 1953, p. 1. MacRae's death date has sometimes mistakenly been given as 1955.

LITERATURE: Elmer L. MacRae papers, Hirshhorn Museum and Sculpture Garden, Smithsonian Institution, Washington, D.C.; Brown (1963) 1988, especially pp. 15–22, 287–88, nos. 866–74; Utica–New York 1963; Bolger in New York 1989–90, pp. 20–21; Greenwich (Conn.) 1990.

19. Schooner at Dock, 1911 or 1914

1975.1.916

Pastel on pumice paper mounted on board.[1] 25 x 27.4 cm. Dated and signed in pencil lower right: *1911* (or *1914*?). *E L MACRAE.*

MacRae was most prolific as a painter in pastel. Here, the dry and delicate touches of muted color that suggest boats docked on a misty evening reveal an affinity for James McNeill Whistler's pastels, which had a profound effect on the American pastel movement of the late nineteenth and early twentieth centuries.[2]

Schooner at Dock is probably one of the pastels that were discovered in the barn behind MacRae's home, the Bush-Holley House in Cos Cob, Connecticut, in 1958, when the house was being restored by the Historical Society of the Town of Greenwich. At least five of those pastels, which were exhibited at Milch Galleries in New York in 1960, are harbor scenes.[3] As a critic for the *Boston Globe* put it in 1911, MacRae had "a rare feeling for the atmospheric depths and the color mysteries which envelop harbor, river and city vistas and a nice sympathy for the soft effects of snow and moonlight."[4] This schooner may have been docked in the harbor he could see from the Bush-Holley House. The harbor is depicted in *Schooner in the Ice, View from the Bush-Holley House*

No. 19

(dated 1900), one of three oils by MacRae that were sold by the Greenwich Historical Society in the 1950s and were again offered for sale at Sotheby's in New York in 1985.[5]

Five harbor scenes were included in an exhibition of MacRae's work at Davis Galleries in New York in 1964; one of those could well have been *Schooner at Dock*.[6] Robert Lehman may have purchased the drawing from Davis soon after that exhibition.

NOTES:

1. Shelley (1989, p. 42) has pointed out that John H. Twachtman and William Merritt Chase also used *papier pumicif*, which had been patented by 1850 and was made by sprinkling finely ground pumice on adhesive-coated wood-pulp paper or board.
2. See Pilgrim 1978; Gerdts 1984, especially pp. 47–48; and New York 1989–90, especially pp. 3–17, 49–51.
3. New York 1960, nos. 9 (*New Bedford*), 12 (*The Boatyard, Cos Cob*), 24 (*The Shipyard*), 25 (*New Bedford Harbor*),

38 (*Boston Waterfront*); only no. 9 is illustrated. The oil paintings found in the barn were exhibited at Milch Galleries in 1959 (see New York 1959), along with the documents pertaining to the Armory Show that were also uncovered during the restoration.
4. Quoted in New York 1959.
5. Sale, Sotheby's, New York, 30 May 1985, lot 163, ill. The other two paintings in the sale were *The MacRae Twins* (lot 149, ill.) and *Mill Bridge from the Bush-Holley House* (lot 166, ill.), both signed and dated 1906.
6. New York 1964a, nos. 1 (*New York Waterfront*), 3 (*The Wharf*), 6 (*Sailboat and Shore*), 10 (*Sailing Boat at Wharf, Cos Cob*), 20 (*The Wharf, Connecticut*); none of these pastels are illustrated.

PROVENANCE: [Davis Galleries, New York(?)]; Robert Lehman, ca. 1964(?).

EXHIBITED: New York 1960(?); New York 1964a(?).

LITERATURE: Shelley 1989, p. 42; New York 1989–90, p. 202, ill.

Marjorie Organ Henri
Ireland 1886–New York 1930

Marjorie Organ's father, a designer of wallpapers, moved his wife and five children to New York from Ireland in 1899, when Marjorie was thirteen.[1] Marjorie attended Saint Joseph's School for a year and then entered the Normal College (later Hunter College), but she left a month later to study with the cartoonist Dan McCarthy. In 1902, when she was just sixteen years old, she became the only woman on the art staff of the *New York Journal*, for which she created the comic strip "Reggie and the Heavenly Twins." She later also worked as a sketch artist for the *New York World*.

In February 1908, at dinner after the opening of The Eight's exhibition at the Macbeth Gallery, she met Robert Henri, the group's leading organizer and spokesman (see No. 10). They were married three months later. Marjorie was one of her husband's favorite models, and she devoted herself to managing his business and his now much richer social life so that he could be free to paint. She also continued to draw, if on a less regular and only intermittently commercial basis, and to exhibit her work. Six of her drawings appeared in the International Exhibition of Modern Art (the Armory Show) in 1913. Although twenty years his junior, she survived Henri by only a year, leaving a legacy of his work to her sister Violet, who prepared an unpublished biography of her brother-in-law.[2]

NOTES:

1. I am grateful to Janet J. Le Clair for correcting previously published information on Marjorie Organ's birthplace. My entry also draws on new information that Perlman published in 1991 (pp. 85–87). In a letter to me of 16 November 1991, Perlman reported that he based his text on Violet Organ's records and on his interview with John Dirks, son of the cartoonist Rudolf Dirks and Marjorie Organ's close friend Helen Walsh Dirks, on 17 August 1977.
2. The four-volume biography, which Homer used extensively for his biography of Henri, is in the collection of Janet J. Le Clair.

LITERATURE: Homer (1969) 1988; Perlman 1991, especially pp. 85–87.

20. Sketchbook, 1901

1975.1.917

28 pages, with 49 drawings in pen and ink (20 also with pencil), 2 in pen and ink and brush and wash, 1 in brush and wash over pencil, 1 in pencil, and 1 in watercolor, originally bound in beige fabric over board with *Sketch / Book* printed in brown on front cover. 13 x 19 cm. Paginated in pencil in lower right corners of rectos. (From page 5 on an earlier pagination has been erased and replaced; the number 3 can be seen under the number 5, the number 4 under the number 6, and so on.) Inscribed(?) in pencil on inside back cover: *Eagle*(?) *87 5 Ave.* Pages removed after 15v and 20v. The pages have come loose from the binding but are still kept within the original covers; binding holes and traces of glue remain along the bound edges.

Marjorie Organ was fifteen when she drew the figure, animal, and landscape studies in this sketchbook. Some of the sketches may be after unidentified paintings, prints, or book illustrations, and others seem to depict Ireland and may have been drawn from memory.[1]

NOTE:

1. Robert Lehman acquired this sketchbook and No. 10, the Henri sketchbook, at the same time; see No. 10, note 22.

PROVENANCE: Probably Violet Organ, the artist's sister, 1930; probably her nephew, John C. Le Clair, 1959; [Hirschl and Adler Galleries, New York]; Robert Lehman, February 1962.

No. 20, 1r

1r. Inscribed in pencil reinforced in pen and dark gray ink in upper left corner: *April 11——1901 / Sketches / By / Marjorie D Organ*; in pencil along right edge: *L all a*(?) *Rooth*(?). Creased and badly damaged along unbound edges.

1v. Blank.

2r. Landscape with a mountain and a lake. Watercolor.

2v. Heads of two women. Pen and gray ink. The younger woman may be the artist (see Fig. 20.1) and the older one her mother, according to Janet J. Le Clair (letter to the author, 21 January 1991).

3r. A peasant woman carrying a lyre. Pen and gray ink over pencil.

No. 20, 2r

No. 20, 2v

No. 20, 3r

No. 20, 3v

No. 20, 4r

No. 20, 4v

No. 20, 5r

No. 20, 5v

No. 20, 6r

No. 20, 6v

No. 20, 7r

No. 20, 7v

No. 20, 8r

3v. A peasant woman in a cloak. Pen and gray ink.

4r. A peasant woman holding a child on her lap. Pen and gray ink over pencil.

4v. Half-length sketch of a seated woman. Pen and gray ink over pencil.

5r. A water bird and a field bird. Pen and black ink over pencil; bordered. These drawings appear to be copies of two pages from a bird album.

5v. Ducklings in a pond. Pen and dark brown ink.

6r. A kneeling peasant woman with a basket in a field. Pen and dark brown ink.

6v. A hen and chicks and branches and grass. Pen and dark brown ink; bordered. Like those on 5r, these sketches seem to have been copied from a bird album.

7r. Flowers. Pen and dark brown ink over pencil.

7v. A cow in a field. Pen and gray ink; bordered. There is a pentimento of a cow above the horizon at the left.

8r. A figure beneath a tree on a riverbank or lakeshore, with a boat at the left and mountains in the distance. Pen and brown and gray ink; bordered.

No. 20, 8v

No. 20, 9r

No. 20, 9v

No. 20, 10r

8v. A peasant woman with a platter of game(?) in a kitchen. Pen and gray ink over pencil.

9r. Three studies of a woman's head. Pen and dark brown ink over pencil.

9v. A seated boy with a lamb. Pen and dark brown ink over pencil.

10r. Landscape with trees along a riverbank. Pen and dark brown ink; bordered.

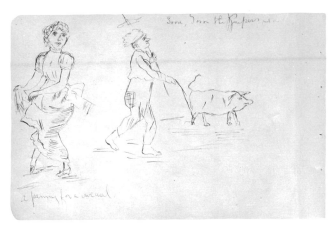

No. 20, 10v

No. 20, 11r

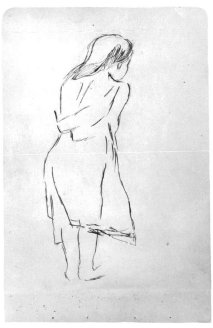

No. 20, 11v

No. 20, 12r

10v. A dancing peasant woman and a boy with a pig on a leash. Pen and dark brown ink. Inscribed in pen and dark brown ink at lower left: *a penny for a weasel.*; at top right: *Tom, Tom the Pipers son*.

11r. A peasant woman seated at a table painting pottery, with a sketch of another woman's head and shoulders. Pen and brown and gray ink. Circles drawn in pencil by a later hand.

11v. A woman or girl seen from the back. Pen and dark brown ink over pencil.

12r. An old, blind beggar and a boy. Pen and dark brown ink over pencil.

No. 20, 12v

No. 20, 13r

No. 20, 13v

No. 20, 14r

12v. A woman holding a violin and a sketch of a violin. Pen and brown ink (the woman and violin) and pencil (the violin). The violin may have been redrawn in pencil by a later hand.

13r. A street bordered by houses and trees. Pen and dark brown ink; bordered.

13v. A cow, a horse and rider, a man's profile, and a landscape. Pen and brown (the cow) and gray ink.

14r. A woman sitting in a chair with a baby on her lap. Pen and dark brown ink.

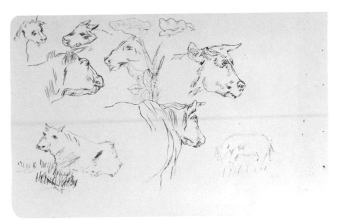

No. 20, 14v

No. 20, 15r

14v. Cows and a plant. Pen and brown and gray ink.

15r. Head of a woman, a woman in folk dress, and two sailboats. Pen and brown and gray ink. The drawing of the woman's head is probably a self-portrait (see Fig. 20.1).

15v. A peasant man playing an accordion. Pen and brown and gray ink.

Page removed between 15v and 16r.

16r. A woman kneeling to look at her reflection in a pool. Pen and brown ink.

Fig. 20.1 Marjorie Organ, ca. 1907. Collection of Janet J. Le Clair. Photograph courtesy of the Delaware Art Museum, Wilmington

No. 20, 15v

No. 20, 16r

No. 20, 16v

No. 20, 17r

No. 20, 17v

No. 20, 18r

No. 20, 18v

No. 20, 19r

No. 20, 19v

No. 20, 20r

No. 20, 20v

No. 20, 21r

16v. A man playing an organ. Pen and dark brown ink over pencil.

17r. Landscape with a river and trees. Pen and dark brown ink; bordered.

17v. Faces of men and women. Pen and brown and gray ink, the central face over pencil. Inscribed in pen and brown ink at lower left: *Faces / I have seen*. The face in the center may be a self-portrait (see Fig. 20.1).

18r. Faces of three women. Pen and gray (the woman at left) and brown ink. The woman at the left may be the artist (see Fig. 20.1).

18v. A rooster. Brush and gray wash over light sketch in pen and brown ink; bordered.

19r. An old peasant woman seated in a chair reading. Pen and dark brown ink.

19v. Head and shoulders of a fashionably dressed woman. Brush and gray wash over pencil. This is probably a self-portrait (see Fig. 20.1).

20r. A donkey and the heads of two women and a man. Pen and gray ink over pencil. Inscribed in pen and gray ink at upper center: *W. Moore*.

20v. A woman's head in profile. Pen and gray ink over pencil.

Page removed between 20v and 21r.

21r. Heads and shoulders of two women wearing elaborate hats. Pen and gray ink over pencil.

No. 20, 21v

No. 20, 22r

No. 20, 22v

No. 20, 23r

21v. A priest sitting at a table. Pen and gray ink.

22r. A woman caressing a baby. Pen and gray ink.

22v. Landscape with trees and cottages in the snow. Pen and gray ink over pencil; bordered.

23r. Head of a woman and the head and shoulders of another woman. Pen and gray ink and brush and gray wash. The bordered wash drawing at the left is probably a self-portrait (see Fig. 20.1).

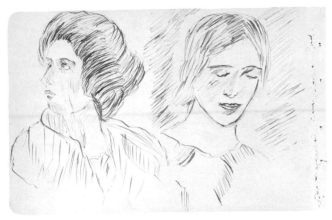

No. 20, 23v

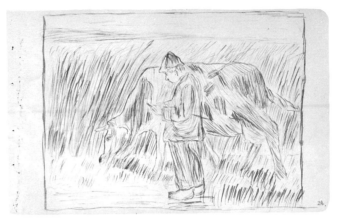

No. 20, 24r

No. 20, 24v

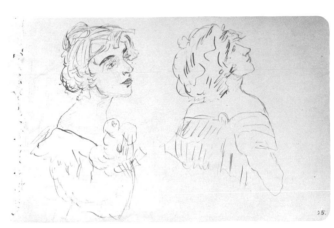

No. 20, 25r

23v. Heads and shoulders of two women. Pen and gray ink.

24r. A man and a grazing cow in a field. Pen and gray ink over pencil; bordered.

24v. Landscape with trees and hills along a river. Pen and gray ink; bordered.

25r. Heads and shoulders of two women. Pen and gray ink.

No. 20, 25v

No. 20, 26r

No. 20, 26v

No. 20, 27r

25v. A woman caressing a baby. Pen and gray ink.

26r. A woman resting her head on her hands while leaning her elbows on a cushion. Pen and gray ink over pencil; bordered. Lower left corner torn off.

26v. A man driving a carriage by a road sign. Pencil; bordered. The sign reads: OROUGH / MASONS DITCH / 3 MILES.

27r. A blanket-covered horse hitched to a wagon. Pen and gray ink over pencil.

No. 20, 27v

No. 20, 28r

No. 20, 28v

No. 20, inside back cover

27v. Half-length study of an old man. Pen and gray ink.

28r. An old man slumped forward onto a table. Pen and gray ink. Badly damaged on unbound edges.

28v. A woman in evening dress seated on a couch. Pen and gray ink; bordered.

Van Day Truex

Delphos, Kansas, 1904–Paris(?) 1979

Draftsman and designer Van Day Truex studied at the Parsons School of Design in New York from 1922 to 1925, when he went to Paris, and then served as head of the school's Paris branch from 1930 to 1939. After 1939 he lived in New York and the south of France. He was president of the Parsons School from 1942 to 1953, design director for Tiffany's from 1955 until his death, and consultant to many manufacturers of household objects, notably Baccarat and Yale and Towne.

LITERATURE: Loring 1979.

21. Rome III, 1950s(?)

1975.1.972
Pen and brown ink with gray, brown, yellow, and orange wash. 52 x 68.6 cm. Signed in pen and brown ink lower right: *Truex*. Inscribed in pencil at upper right of verso: *Rome*. Tack holes in all four corners.

Truex showed his appreciation for the European architectural past, and his admiration for the eighteenth-century artists who drew it, in this drawing and *View of Spoleto*

(No. 22), two of the many tonal city views he exhibited in New York from the late 1930s through the early 1960s.[1]

Rome III is a variation of a view of the Campus Martius, just north of the Theater of Marcellus (Fig. 21.1).

Fig. 21.1 View of the Campus Martius, just north of the Theater of Marcellus, Rome: The Temple of Janus is at the center, between the columns of the Temple of Apollo and the church of Santa Rita da Cáscia. Photograph courtesy of Fototeca Unione, Presso Accademia Americana, Rome

No. 21

No. 22

The Temple of Janus (260 B.C., restored A.D. 17), in the center foreground, was excavated in 1932–33, and in 1940 the three standing columns with entablature from the southeast corner of the Temple of Apollo Sosianus (431 B.C., restored ca. 33 B.C.) were reerected from fragments found during the excavations. To the right of the ruins is Carlo Fontana's mid-seventeenth-century Santa Rita da Cáscia, which was moved in 1927 from beside the steps of Santa Maria in Aracoeli to this spot on the Piazza Santa Maria in Campitelli. The dome of Santa Maria in Campitelli is visible just to the right of the three columns of Apollo Sosianus. Altogether theatrical, Truex's drawing is a stage set composed of (often rearranged) fragments of ancient and baroque Rome, through which some figures wander as others gather around the thoroughly modern canopied bar at the right.[2]

NOTES:
1. An old label removed from No. 21 (Robert Lehman Collection files) says that it, like No. 22, was acquired from Carstairs Gallery. Robert Lehman may have purchased this drawing about the same time he acquired No. 22, for which there is a bill of sale in the files from Carstairs dated 13 April 1959.
2. I am indebted to Elizabeth Will for identifying this site in Rome. For information on and illustrations of the monuments, see Nash 1968, vol. 1, pp. 28–29, 500–501, and Krautheimer 1985.

PROVENANCE: [Carstairs Gallery, New York]; Robert Lehman, 1959(?).

22. View of Spoleto, 1950s

1975.1.973
Pen and black ink with brown and gray wash. 21.1 x 30.9 cm. Signed in ballpoint pen lower left: *Truex*. Watermark: *C. M. FABRIANO*.

Although on the whole *View of Spoleto* suggests a stage set created from the naturally theatrical Italian piazza, the left half of the composition is quite similar to an Alinari photograph of the sixteenth-century Palazzo Arroni.[1] Truex may have been in Spoleto for the Festival dei due mondi, the international theater and music festival the city has hosted every summer since 1957. See also No. 21.

NOTE:
1. The photograph is reproduced in Bandini [1920], p. 92, and elsewhere.

PROVENANCE: [Carstairs Gallery, New York]; Robert Lehman, April 1959.

LITERATURE: *Institute of International Education News Bulletin*, January 1960, cover ill.

Seymour Remenick

Born Detroit, 1923

Seymour Remenick, who has lived in Philadelphia since 1936, trained at the Tyler School of Art at Temple University, Philadelphia; the Hans Hofmann School, New York and Provincetown; and the Pennsylvania Academy of the Fine Arts, Philadelphia. He is a member of the National Academy of Design. A painter in oil and watercolor, he has taught at the Pennsylvania Academy since 1977. Many of his paintings are views of his city neighborhood and of Gloucester, Massachusetts. His work is in a number of public collections, including the Pennsylvania Academy and the Philadelphia Museum of Art.

LITERATURE: Pitz 1971.

23. Still Life, Interior, 1950s

1975.1.971

Pen and brown ink; brown, gray, and orange wash; and white gouache on paper washed with brown. Four strips of brown paper pasted along edges of sheet to frame the image before the paper was washed with brown. 23.7 x 26.7 cm (22.1 x 25.3 cm without strips). Signed in pencil lower left: REMENICK. Stamp in black at lower left of verso: eagle holding four arrows and a branch, overwritten *L Davis* (stamp of Davis Galleries, overwritten by Leroy Davis, owner of the gallery).

This wash drawing of a tranquil, modest interior, rendered in the warm brown tones he was using at the time, represents a corner of Remenick's studio in Philadelphia in the 1950s.[1] It reflects his admiration of seventeenth-century Dutch and Flemish drawings.

NOTE:
1. Remenick, letter to the author, 11 July 1986.

PROVENANCE: [Davis Galleries, New York, 1957(?)]; Robert Lehman, 1957(?).

EXHIBITED: Davis Galleries, New York, 10 January–2 February 1957(?).

No. 23

No. 24

Alfred Hammer

Born New Haven, Connecticut, 1925

Alfred Hammer earned a B.F.A. from the Rhode Island School of Design, Providence, and a B.F.A. and M.F.A. from Yale University, New Haven. He has held a number of teaching and administrative posts, at the Rhode Island School of Design (1952–69), the Cleveland Institute of Art (1969–74), the University of Manitoba School of Art (1974–81) in Winnipeg, and the Hartford Art School at the University of Hartford (1983–86). He lives in Bloomfield, Connecticut, and teaches in the area.

24. Field with Figure, 1959

1975.1.904
Blue ballpoint pen and pen and black ink. 21.1 x 28.1 cm.
Signed and dated in pencil lower right: *A H[a]m[mer] 59.*
Small crease at lower left.

The female figure, seen from behind, can barely be distinguished from the parallel lines that define the abstract landscape in this drawing.

PROVENANCE: Not established.

Stuart Martin Kaufman

Born Brooklyn, New York, 1926

Stuart Kaufman, who considers himself a traditional figure painter strongly influenced by Renaissance art, studied at the Pratt Institute and at the Art Students League in New York. From the mid-1950s to the mid-1960s he exhibited paintings and drawings in the New York area. Since then he has continued to show his paintings while also doing commercial work, in particular book-cover illustrations for major publishers.

LITERATURE: Singer 1972.

No. 25

25. Nude, ca. 1960

1975.1.911

Pencil; yellow, red, pink, blue, and brown pastel; and white gouache on brown paper. 20.3 x 18 cm. Signed in pencil lower left: *Stuart Kaufman*. Right and bottom edges irregular.

Kaufman obviously had Edgar Degas's bathers in mind when he drew this nude standing with her back turned, seemingly unaware of the artist's presence, and holding a large sheet or towel in an unspecified yet intimate domestic setting. He remembers working on this drawing and a series of others of the same model about 1960.[1]

NOTE:

1. Conversation with Phyllis Kaufman, the artist's wife, 22 March 1991. She also confirmed that the drawing was sold through Davis Galleries.

PROVENANCE: [Davis Galleries, New York, about 1960]; Robert Lehman, about 1960.

David Levine

Born Brooklyn, New York, 1926

David Levine's drawings and caricatures have been appearing in *Esquire* since 1958 and in the *New York Review of Books* since 1963, the year it began regular publication. After receiving a B.S. and a B.F.A. from the Tyler School of Art at Temple University in Philadelphia in 1949, Levine studied briefly with Hans Hofmann in New York. He has received many prizes and was elected to the National Academy of Design in 1971. A skilled draftsman, he is best known for his biting and incisively revealing caricatures, particularly those of the late 1960s and early 1970s, but he has also exhibited charcoal drawings, watercolors, and oils at galleries and museums throughout the country. His watercolors, too, are often witty observations on the human condition.

LITERATURE: Levine 1963; Washington, D.C. 1976; Levine 1978; Washington, D.C. 1980; Oxford 1987–88.

26. Sketchbook: Paris, Amsterdam, The Hague, and London, 1960

1975.1.912

49 pages, with 42 sketches in pencil; 1 in pen and ink; 2 in pencil, pen and ink, and wash; and 2 in watercolor over pencil, bound in beige fabric over board. 13.5 x 21.3 cm. Paginated in pencil in upper right corners of rectos. On the inside front cover, a label that reads: *ALBUM A DESSIN / MARQUE DÉPOSÉE / N° 2 Bis Dimens. : ⅛ Coquille / Rappeler ce N° et / les Dimensions pour / avoir le même album. / Prix : 5,80 / SENNELIER - PARIS / 3, Quai Voltaire et 4 bis, rue de la Grande-Chaumière (2 Bis* and *⅛ Coquille* handwritten in pen and black ink, *5,80* handwritten in pencil, the remainder printed). Stamp in black to right of label: eagle holding four arrows and a branch, overwritten *L Davis / 1960* (stamp of Davis Galleries, overwritten by Leroy Davis, owner of the gallery). Page removed after 46v.

This sketchbook was part of what David Levine describes as "a wonderful commission by *Esquire Magazine*." In the summer of 1960, when he had been cartooning for *Esquire* for about two years and had also had several exhibitions of his paintings at Davis Galleries in New York, Levine approached Clay Felker, then the maga-zine's feature editor, and asked to be given an assignment in Europe, so that he could "see all the museums and great paintings." Felker "concocted a piece based on the Grand Tour of the nineteenth century." Levine was "to paint and draw and the art director would figure out how to use the work as illustration."[1] The February 1961 issue of *Esquire* carried an article by travel editor Richard Joseph that is illustrated with eleven of Levine's watercolors and two drawings – of sights in and near Madrid, Venice, Geneva, Lapland, Paris, and Scheveningen (near The Hague) and along the banks of the Rhine. The article opens with the pencil drawing on page 41r of the Lehman sketchbook, of the stone lion guarding the entrance to Hatfield House, some seventeen miles northwest of London; the cartouche the lion holds frames the article's title, "The New Grand Tour" (see Fig. 26.7).[2]

Levine began his trip in Madrid, but he did not purchase this sketchbook until he was in Paris, between 17 and 22 August. His sketches of Paris record his visit to the Poussin exhibition and his delight with the grimacing gargoyles of Notre Dame. In Amsterdam he made a pilgrimage to Rembrandt's house and the Jan Six Collection and sketched Dutch street scenes that were well suited to his style and his approach to subject matter.[3] In London he contrasted the lives of the rich and the poor and with notable wit drew museum visitors looking at pictures. The final two pages of the sketchbook are watercolors he painted after he returned to New York. The last page is a beach scene he believes he sketched at Coney Island, which is the subject of the *Summer Sketchbook* he published in 1963 and continues to be a primary site for his work.

Levine's keen eye and skill as a caricaturist are evident in these quick but masterful sketches of shopkeepers, strollers, lovers, fishermen, bicyclists, and café patrons in Paris, Amsterdam, The Hague, and London. The sketchbook, he says, "continued a practice of mine which had started with my emulation of 'the Eight,' journalist art. This enables the artist to bring the life outside of the studio into the studio." For his present work, done mostly at Coney Island, he still makes "studies in a sketchbook which sometimes provides a figure to be included in a mass scene. The painting is a personalized synthesis and a photo simply doesn't provide the personal focus that a drawing does."[4]

NOTES:

1. Levine, letter to the author, 12 July 1986. Levine remembers that not too long before the trip to Europe, Roy Davis, the director of Davis Galleries, was asked to frame many works in Robert Lehman's collection and that on one occasion he went with Davis to see the collection at 7 West 54 Street. It was during that visit that Robert Lehman said he would like to purchase one of the sketchbooks from Levine's European trip.
2. See Joseph 1961, p. 53.
3. I am grateful to Egbert Haverkamp-Begemann for his interest in and help with this entry, and particularly for identifying and photographing sites Levine sketched in Amsterdam (see Figs. 26.4, 26.5, and 26.6).
4. Levine, letter to the author, 12 July 1986.

PROVENANCE: [Davis Galleries, New York, 1960]; Robert Lehman, late 1960(?).

1r. Inscribed in pen and black ink: *To Robert Lehman, / I am deeply honored by your / patronage. / David Levine.*

1v. Blank.

2r. Signed and dated in pen and brown ink: *David Levine 1960 / Paris August 17–22* (*August 17–22* in darker brown ink). It is possible that Levine added the signatures, dates, and inscriptions in pen and brown ink on the rectos after the sketchbook was completed; the inscriptions on the versos, in the same pen but in slightly darker brown ink, may also have been added later but at a different time.

2v. Inscribed in pencil: *1* (in a circle).

No. 26, inside front cover

To Robert Lehman,
I am deeply honored by your patronage.

David Levine

No. 26, 1r

David Levine 1960
Paris August 17–22

No. 26, 2r

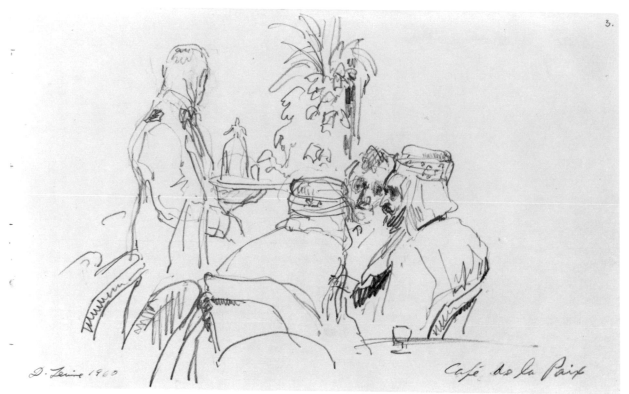

No. 26, 3r

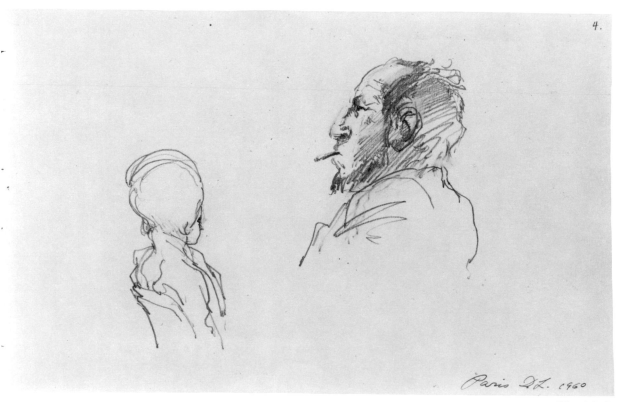

No. 26, 4r

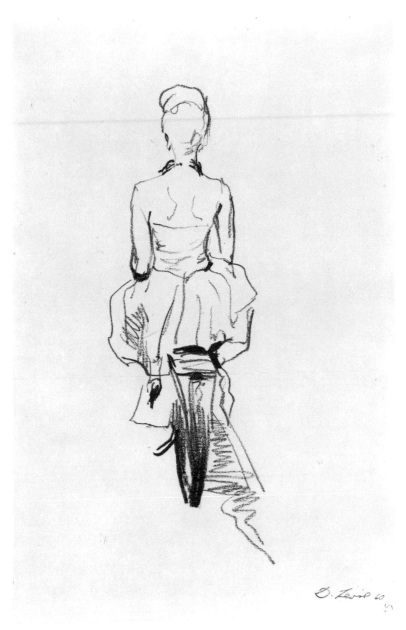

No. 26, 5r

3r. Men from French North Africa sitting in the Café de la Paix in the Place de l'Opéra, Paris. Pencil. Signed and dated in pen and brown ink lower left: *D. Levine 1960*; inscribed in pencil lower right: *Café de la Paix*.

3v. Inscribed in pen and brown ink upper left: *Café De La Paix, Paris*.

4r. A man in the Café de la Paix and a sketch of a woman. Pencil. Inscribed, signed, and dated in pen and brown ink lower right: *Paris D. L. 1960*.

4v. Inscribed in pen and brown ink upper left: *Man in Café De La Paix*.

5r. A woman in evening dress on a motor scooter in Paris. Pencil. Signed and dated in pen and brown ink lower right: *D. Levine 60*.

5v. Inscribed in pen and brown ink upper left: *Paris*.

No. 26, 6r

No. 26, 7r

No. 26, 8r

6r. People at outdoor cafés along the Champs-Elysées. Pencil. Inscribed in pen and brown ink lower right: *Champs Elysee.*

6v. Inscribed in pen and brown ink upper left: *Champs Elysée.*

7r. Sketches of a woman selling peaches on the rue Lepic in Montmartre. Pencil. Inscribed in pencil lower right: *Rue Lepic*; in pen and brown ink lower right: *Des Pêches.*

7v. Inscribed in pen and brown ink upper left: *"Des Pêches" Rue Lepic.*

8r. A butcher standing by his stock on the rue Lepic. Pencil. Inscribed in pencil lower left: *Boucher*; inscribed, signed, and dated in pen and brown ink lower center and right: *Rue Lepic D. Levine 1960.*

8v. Inscribed in pen and brown ink upper left: *Boucher, Rue Lepic.*

No. 26, 9r

9r. A fruit vendor on the rue Lepic. Pencil. Signed and dated in pen and brown ink lower right: *D. Levine 1960*.

9v. Inscribed in pen and brown ink upper left: *Fruit Vender, Rue Lepic, Paris*.

10r. A fishmonger with his wares on the rue Lepic. Pencil. Inscribed in pencil lower left: *Poissonerie*; signed and dated in pen and brown ink lower right: *D. L. 1960*.

10v. Inscribed in pen and brown ink upper left: *Poissonerie, Rue Lepic, Paris*.

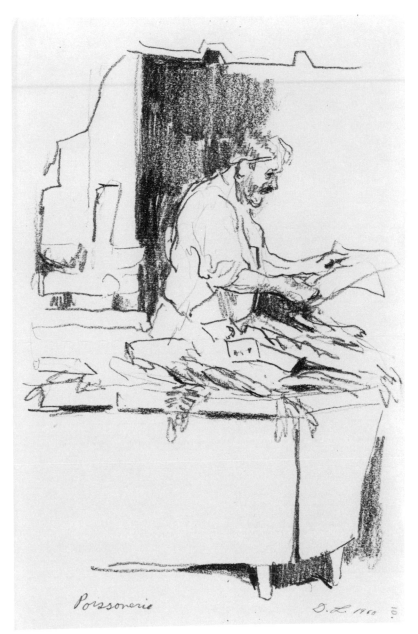

Poissonerie

No. 26, 10r

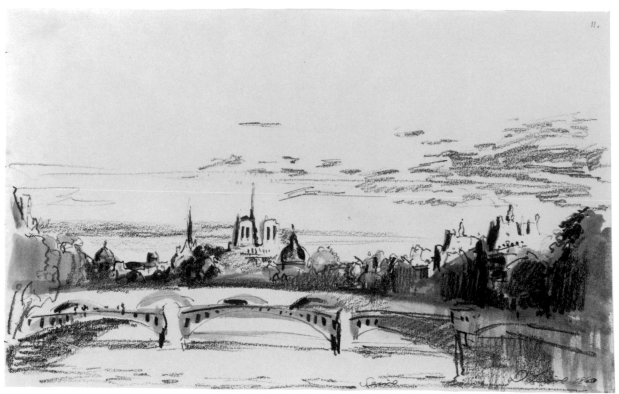

No. 26, 11r

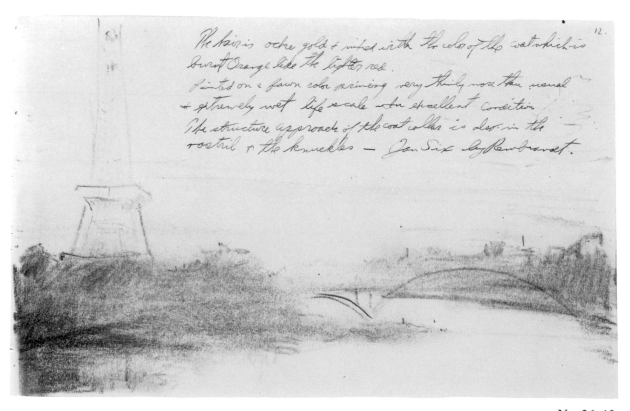

No. 26, 12r

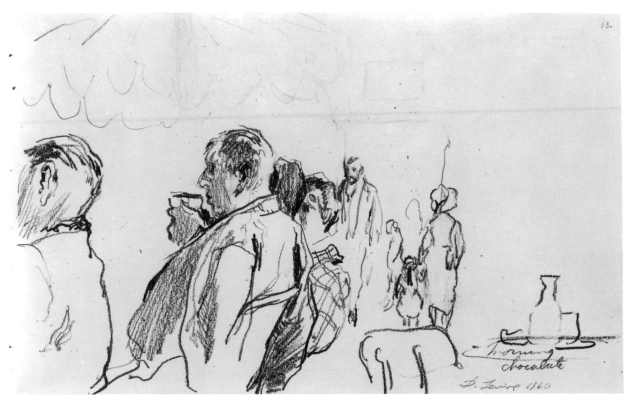

No. 26, 13r

11r. The Seine, with Notre Dame in the distance. Gray wash, pencil, pen and brown ink. Inscribed, signed, and dated in pen and brown ink lower right: *Seine D Levine 1960.*

11v. Inscribed in pen and brown ink upper left: *Seine, Paris.*

12r. The Eiffel Tower and the Seine. Pencil. Inscribed in pen and brown ink upper right: *The hair is ochre gold & mixed with the color of the coat which is / burnt Orange like the lighter red. / Painted on a fawn color priming very thinly more than usual / & extremely wet life scale – In excellent condition/ The structure approach of the coat collar is also in the / nostril & the knuckles – Jan Six by Rembrandt. (Jan Six by Rembrandt* added in slightly darker brown ink.) Rembrandt's *Jan Six* (1654) is in the Jan Six Collection, Amsterdam.

12v. Inscribed in pen and brown ink upper left: *Paris.*

13r. Men drinking chocolate in the morning at an outdoor café. Pencil. Inscribed in pencil lower right: *Morning / Chocolate*; signed and dated below that in pen and brown ink: *D. Levine 1960.*

13v. Inscribed in pen and brown ink upper left: *Paris, Café in Morning.*

No. 26, 14r

14r. A man sitting painting at an easel in the Louvre. Pencil. Inscribed and signed in pen and brown ink lower right: *Louvre D. L.*

14v. Inscribed in pen and brown ink upper left: *Louvre, Paris.*

15r. Two reclining figures and a putto, after Nicolas Poussin. Pencil. Inscribed and signed in pen and brown ink lower right:

Poussin D. L. The figures are copied from the foreground of Poussin's *Triumph of Flora* (ca. 1627) in the Louvre (Fig. 26.1).

15v. Inscribed in pen and brown ink upper left: *Poussin Figures, Poussin Exhibit, Louvre, Paris.*

No. 26, 15r

Fig. 26.1 Nicolas Poussin, *The Triumph of Flora*. Oil on canvas, ca. 1627. Musée du Louvre, Paris. Photograph courtesy of the Réunion des Musées Nationaux, Paris

No. 26, 16r

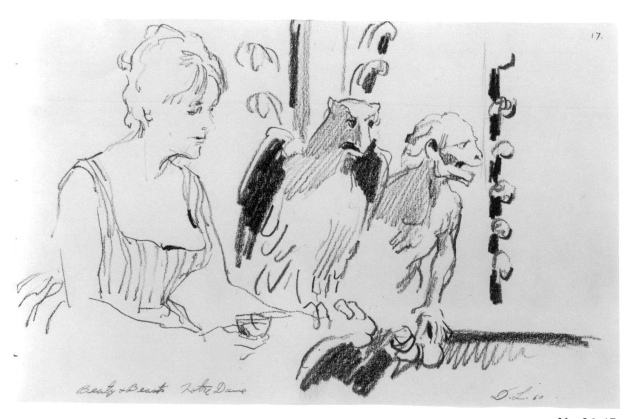

No. 26, 17r

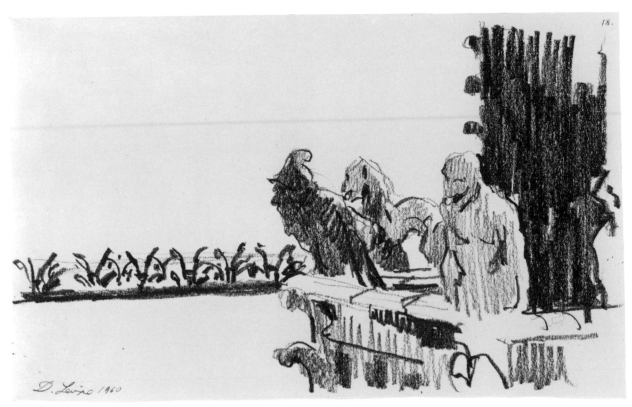

No. 26, 18r

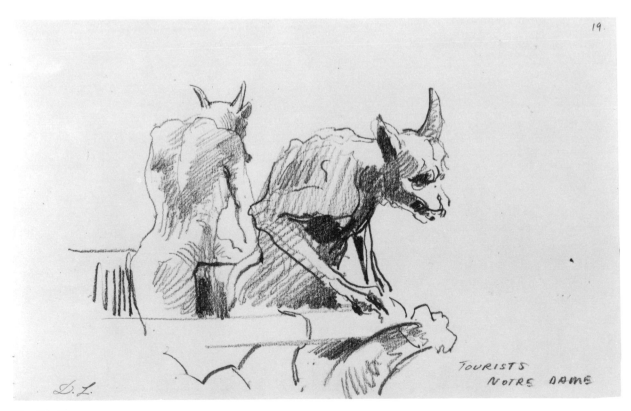

No. 26, 19r

16r. Lovers on the Champs-Elysées. Pencil. Inscribed and signed in pen and brown ink lower right: *Lovers on the Champs Elysee D. L.*

16v. Inscribed in pen and brown ink upper left: *Lovers on the Champs Elysée.*

17r. A woman standing next to the gargoyles of Notre Dame. Pencil. Inscribed in pen and brown ink lower left: *Bea[u]ty & Beasts Notre Dame*; signed and dated in pen and brown ink lower right: *D. L. 60.* To his sketch of the gargoyles atop Notre Dame Levine seems to have added his own personification of Beauty, a Manet-like woman incongruously holding a drink in her hand.

17v. Inscribed in pen and brown ink upper left: *Girl & Gargoyles, Notre Dame, Paris.*

18r. The gargoyles of Notre Dame. Pencil. Signed and dated in pen and brown ink lower left: *D. Levine 1960.* Here Levine added what appears to be a nude man with a mustache and beard, looking over the parapet as if he were one of the gargoyles.

18v. Inscribed in pen and brown ink upper left: *Gargoyles, Notre Dame, Paris.*

19r. "Tourists" at Notre Dame. Pencil. Inscribed in pencil lower right: *TOURISTS / NOTRE DAME*; signed in pen and brown ink lower left: *D. L.*

19v. Inscribed in pen and brown ink upper left: *Gargoyles, Notre Dame.*

20r. Rembrandt. Pencil. Signed in pen and brown ink lower right: *D. L.* Levine's quick sketch, which, as Egbert Haverkamp-Begemann has pointed out, is from Rembrandt's *Self-portrait as the Apostle Paul* of 1661 in the Rijksmuseum, Amsterdam (Fig. 26.2), caricaturizes Rembrandt's nose, eye, and mustache and indicates the collar of his jacket. A caricature of Rembrandt by Levine appeared in the *New York Review of Books* in 1970 (Fig. 26.3) and later became part of *David Levine's Gallery*, a collection of caricatures of artists that the *New York Review* published in 1974 (no. 10; also reproduced in Levine 1978).

20v. Inscribed in pen and brown ink upper left: *Rembrandt Self Portrait.*

No. 26, 20r

Fig. 26.2 Rembrandt, *Self-portrait as the Apostle Paul*. Oil on canvas, 1661. Rijksmuseum, Amsterdam

Fig. 26.3 David Levine, *Rembrandt*. Reprinted with permission from *The New York Review of Books* (14, no. 5 [12 March 1970], p. 8). Copyright © 1970 Nyrev, Inc.

No. 26, 21r

No. 26, 22r

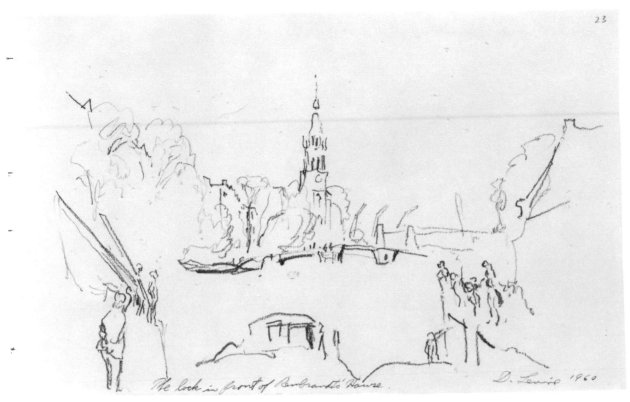

The lock in front of Rembrandt's House. D. Levine 1960

No. 26, 23r

21r. Two women bicyclists in Amsterdam. Pencil. Inscribed, signed, and dated in pen and brown ink lower right: *Holland D. Levine 1960*. The woman on the left is giving a companion a ride on the luggage carrier; the one on the right is carrying a large suitcase.

21v. Inscribed in pen and brown ink upper left: *Bycy* changed to *Byciclists Holland, Amsterdam.*

22r. Entrance to Rembrandt's house, Amsterdam. Pencil. Inscribed in pen and brown ink lower left: *Rembrandt's Door Step / from the cellar steps*; signed and dated in pen and brown ink lower right: *D. Levine 1960.*

22v. Inscribed in pen and brown ink upper left: *Doorway & Steps, Rembrandt's House, Amsterdam, Holland.*

23r. The lock in front of Rembrandt's house, Amsterdam. Pencil. Inscribed in pen and brown ink lower center: *The lock in front of Rembrandt's House*; signed and dated in pen and brown ink lower right: *D. Levine 1960.* Levine was looking from the Sint Antoniesluis lock near Rembrandt's house in the Jodenbreestraat along the canal Oudeschans toward the Montelbaanstoren (Fig. 26.4), which was built in the beginning of the sixteenth century to protect the Lastage, Amsterdam's shipbuilding quarter. In the center foreground a flatboat is

moving toward the viewer from the Oudeschans through the lock into the Zwanenburgwal.

23v. Inscribed in pen and brown ink upper left: *Canal, locks, Amsterdam.*

Fig. 26.4 Amsterdam, view from the Sint Antoniesluis lock near Rembrandt's house in the Jodenbreestraat, along the canal Oudeschans toward the Montelbaanstoren

215

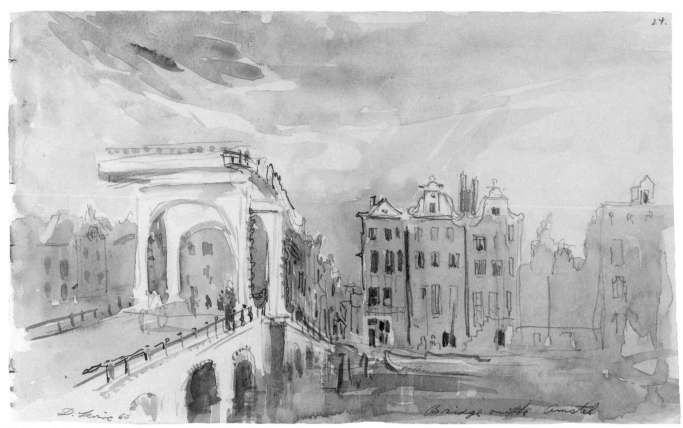

No. 26, 24r

Fig. 26.5 Amsterdam, the Magere Brug over the Amstel
River, looking toward the eighteenth-century houses on the
east side of the river and into the Nieuwe Kerkstraat

24r. Bridge over the Amstel River, Amsterdam. Watercolor and pen and black ink over pencil. Signed and dated in brown ink lower left: *D. Levine 60*; inscribed in pen and dark brown ink lower right: *Bridge on the Amstel.* The view is of the Magere Brug over the Amstel, looking toward the eighteenth-century houses on the east side of the river and into the Nieuwe Kerkstraat (Fig. 26.5). The contours of the bridge are dotted with light bulbs for illumination at night.

24v. Inscribed in pen and brown ink upper left: *Bridge on the Amstel, Holland, Amsterdam.*

25r. Flatboats on the Amstel River, Amsterdam. Pen and brown ink. Signed in pen and brown ink lower left: *D L.*; inscribed in pen and brown ink lower right: *Flatboats on Amstel.* Levine sketched this view a short distance north of the Magere Brug (Fig. 26.6). One of the entrances to the Diaconie Oude Mannen- en Vrouwenhuis (Home for the Elderly; 1681–83) across the Amstel serves as background to the flatboat and its equipage. See also 26r.

25v. Inscribed in pen and brown ink upper left: *Barge on the Amstel.*

Fig. 26.6 Amsterdam, view across the Amstel River a short distance north of the Magere Brug. On the opposite bank is the Diaconie Oude Mannen- en Vrouwenhuis (Home for the Elderly)

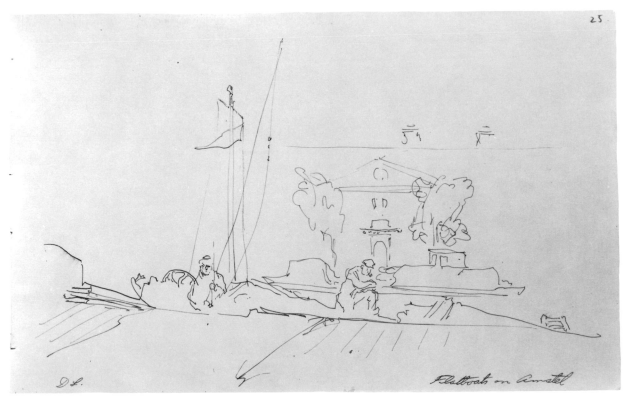

No. 26, 25r

26.

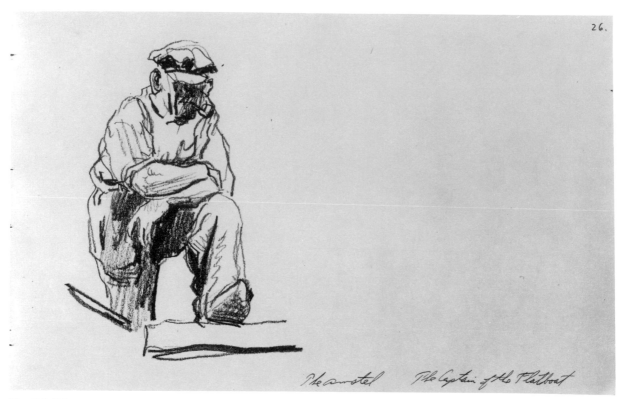

The amstel The Captain of the Flatboat

No. 26, 26r

27.

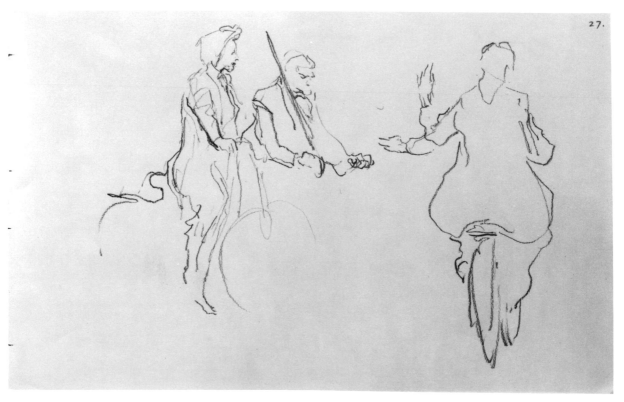

No. 26, 27r

No. 26, 28r

26r. A flatboat captain, Amsterdam. Pencil. Inscribed in pen and brown ink lower right: *The Amstel The Captain of the Flatboat.* The captain stands in the same position in the center foreground on 25r.

26v. Inscribed in pen and brown ink upper left: *Holland, Flatboat Capt.*

27r. Bicyclists in Amsterdam. Pencil. The woman on the right is signaling to turn.

27v. Inscribed in pen and brown ink upper left: *Byciclists Amsterdam, Holland.*

28r. A woman bicycling in Amsterdam with her child in a seat behind her. Pencil.

28v. Inscribed in pen and brown ink upper left: *Mother & Son, Amsterdam, Holland.*

No. 26, 29r

29r. Sketch of *The Docker* by Mari Andriessen. Pencil. Inscribed in pen and brown ink across bottom: *Mari Andriessen 1952 / Statue to the memory of the Port Workers / Strike in 1941 when the Germans took the Jews to Labor Camps*; signed in pen and brown ink lower right: *D. L.* Andriessen's statue, made in 1950–52, was erected in 1958 on the Jonas Daniël Meÿerplein in Amsterdam in commemoration of the so-called February Strike on 25 and 26 February 1941, a protest against the persecution of the Jews.

29v. Inscribed in pen and brown ink across top: *Amsterdam, Statue Commemorating Resistance Movement.*

30r. People watching an artist on the Rembrandtplein in Amsterdam. Pencil. Inscribed in pen and brown ink lower left: *Rembrandt Plein.*

30v. Inscribed in pen and brown ink upper left: *People watching an artist in Amsterdam.*

31r. Men fishing, The Hague. Pencil.

31v. Inscribed in pen and brown ink upper left: *Fishing, Hague, Holland.*

No. 26, 30r

No. 26, 31r

No. 26, 32r

No. 26, 33r

32r. Sketches of a newspaper vendor and a stroller in London. Pencil. Inscribed in pen and brown ink lower center: *Newsvender & Stylish Stroller.*

32v. Inscribed in pen and brown ink upper left: *Newsie, London.*

33r. A newspaper vendor in front of his stall, London. Pencil. Inscribed in pen and brown ink lower left: *Newsie.*

33v. Inscribed in pen and brown ink upper left: *Newspaper Vender, London.*

No. 26, 34r

34r. Two proselytizers on a London street corner. Pencil. One
of the signs reads: *THE END IS AT HAND.*

34v. Inscribed in pen and brown ink upper left: *Religeous sect
London.*

Girl at Picadilly 35.

No. 26, 35r

35r. "Teddy Boy Girl" in Piccadilly Circus, London. Pencil.
Inscribed in pen and brown ink lower right: *Girl at Picadilly.*
The same young woman is sketched on 36r.

35v. Inscribed in pen and brown ink upper left: *"Teddy Boy
Girl" London.*

No. 26, 36r

36r. A girl in Piccadilly Circus, London. Pencil. Inscribed in pen and brown ink lower right: *Girl at Picadilly*. See also 35r.

36v. Inscribed in pen and brown ink upper left: *Picall* (crossed out) *Picadilly Girl*.

37r. Queen's Life Guard, Whitechapel, London. Pencil. Inscribed in pen and brown ink lower left: *Queen's Life Guard*.

37v. Inscribed in pen and brown ink upper left: *Queen's Life Guard, WitechapelLondon*.

No. 26, 37r

No. 26, 38r

No. 26, 39r

38r. A standing man and seated woman at the National
Gallery, London. Pencil. Inscribed in pen and brown ink lower
left: *At the Nat. Gallery.*

38v. Inscribed in pen and brown ink upper left: *London, Nat.
Gallery.*

39r. Derby wearers, London. Pencil. Inscribed in pen and
brown ink lower right: *Derby Wearers.*

39v. Inscribed in pen and brown ink upper left: *London.*

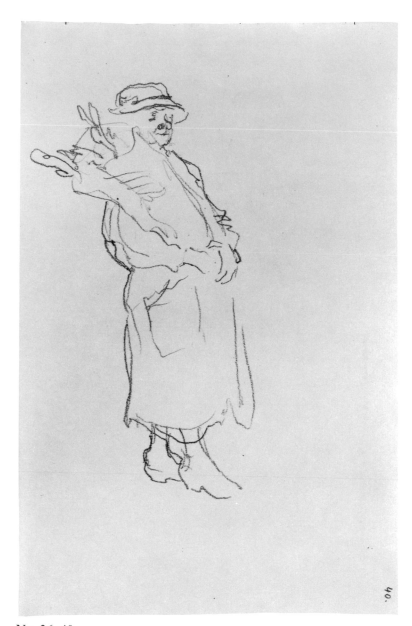

No. 26, 40r

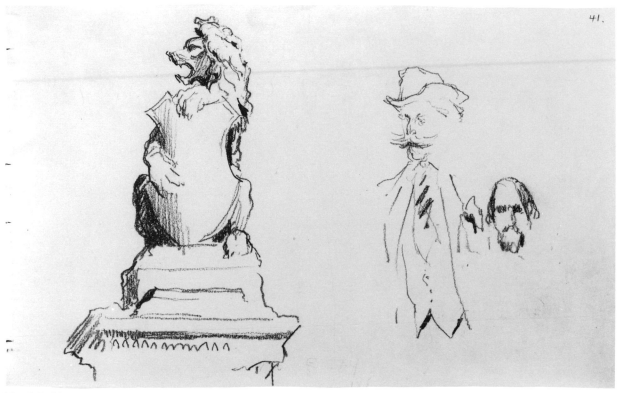

No. 26, 41r

40r. A woman carrying flowers in London. Pencil.

40v. Inscribed in pen and brown ink upper left: *Woman carrying flowers, London.*

41r. Sketches of men with mustaches and the lion on the gate of Hatfield House, Hertfordshire. Pencil. The sketch of the lion illustrates the first page of "The New Grand Tour" (Fig. 26.7), an article published in *Esquire* in 1961 that also includes eleven watercolors and one pen and ink drawing Levine made during this same trip to Europe (see Joseph 1961).

41v. Inscribed in pen and brown ink upper left: *Man with english mustache, / Lion on the gate of Hatfield House / Hertfordshire London.*

Fig. 26.7 David Levine, *Lion on the Gate of Hatfield House.* Reprinted with permission from Richard Joseph, "The New Grand Tour," *Esquire* 55, no. 2 (February 1961), p. 53. Copyright © 1961 the Hearst Corporation

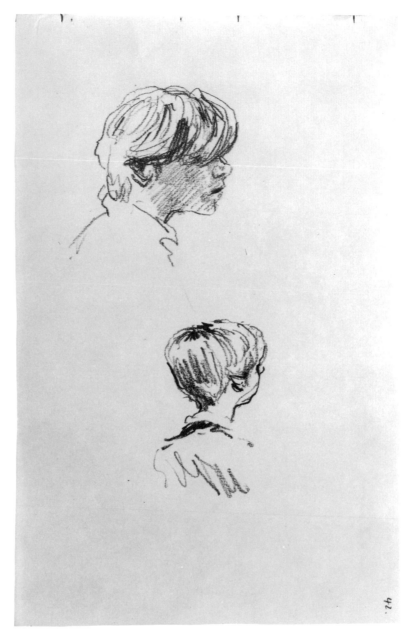

No. 26, 42r

42r. Sketches of a street urchin, London. Pencil.

42v. Inscribed in pen and brown ink upper left: *Street Gamin, London.*

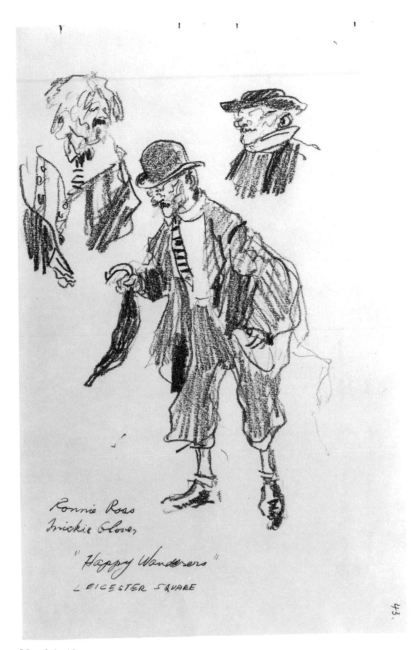

No. 26, 43r

43r. Sketches of street performers in Leicester Square, London. Pencil. Inscribed in pen and brown ink lower left: *Ronnie Ross / Mickie Glover / "Happy Wanderers" / LEICESTER SQUARE.*

43v. Inscribed in pen and brown ink upper left: *Street Vaudevillian, London / "Happy Wanderers" Leicester Square.*

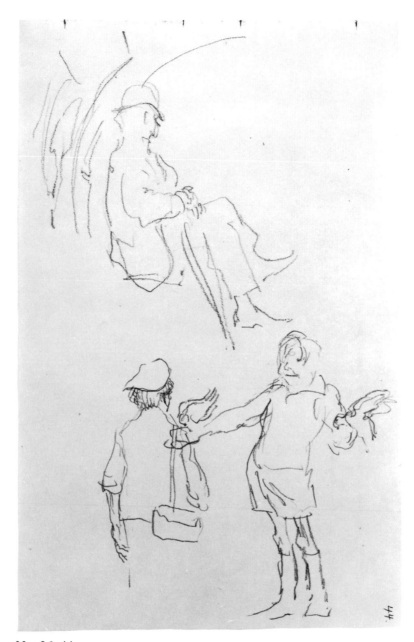

No. 26, 44r

44r. A man sitting in the London Underground, a boy feeding
pigeons in Trafalgar Square, and a woman walking. Pencil.

44v. Inscribed in pen and brown ink upper left: *Boy feeding
Pigeons in Trafalgar Squ. / Man in Underground.*

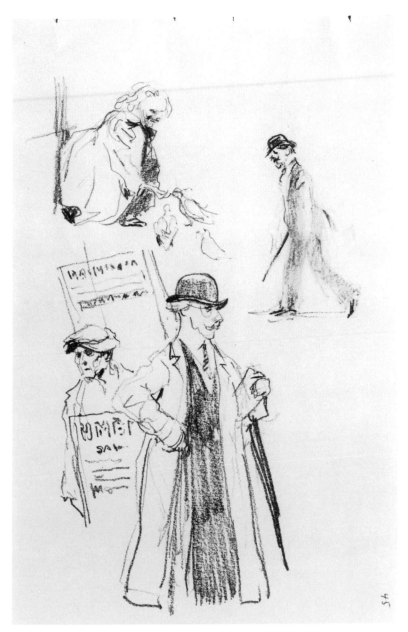

No. 26, 45r

45r. Sketches of Londoners. Pencil.

45v. Inscribed in pen and brown ink upper left: *London*.

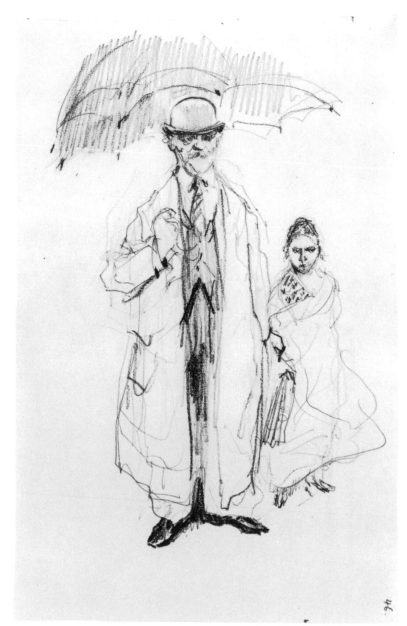

No. 26, 46r

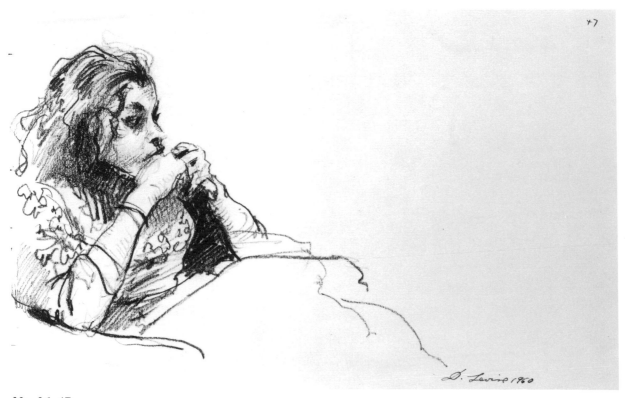

No. 26, 47r

46r. A man standing under an umbrella in London, with an Indian woman in the background. Pencil.

46v. Inscribed in pen and brown ink upper left: *London Man with Indian Girl in / background.*

Page removed between 46v and 47r.

47r. A young Indian woman watching television, London. Pencil. Signed and dated in pen and brown ink lower right: *D. Levine 1960.*

47v. Inscribed in pen and brown ink upper left: *Indian girl watching TV, London.*

No. 26, 48r

48r. A baby sitting on a colorful rug. Watercolor over pencil.

48v. Blank.

49r. Two women and a girl on the beach at Coney Island. Watercolor over pencil. Inscribed in pencil lower center: *The Matriarch* (erased); signed and dated in pencil lower right: *D. L. 1960*(?).

49v. Blank.

No. 26, 49r

Harvey Dinnerstein
Born Brooklyn, New York, 1928

Painter, illustrator, teacher, and author Harvey Dinnerstein studied with Moses Soyer from 1944 to 1946 and at the Art Students League in New York in 1946–47 before earning a certificate from the Tyler School of Art at Temple University in Philadelphia in 1950. In 1974 he was elected a National Academician. He teaches at the National Academy of Design and at the Art Students League. His work is represented in a number of private and public collections, including the National Museum of American Art, Washington, D.C.; the Whitney Museum of American Art, New York; and the Pennsylvania Academy of the Fine Arts, Philadelphia.

Working in oil and in pastel, directly from his subject as well as from memory, Dinnerstein paints in a realistic mode out-of-doors and in the studio, often on a large scale. He says he wants his paintings to "express ideas that are explicit in their reference to contemporary issues, yet invoke mythic images of times past."[1]

NOTE:
1. Quoted in Meredith-Owens 1973, p. 65.

LITERATURE: Meredith-Owens 1973; Dinnerstein 1978; Dinnerstein 1988; New York 1989.

27. Foliage Study, 1960 or earlier

1975.1.906
Charcoal and beige pastel on academy board washed with grayish brown. 25.3 x 32.1 cm. Signed in pencil lower right: *Dinnerstein.* Inscribed(?) in pencil at upper left of verso: *foliage study 1* (*1* in a circle); below that a stamp in black: eagle holding four arrows and a branch (stamp of Davis Galleries); annotated(?) in pencil below the stamp: *D-166*(?).

Dinnerstein used this study of foliage along the Hudson River for the upper left section of his 1960 oil painting *The Motorcycle Ride* (Fig. 27.1), in which he combined landscape studies drawn from nature with the formal portrait of a couple who posed on a motorcycle in his studio in Poughkeepsie, New York.[1] He likes working in pastel, he has said, because its "spontaneity and immediacy... make it a most useful tool for the artist searching for a direct response to contemporary life."[2]

NOTES:
1. Dinnerstein, letter to the author, 12 July 1986. See also New Brunswick (N.J.) 1982, pp. 16–17.
2. Dinnerstein 1988, p. 51.

PROVENANCE: [Davis Galleries, New York]; Robert Lehman, about 1960.

Fig. 27.1 Harvey Dinnerstein, *The Motorcycle Ride.* Oil on canvas, 1960. Collection of Lois and Harvey Dinnerstein

No. 27

CONCORDANCE
BIBLIOGRAPHY
INDEXES

Bibliography

Anderson, Ross
1990 "Charles Prendergast." In Clark, Mathews, and Owens 1990, pp. 85–93.

Andover (Mass.)
1938 *The Prendergasts: Retrospective Exhibition of the Work of Maurice and Charles Prendergast.* Exhibition, Addison Gallery of American Art, Phillips Academy, 24 September–6 November. Catalogue by Van Wyck Brooks.
1990 *George B. Luks: Bronx Park, May 8, 1904; Thirty-three Drawings of Animals in the Bronx Zoo.* Exhibition, Addison Gallery of American Art, Phillips Academy, 6 October–16 December. Facsimile of sketchbook with a preface by S[usan] F[axon] and J[ock] R[eynolds].

Bacon, Edwin M.
1898 *Walks and Rides in the Country Round About Boston.* Cambridge, Mass.

Bandini, Carlo
[1920] *Spoleto.* Bergamo.

Barry, James M.
1896 *My Lady Nicotine: A Study in Smoke.* Illustrated by Maurice Prendergast. Boston.

Basso, Hamilton
1946 "Profiles: A Glimpse of Heaven" [interview with Charles Prendergast]. Parts 1, 2. *New Yorker* 22 (27 July), pp. 24–28, 30; (3 August), pp. 28–32, 34, 36, 37.

Benesch, Otto
1973 *The Drawings of Rembrandt.* Vol. 2. Enlarged and edited by Eva Benesch. London.

Berman, Avis
1982 "Strolling Through the Park" *Eastern [Airlines] Review*, May, pp. 48–51.

Bolger, Doreen
1989 "Modern Mural Decoration: Prendergast and His Circle." In Williamstown (Mass.) 1988–89, pp. 52–63.

Boston
1960–61 *Maurice Prendergast, 1859–1924.* Exhibition, Museum of Fine Arts, Boston, 26 October–4 December; Wadsworth Atheneum, Hartford, 29 December–5 February; Whitney Museum of American Art, New York, 21 February–2 April; California Palace of the Legion of Honor, San Francisco, 22 April–3 June; Cleveland Museum of Art, 20 June–30 July. Catalogue by Hedley Howell Rhys and Peter A. Wick, 1960.

Boston–New Brunswick (N.J.)–Washington, D.C.
1968–69 *The Art of Charles Prendergast.* Exhibition, Museum of Fine Arts, Boston, 2 October–3 November; Rutgers University Art Gallery, New Brunswick, N.J., 17 November–22 December; Phillips Collection, Washington, D.C., 11 January–16 February. Catalogue by Richard J. Wattenmaker, 1968.

Brooklyn
1957 *Golden Years of American Drawings, 1905–1956.* Exhibition, Brooklyn Museum, 22 January–17 March. Catalogue by Una E. Johnson.

Brooks, Van Wyck
1938 "Anecdotes of Maurice Prendergast." *Magazine of Art* 31, no. 10 (October), pp. 564–69, 604. Reprinted from Andover (Mass.) 1938.

Brown, Milton W.
1963 *The Story of the Armory Show.* Greenwich, Conn. 2d ed., New York, 1988.
1990 "Maurice B. Prendergast." In Clark, Mathews, and Owens 1990, pp. 15–22.

Cambridge (Mass.)
1977 *Wash and Gouache: A Study of the Development of the Materials of Watercolor.* Exhibition, Fogg Art Museum, 12 May–22 June. Catalogue by Marjorie B. Cohn and Rachel Rosenfield.

Clark, Carol
1990 "Modern Women in Maurice Prendergast's Boston of the 1890s." In Clark, Mathews, and Owens 1990, pp. 23–33.

Clark, Carol, Nancy Mowll Mathews, and Gwendolyn Owens
1990 *Maurice Brazil Prendergast, Charles Prendergast: A Catalogue Raisonné.* Munich.

College Park (Md.)
1976–77 *Maurice Prendergast: Art of Impulse and Color.* Exhibition, University of Maryland Art Gallery, College Park, 1 September–6 October; University Art Museum, University of Texas, Austin, 17 October–21 November; Des Moines Art Center, Des Moines, Iowa, 1 December–2 January; Columbus Gallery of Fine Arts, Columbus, Ohio, 14 January–20 February; Herbert F. Johnson Museum of Art, Cornell University, Ithaca, N.Y., 1 March–15 April.

Catalogue by Eleanor Green, Ellen Glavin, and Jeffrey R. Hayes, 1976.

Cortissoz, Royal
1925 *Catalogue of the Etchings and Dry-Points of Childe Hassam, N.A.* New York.

Cuba, Stanley L.
1987 "George Luks (1866–1933)." In Wilkes-Barre 1987, pp. 7–48.

Derby, Carol
1990 "Charles Prendergast's Frames: Reuniting Design and Craftsmanship." In Clark, Mathews, and Owens 1990, pp. 95–105.

Dinnerstein, Harvey
1978 *Harvey Dinnerstein: Artist at Work.* New York.
1988 "Harvey Dinnerstein on Pastel." *American Artist* 52 (May), pp. 46–51.

du Bois, Guy Pène
1931 *William Glackens.* New York.

East Hampton (N.Y.)
1968 *Memorial Exhibition: James Preston, May Wilson Preston.* Exhibition, Guild Hall, 18 May–9 June. Catalogue essay by Ira Glackens.

Fine, Ruth E., ed.
1987 "James McNeill Whistler: A Reexamination." *Studies in the History of Art* 19. Washington, D.C.: National Gallery of Art.

Friends of the Public Garden and Common
1988 *The Public Garden, Boston.* Boston.

Gallatin, A. E.
1910 "The Art of William J. Glackens: A Note." *International Studio* 40, no. 159 (May), pp. LXVIII–LXXI.

Garland, Joseph E.
1978 *Boston's North Shore, Being an Account of Life Among the Noteworthy, Fashionable, Wealthy, Eccentric, and Ordinary, 1823–90.* Boston.
1981 *Boston's Gold Coast: The North Shore, 1890–1929.* Boston.

Gengarelly, W. Anthony
1989 "Maurice Prendergast's Applied Graphic Art." In Williamstown (Mass.) 1988–89, pp. 8–27.
1990 "Maurice Prendergast's Dancing Figures." Typescript.

Gerdts, William H.
1984 *American Impressionism.* New York.

Getscher, Robert H., and Paul G. Marks
1986 *James McNeill Whistler and John Singer Sargent: Two Annotated Bibliographies.* New York.

Glackens, Ira
1957 *William Glackens and the Ashcan Group: The Emergence of Realism in American Art.* New

York. Rev. ed. published as *William Glackens and The Eight: The Artists Who Freed American Art.* New York, 1983.

Glavin, Ellen M.
1982 "Maurice Prendergast: The Boston Experience." *Art and Antiques* 6 (July–August), pp. 64–71.

Greensburg (Pa.)–New York
1990 *James M. Preston: Pennsylvania Post-Impressionist.* Exhibition, Westmoreland Museum of Art, Greensburg, Pa., 24 March–29 April; Altman/Burke Fine Art, Inc., New York, 13 September–25 October. Catalogue essay by Richard J. Boyle.

Greenwich (Conn.)
1990 *On Home Ground: Elmer Livingston MacRae at the Holley House.* Exhibition, Bruce Museum, 16 September–11 November. Catalogue by Susan G. Larkin.

Hardie, Martin
1966–68 *Water-colour Painting in Britain.* 3 vols. London.

Henri, Robert
1923 *The Art Spirit.* Philadelphia.

Hitchings, Sinclair
1989 "The Prendergasts' Boston." In Williamstown (Mass.) 1988–89, pp. 44–51.

Homer, William Innes (with the assistance of Violet Organ)
1969 *Robert Henri and His Circle.* Ithaca. 2d ed., New York, 1988.

Joseph, Richard
1961 "The New Grand Tour." *Esquire* 55, no. 2 (February), pp. 53–60.

Jowell, Frances S.
1989 "The Rediscovery of Frans Hals." In *Frans Hals,* edited by Seymour Slive, pp. 61–86. Exhibition catalogue, Royal Academy of Arts. London.

Kasanof, Nina
1987 "George Luks, Artist/Reporter/Illustrator." In Wilkes-Barre 1987, pp. 91–100.

Kiehl, David W.
1987 *American Art Posters of the 1890s in The Metropolitan Museum of Art, Including the Leonard A. Lauder Collection.* New York.

Koke, Richard J., comp.
1982 *American Landscape and Genre Paintings in the New-York Historical Society.* 3 vols. Boston.

Krautheimer, Richard
1985 *The Rome of Alexander VII, 1655–1667.* Princeton.

Langdale, Cecily
1984 *Monotypes by Maurice Prendergast in the Terra Museum of American Art.* Chicago.

Levine, David
1963 *A Summer Sketchbook.* Foreword by Peter A.
 Wick. New York.
1974 *David Levine's Gallery.* New York.
1978 *The Arts of David Levine.* Foreword by Thomas
 S. Buechner. New York.

Lochnan, Katharine A.
1984 *The Etchings of James McNeill Whistler.* New
 Haven and London.

Loring, John
1979 "Van Day Truex: Late Dean of Twentieth-Century
 American Design." *Connoisseur* 202 (December),
 pp. 232–35.

MacInnes, Margaret F.
1969 "Whistler's Last Years: Spring 1901 – Algiers
 and Corsica." *Gazette des Beaux-Arts* 73 (May–
 June), pp. 323–42.

Madormo, Dominic
1990 "The 'Butterfly' Artist: Maurice Prendergast
 and His Critics." In Clark, Mathews, and Owens
 1990, pp. 59–69.

Mathews, Nancy Mowll
1990 "Maurice Prendergast and the Influence of
 European Modernism." In Clark, Mathews, and
 Owens 1990, pp. 35–45.

Meredith-Owens, Heather
1973 "An Interview with Harvey Dinnerstein."
 American Artist 37 (May), pp. 26–33, 65, 70–71.

Milroy, Elizabeth
1991 "Modernist Ritual and the Politics of Display"
 and "The Legacy of The Eight: Independent
 Exhibitions and the 'National Salon.'" In Mil-
 waukee 1991-92, pp. 21–59, 87–102.

Milwaukee
1991–92 *Painters of a New Century: The Eight and
 American Art.* Exhibition, Milwaukee Art
 Museum, 6 September–3 November; Denver
 Art Museum, 7 December–16 February; National
 Gallery of Canada, Ottawa, 16 April–7 June;
 Brooklyn Museum, 26 June– 21 September.
 Catalogue by Elizabeth Milroy, with an essay by
 Gwendolyn Owens, 1991.

Nash, Ernest
1968 *Pictorial Dictionary of Ancient Rome.* 2 vols.
 Rev. ed. New York.

New Brunswick (N.J.)
1967 *The Art of William Glackens.* Exhibition, Rutgers
 University Art Gallery, 10 January–10 February.
 Catalogue by Richard J. Wattenmaker. Published
 as *University Art Gallery Bulletin* 1, no. 1 (1967).
1982 *Realism and Realities: The Other Side of
 American Painting, 1940–1960.* Exhibition,
 Rutgers University Art Gallery, 17 January–26

March. Catalogue by Greta Berman and Jeffrey
Wechsler, 1981.

Newton, Norman T.
1971 *Design on the Land: The Development of Land-
 scape Architecture.* Cambridge, Mass.

New York
1926 *Exhibition of Carved-Painted Decorative Wood
 Panels by Elmer L. MacRae.* Exhibition, Montross
 Gallery, 15–27 March. Checklist.
1950 *Maurice Prendergast: Retrospective Exhibition
 of Paintings, Water Colors and Monotypes.*
 Exhibition, Kraushaar Galleries, 3–28 January.
 Checklist.
1959 *Elmer L. MacRae (1875–1955): Forgotten Artist
 of the 1913 Armory Show.* Exhibition, Milch
 Galleries, 23 March–18 April. Brochure with
 essay by Anya Seton.
1960 *Elmer Livingston MacRae (1875–1955): Re-
 discovered Artist of the 1913 Armory Show and
 a Founder of "The Pastellists."* Exhibition, Milch
 Galleries, 18 January–6 February. Checklist.
1964a *Elmer Livingston MacRae: A Selection of Pastels
 and Watercolors.* Exhibition, Davis Galleries,
 31 March–25 April. Checklist.
1964b *James Preston.* Exhibition, Graham Gallery,
 17 November–12 December. Catalogue intro-
 duction by Ira Glackens.
1966–67 *Two Hundred Years of Watercolor Painting in
 America: An Exhibition Commemorating the
 Centennial of the American Watercolor Society.*
 Exhibition, The Metropolitan Museum of Art,
 8 December–29 January. Catalogue with fore-
 word by Stuart P. Feld, 1966.
1976–77 *Maurice Prendergast's Large Boston Public
 Garden Sketchbook.* Exhibition, The Metro-
 politan Museum of Art, 18 December–1 May.
1977 *Drawings by William Glackens.* Exhibition,
 Kraushaar Galleries, 8–26 February. Brochure.
1979 *The Monotypes of Maurice Prendergast: A Loan
 Exhibition.* Exhibition, Davis and Long Com-
 pany, 4–28 April. Catalogue by Cecily Langdale.
1982 *Maurice Prendergast's "Large Boston Public
 Garden Sketchbook" from the Robert Lehman
 Collection.* Exhibition, The Metropolitan
 Museum of Art, 12 May–6 September. Checklist.
1985–86 *One Hundred Master Drawings from the Robert
 Lehman Collection.* Exhibition, The Metropolitan
 Museum of Art, 1 October–15 January.
1987 *Maurice Prendergast: The Large Boston Public
 Gardens Sketchbook.* Exhibition, Lehman College
 Art Gallery, Bronx, 5 November–12 December.
 Brochure with essay by Eleanor Green.
1988 *Images of Women: Drawings from Five Centuries
 in the Robert Lehman Collection.* Exhibition,
 The Metropolitan Museum of Art, 3 May–10 July.
1989 *Harvey Dinnerstein: Recent Work.* Exhibition,
 Sid Deutsch Gallery, 22 April–17 May.

1989–90 *American Pastels in The Metropolitan Museum of Art.* Exhibition, The Metropolitan Museum of Art, 17 October–14 January. Catalogue by Doreen Bolger et al., 1989.

1990–91 *Maurice Prendergast.* Exhibition, Whitney Museum of American Art, New York, 31 May–2 September; Williams College Museum of Art, Williamstown, Mass., 6 October–16 December; Los Angeles County Museum of Art, 21 February–22 April; Phillips Collection, Washington, D.C., 18 May–25 August. Catalogue by Nancy Mowll Mathews, 1990.

Oklahoma City–Memphis

1981–82 *Prendergast: The Large Boston Public Garden Sketchbook.* Exhibition, Oklahoma Museum of Art, Oklahoma City, 18 October–22 November; Dixon Gallery and Gardens, Memphis, 14 February–28 March. Catalogue by George Szabo, 1981. Memphis venue not listed in catalogue.

O'Toole, Judith H.

1987 "George Luks: An American Artist." In Wilkes-Barre 1987, pp. 51–89.

Owens, Gwendolyn

1990 "Maurice Prendergast Among His Patrons." In Clark, Mathews, and Owens 1990, pp. 47–58.

1991 "Art and Commerce: William Macbeth, The Eight and the Popularization of American Art." In Milwaukee 1991–92, pp. 61–86.

Oxford

1987–88 *Caricatures and Watercolours by David Levine.* Exhibition, Ashmolean Museum, 27 October–3 January. Catalogue by Nicholas Penny, 1987.

Parkhurst, Charles

1990 "Color and Coloring in Maurice Prendergast's Sketchbooks." In Clark, Mathews, and Owens 1990, pp. 71–84.

Pennell, E. R., and J. Pennell.

1908 *The Life of James McNeill Whistler.* 2 vols. London and Philadelphia.

Perlman, Bennard B.

1962 *The Immortal Eight: American Painting from Eakins to the Armory Show (1870–1913).* New York. Rev. ed. published as *Painters of the Ashcan School: The Immortal Eight.* New York, 1988.

1991 *Robert Henri: His Life and Art.* New York.

Pilgrim, Dianne H.

1978 "The Revival of Pastels in Nineteenth-Century America: The Society of Painters in Pastel." *American Art Journal* 10, no. 2 (November), pp. 43–62.

Pitz, Henry Clarence

1971 "Seymour Remenick: A Quiet Voice." *American Artist* 35 (August), pp. 44–49, 65–67.

Prendergast, Charles

1909 "Revival of Wood-Carving." *House Beautiful* 27 (August), p. 70.

Prendergast, Maurice

1960 *Maurice Prendergast: Water-Color Sketchbook 1899.* Facsimile with critical note by Peter A. Wick. Boston and Cambridge, Mass.

1987 *Maurice Prendergast: Large Boston Public Garden Sketchbook.* Facsimile with introduction by George Szabo. New York.

Shelley, Marjorie

1989 "American Pastels of the Late Nineteenth and Early Twentieth Centuries: Materials and Techniques." In New York 1989–90, pp. 33–45.

Shinn, Everett

1945 "William Glackens as an Illustrator." *American Artist* 9 (November), pp. 22–27, 37.

1966 "George Luks." *Journal of the Archives of American Art* 6 (April), pp. 1–12.

Singer, Esther Forman

1972 "The Figure Paintings of Stuart Kaufman." *American Artist* 36 (April), pp. 45–49, 83.

Sloan, John

1965 *John Sloan's New York Scene: From the Diaries, Notes, and Correspondence, 1906–1913.* Edited by Bruce St. John, with an introduction by Helen Farr Sloan. New York.

Smith, Jacob Getlar

1956 "The Watercolors of Maurice Prendergast." *American Artist* 20 (February), pp. 52–57.

Szabo, George

1975 *The Robert Lehman Collection: A Guide.* New York.

Utica

1973 *George Luks, 1866–1933.* Exhibition, Munson-Williams-Proctor Institute, 1 April–20 May. Catalogue by Joseph S. Trovato.

Utica–New York

1963 *1913 Armory Show: Fiftieth Anniversary Exhibition, 1963.* Exhibition sponsored by the Henry Street Settlement, New York: Munson-Williams-Proctor Institute, Utica, 17 February–31 March; Armory of the Sixty-ninth Regiment, New York, 6–28 April. Catalogue essay by Milton Brown.

Washington, D.C.

1972 *Drawings by William Glackens, 1870–1938.* Exhibition, National Collection of Fine Arts, 25 February–30 April. Catalogue by Janet A. Flint.

1976 *Artists, Authors, and Others: Drawings by David Levine.* Exhibition, Hirshhorn Museum and Sculpture Garden, 4 March–6 June. Catalogue introduction by Daniel P. Moynihan.

1980 *The Watercolors of David Levine.* Exhibition, Phillips Collection, 14 June–20 July. Catalogue introduction by Ian McKibbin White.

1984 *James McNeill Whistler at the Freer Gallery of Art.* Exhibition, Freer Gallery of Art, 11 May– 5 November. Catalogue by David Park Curry.

Wattenmaker, Richard J.

1972 "The Art of William Glackens." Ph.D. dissertation, New York University.

1988 "William Glackens's Beach Scenes at Bellport." *Smithsonian Studies in American Art* 2, no. 2 (Spring), pp. 75–94.

Wilkes-Barre

1987 *George Luks: An American Artist.* Exhibition, Sordoni Art Gallery, Wilkes College, 3 May–14 June. Catalogue essays by Stanley L. Cuba, Nina Kasanof, and Judith O'Toole.

Williamstown (Mass.)

1985 *Maurice Prendergast: Sketchbooks.* Exhibition, Williams College Museum of Art, 4 April–26 May. Brochure.

1988–89 *The Prendergasts and the Arts and Crafts Movement: The Art of American Decoration and Design, 1890–1920.* Exhibition, Williams College Museum of Art, 8 October–8 January. Catalogue by W. Anthony Gengarelly and Carol Derby, with additional essays by Doreen Bolger, Joseph T. Butler, and Sinclair Hitchings, 1989.

1989–90 *Kindred Spirits: Maurice and Charles Prendergast.* Exhibition, Williams College Museum of Art, 2 December–18 March. Brochure.

Wilmington

1984 *Robert Henri: Painter.* Exhibition, Delaware Art Museum, 4 May–24 June. Catalogue by Helen Farr Sloan and Bennard B. Perlman.

1985 *William Glackens: Illustrator in New York, 1897–1919.* Exhibition, Delaware Art Museum, 15 March–28 April. Catalogue by Nancy E. Allyn.

Young, Andrew McLaren, Margaret MacDonald, and Robin Spencer (with the assistance of Hamish Miles)

1980 *The Paintings of James McNeill Whistler.* 2 vols. New Haven and London.

Zaitzevsky, Cynthia

1982 *Frederick Law Olmsted and the Boston Park System.* Cambridge, Mass.

Index of Artists

References are to catalogue numbers.

Dinnerstein, Harvey, *Foliage Study*, 27

Glackens, William J., *Edith Glackens Walking*, 14; *Two Women Walking*, 15

Hammer, Alfred, *Field with Figure*, 24

Henri, Marjorie Organ, *Sketchbook*, 20

Henri, Robert, *Sketchbook: Spain*, 10

Kaufman, Stuart Martin, *Nude*, 25

Levine, David, *Sketchbook: Paris, Amsterdam, The Hague, and London*, 26

Luks, George Benjamin, *Artist with Portfolio*, 11; *Sketches of Children*, 12; *Three Figures*, 13

MacRae, Elmer Livingston, *Schooner at Dock*, 19

Prendergast, Charles, *Allegory*, 9

Prendergast, Maurice Brazil, *Large Boston Public Garden Sketchbook*, 4; *Late Afternoon, Summer*, 6; *Low Tide, Beachmont*, 7; *Paris Sketchbook*, 3; *Standing Nude Woman and Studies of a Hand, a Leg, and Feet*, 8; *Swings, Revere Beach*, 5

Preston, James Moore, *East Hampton House, Autumn*, 18; *France*, 16; *The Meadow*, 17

Remenick, Seymour, *Still Life, Interior*, 23

Truex, Van Day, *Rome III*, 21; *View of Spoleto*, 22

Unidentified artist, *Farm Scene*, 2

Whistler, James Abbott McNeill, *Museum Interior(?) with a Man Seated*, 1

Index of Previous Owners

References are to catalogue numbers.

Birnie Philip, Rosalind, 1

Carstairs Gallery, 21, 22

Childs Gallery, 2

Colnaghi, P. and D., and Co., 1

Davis Galleries, 9, 11, 12, 13, 14, 15, 16, 17, 18, 19, 23, 25, 26, 27

Henri, Marjorie Organ, 10

Hirschl and Adler Galleries, 10, 20

Katz, Joseph, 6

Kraushaar Galleries, 6

Le Clair, John C., 10, 20

Lock Galleries, 6

Matthews, Alister, 1

Organ, Violet, 10, 20

Prendergast, Charles, 3, 4, 5, 6, 7, 8

Prendergast, Eugénie, 3, 4, 5, 6, 7, 8, 9

Preston, James, 14

Spark, Victor, 6

Index

Drawings in the Robert Lehman Collection are indicated by Nos. Comparative illustrations are indicated by Figs. All other references are to page numbers.

Académie Julian, Paris, 6, 7, 142
Allison, George K., collection of,
 Prendergast, Maurice: *In the Bois*, 7;
 Fig. 3.2
American Water Color Society, New York,
 168
Amsterdam
 Amstel River, 217; Figs. 26.5, 26.6
 Diaconie Oude Mannen- en
 Vrouwenhuis, 217; Fig. 26.6
 Magere Brug, over Amstel River, 217;
 Fig. 26.5
 Montelbaanstoren, 215; Fig. 26.4
 Nieuwe Kerkstraat, 217; Fig. 26.5
 Oudeschans canal, 215, Fig. 26.4
 Rijksmuseum, Rembrandt: *Self-portrait
 as the Apostle Paul*, 212; Fig. 26.2
 Sint Antoniesluis lock, 215
 Six, Jan, Collection, Rembrandt: *Jan
 Six*, 207
Andover (Massachusetts)
 Addison Gallery of American Art, Phillips
 Academy, Luks: *Spielers, The*, 164;
 Prendergast, Charles: *Hill Town*,
 140; Fig. 9.1; Prendergast, Maurice:
 Sketches in Paris, 7, 37; Fig. 3.5
Andriessen, Mari, 220
 work by: *Docker, The*, 220
Anshutz, Thomas, 142
Armory Show (International Exhibition of
 Modern Art), New York
 artists exhibiting at, 6, 143, 164, 165,
 168, 172, 178
 organization of, 168, 176, 177
Arts and Crafts Movement, 140
Art Spirit, The (Henri, Robert), 143
Art Students League, New York, 143, 145,
 176, 196, 240
Asiego, Felix, 144, 145
Association of American Painters and
 Sculptors, 176

Bacon, Edwin M., 132
Barnes, Albert C., 6, 140, 168
Barrie, James M., 60, 81, 91, 106, 112,
 131
Baudelaire, Charles, 2
Beachmont, near Boston, 137
Birnie Philip, Ronald, 3

Birnie Philip, Rosalind, 3, 4
Bliss, Lillie, 6, 140
Boston
 beaches near: Crescent Beach, 82; Revere
 Beach, 62, 69, 82, 132, 134; Stony
 Beach, 137
 Boston Common, 69, 94
 Boston Public Garden, 61, 69, 94, 97,
 106; Figs. 4.1, 4.2, 4.13
 Childs Gallery, 5
 Franklin Park, 62, 132
 Museum of Fine Arts, Luks: *Wrestlers,
 The*, 164; Prendergast, Maurice:
 *Boston Watercolor Sketchbook (1899
 Sketchbook)*, 62, 78, 82, 86, 99,
 121, 134, 136; Figs. 4.5, 4.9, 4.10,
 4.14, 4.21, 5.2; sketchbooks, 8
 South Boston Pier, 132
 Vose Galleries, 94
Boston Globe, 176
Buffalo
 Albright-Knox Art Gallery, Prendergast,
 Maurice: *Along the Boulevard*, 7,
 31; Fig. 3.4
Bush-Holley House (formerly Holley
 House), Cos Cob (Connecticut), 176

Café de la Paix, Paris, 201
Café Francis, New York, 164, 172
Carmona, Signora, 144
Carrig-Rohane, Boston, 140
Carstairs Gallery, New York, 193
Cassatt, Mary, 176
Chase, William Merritt, 94, 177
Chicago
 Art Institute of Chicago, Glackens: *Chez
 Mouquin*, 168
 Terra Museum of American Art,
 Prendergast, Maurice: *Circus Scene
 with Horse*, 110; *Crescent Beach*,
 60–61, 82; Fig. 4.8; *Nouveau
 Cirque*, 110; *Street Scene*, 61, 123;
 Fig. 4.22; *Tuileries Gardens, Paris,
 The*, 45, 81; Fig. 4.6
Childs, Charles, 5
Childs Gallery, Boston, 5
Cleveland
 Cleveland Institute of Art, 195
 Cleveland Museum of Art, Prendergast,

Maurice: *Bareback Rider*, 61, 110;
 Fig. 4.16; sketchbooks, 8
Colarossi's studio, Paris, 6, 7, 140, 172
Colnaghi, P. and D., and Co., London, 4
Columbia bicycle poster competition, 69,
 110
 drawings for (Prendergast, Maurice), 60,
 69, 110, 124
Comstock, Anthony, 145
Coney Island, New York, 197, 238
Connah, Douglas John, 143
Conner, Margaret L., collection of,
 Prendergast, Maurice: *Two Women in
 a Park*, 7, 59; Fig. 3.10
Co-operative Mural Workshops, New York,
 6
Cos Cob (Connecticut)
 Holley House (now called Bush-Holley
 House), 176
Courbet, Gustave, 2
Cozad, John Jackson, 142; *see also* Lee,
 Richard Henry
Cozad, Robert Henry, *see* Henri, Robert
Craige, Linda, *see* Henri, Linda Craige

David Levine's Gallery, 212
 illustration from, 212; Fig. 26.3
Davies, Arthur B., 6, 176
Davis, Leroy (Roy), 194, 197, 198
Davis Galleries, New York
 exhibitions at, 177, 197
 works sold through, 142, 165, 166, 167,
 170, 172, 174, 175, 177, 194, 196,
 197, 198, 240
Degas, Edgar, 196
Detroit Institute of Arts, Whistler: *Nocturne
 in Black and Gold: The Falling Rocket*,
 2
Dewing, Thomas, 99
Dignam, Michael, 7
Dimock, Edith, *see* Glackens, Edith Dimock
Dinnerstein, Harvey, 240–41
 works by: *Foliage Study*, 240; No. 27;
 Motorcycle Ride, The, 240; Fig.
 27.1
Dinnerstein, Lois and Harvey, collection
 of, Dinnerstein, Harvey: *Motorcycle
 Ride, The*, 240; Fig. 27.1
Dirks, Helen Walsh, 178

Dirks, John, 178
Dirks, Rudolf, 178
Düsseldorf
 Kunstakademie Düsseldorf, 164

Eakins, Thomas, 142
Ecole des Beaux-Arts, Paris, 142
Eight, The, 6, 140, 142, 164, 168, 172,
 176, 178, 197
Eliot, Charles, 132
Escorial, near Madrid, 144
Esquire magazine, 197, 231
 illustration from (Levine), 231; Fig. 26.7
Exhibition of Independent Artists, New
 York, 142–43, 168

Fauves, 6
Felker, Clay, 197
Folsom Galleries, New York, 176
Fontana, Carlo, 193
Forain, Jean-Louis, 168
French, Marcia Fuller, collection of,
 Prendergast, Maurice: *Flying Swings,
 The*, 134; Fig. 5.1; *Paris Boulevard in
 the Rain*, 7, 57; Fig. 3.8
Friendly Sons of Saint Bacchus, 164

Gaylor, Samuel Wood, 6
Gibson, Charles Dana, 99
Gibson girls, 99
Glackens, Edith Dimock, 144, 168, 172
 drawings of(?) (Glackens, William), 168,
 170; Nos. 14, 15
Glackens, Ira, 170
Glackens, William, 6, 140, 142, 144, 168–71,
 172, 176
 works by: *Chez Mouquin*, 168; *Edith
 Glackens Walking*, 168, 170; No.
 14; *Green Car, The*, 168; *Shoppers,
 The*, 168; *Sketches*, 170; Fig. 14.1;
 Two Women Walking, 170; No. 15
Gordillo Alvarez de Sotomayor, Clemente,
 144, 161
Goya y Lucientes, Francisco José de, 144,
 149, 164
 works by: *Caprichos, Los*, 144; *Desastres
 de la guerra, Los*, 144; *Naked Maja*,
 145, 152; *Proverbios, Los*, 144
Greco, El (Doménikos Theotokópoulos), 144
Green, J. Barcham, and Son, Hayle Mill,
 Maidstone, England, 137
Greenwich (Connecticut)
 Historical Society of the Town of
 Greenwich, 176, 177
Greenwich Time newspaper, 176
Gussman, Mr. and Mrs. Herbert, collection
 of, Prendergast, Maurice: *Two Girls
 on a Bridge*, 7, 22; Fig. 3.3

Hals, Frans, 142, 164, 167
Hambidge, Jay, 143
Hammer, Alfred, 195
 work by: *Field with Figure*, 195; No. 24
Hardy, Thomas, 64
Harper's New Monthly Magazine, 64
Hartford (Connecticut)
 Hartford Art School, University of
 Hartford, 195
 Wadsworth Atheneum, Prendergast,
 Maurice: sketchbook, 8
Hassam, Childe, 175
 work by: *Lion Gardiner House,
 Easthampton*, 175
Hatfield House, Hertfordshire, 197, 231
Hearst, William Randolph, 164
Henri, Linda Craige, 143, 172
Henri, Marjorie Organ, 143, 145, 178–91;
 Fig. 20.1
 work by: *Sketchbook*, 145, 178–91;
 No. 20
Henri, Robert Earle (Robert Henry Cozad),
 142–63; Fig. 10.1
 as artistic leader and teacher, 142–43,
 144, 164, 168, 178
 artistic philosophy of, 143, 144, 145, 166
 art organizations and, 142, 176
 caricatures by, 145, 149, 150, 157, 158, 162
 The Eight and, 6, 142, 164, 168, 176
 in Europe, 142, 143–45, 162, 168, 172
 exhibitions of the work of, 142–43, 144,
 176, 178
 exhibitions organized by, 142–43, 164
 friendships of, 142, 144, 162, 172
 influences on, 142, 143, 144, 149, 152
 in New York, 142–43, 145, 172
 in Philadelphia, 142, 168, 172
 portraits by, 144, 161
 self-portraits by, 145, 149, 150
 in Spain, 143–45 (drawings from,
 146–63)
 work by: *Sketchbook: Spain*, 143–63;
 No. 10
Hirschl and Adler Galleries, New York,
 145, 178
Historical Society of the Town of
 Greenwich, 176, 177
Hofmann, Hans, 197
Hofmann, Hans, School, New York and
 Provincetown, 194
"Hogan's Alley" comic strip, 164
Holley, Emma Constant, *see* MacRae,
 Emma Constant Holley
Holley House (now called Bush-Holley
 House), Cos Cob, Connecticut, 176
Holston, George, 5
 work by: *Dyckman's Creek, Kingsbridge,
 New York City*, 5; Fig. 2.1
Horn, C. C., 166
House Beautiful magazine, 140
Howald, Ferdinand, 6

Impressionists, 99
International Exhibition of Modern Art,
 New York, *see* Armory Show, New
 York
International Studio magazine, 169

Jacquier, Henry, 144, 145
Jude the Obscure (Hardy), 64

Katz, Joseph, 136
Kaufman, Phyllis, 196
Kaufman, Stuart Martin, 196
 work by: *Nude*, 196; No. 25
King's How to See Boston, 67
Knight, Joseph, Company, Boston, 60, 69,
 81, 91, 106, 112, 131
Kraushaar Galleries, New York, 136, 164
Kuhn, Walt, 6, 176
Kunstakademie Düsseldorf, 164

Landau, Mr. and Mrs. Jon, collection of,
 Prendergast, Charles and Maurice:
 Spirit of the Hunt, The, 140
Lawson, Ernest, 6, 168
Le Clair, Janet J., 178, 179
Le Clair, John C., 145, 178
Lee, Mrs. Richard Henry, 142, 145
Lee, Richard Henry, 142, 145
Levine, David, 197–239
 works by: *Lion on the Gate of Hatfield
 House*, 197, 231; Fig. 26.7;
 Rembrandt, 212; Fig. 26.3;
 *Sketchbook: Paris, Amsterdam, The
 Hague, and London*, 197–239; No.
 26; *Summer Sketchbook*, 197
Leyland, Frederick R., 2
Lock Galleries, New York, 136
London
 Colnaghi, P. and D., and Co., 4
 Leicester Square, 233
 National Gallery, 229
 Piccadilly Circus, 225, 226
 Royal Academy of Arts, 2
 Trafalgar Square, 234
 Whitechapel, Queen's Life Guard, 226
Long, Cornelia and Meredith, collection
 of, Prendergast, Maurice: *Old
 Shipyard, The*, 60, 67; Fig. 4.4
Luks, George Benjamin, 6, 142, 164–67,
 168, 172
 works by: *Artist with Portfolio*, 164–65,
 166, 167; No. 11; *Sketches of
 Children*, 165, 166, 167; No. 12;
 Spielers, The, 164; *Three Figures
 Walking*, 165, 166, 167; No. 13;
 Wrestlers, The, 164

Macbeth, William, 6, 142, 168, 176
Macbeth Gallery, New York, 6, 142, 164, 168, 176, 178
McCarthy, Dan, 178
McClure's Magazine, 168
MacDowell Club, New York, 143
MacRae, Elmer Livingston, 176–77
 works by: *Boatyard, Cos Cob, The*, 177; *Boston Waterfront*, 177; *MacRae Twins, The*, 177; *Mill Bridge from the Bush-Holley House*, 177; *New Bedford*, 177; *New Bedford Harbor*, 177; *New York Waterfront*, 177; *Sailboat and Shore*, 177; *Sailing Boat at Wharf, Cos Cob*, 177; *Schooner at Dock*, 176–77; No. 19; *Schooner in the Ice, View from the Bush-Holley House*, 176–77; *Shipyard, The*, 177; *Wharf, The*, 177; *Wharf, Connecticut, The*, 177
MacRae, Emma Constant Holley, 176
Madrid
 Prado, 144, 145, 152, 162
 Puerta del Sol square, 162
Mallarmé, Stéphane, 2
Manet, Édouard, 168, 212
Maratta, Hardesty, 143
Maria's, New York, 164
Matisse, Henri, 168
Matthews, Alister, 4
Milch Galleries, New York, 176, 177
Modern School of the Ferrer Center, New York, 143
Monté, Louis Gaspard, 144
Montesquiou-Fezensac, Robert de, 2
Montross Gallery, New York, 176
Moreno, Milagros (La Reina Mora), 144
Mouquin's, New York, 164, 172
Munch, Edvard, 91
Murillo, Bartolomé Esteban, 145, 152
Murphy, Hermann Dudley, 140
My Lady Nicotine: A Study in Smoke (Barrie), 60
 illustrations for (Prendergast, Maurice), 60, 81, 91, 106, 112, 119, 131; Figs. 4.7, 4.11, 4.15, 4.18, 4.24

Nabis, 7
Nahant, near Boston, 134
National Academy of Design, New York, 140, 142, 164, 168, 194, 197, 240
National Arts Club, New York, 164
New York
 Art Students League, 143, 145, 176, 196, 240
 Bronx Zoo, 165
 Café Francis, 164, 172
 Carstairs Gallery, 193
 Central Park, 94
 Central Park Zoo, 140

Coney Island, 197, 238
Davis Galleries, exhibitions at, 177, 197; works sold through, 142, 165, 166, 167, 170, 172, 174, 175, 177, 194, 196, 197, 198, 240
Folsom Galleries, 176
Hirschl and Adler Galleries, 145, 178
Hofmann, Hans, School, 194
Kraushaar Galleries, 136, 164
Lock Galleries, 136
Macbeth Gallery, 6, 142, 164, 168, 176, 178
MacDowell Club, 143
Maria's, 164
Metropolitan Museum of Art, Glackens: *Green Car, The*, 168; Prendergast, Maurice: *Excursionists, Nahant*, 136; Fig. 6.1
Milch Galleries, 176, 177
Modern School of the Ferrer Center, 143
Montross Gallery, 176
Mouquin's, 164, 172
National Academy of Design, 140, 142, 164, 168, 194, 197, 240
National Arts Club, 164
New-York Historical Society, Holston: *Dyckman's Creek, Kingsbridge, New York City*, 5; Fig. 2.1
New York School of Art, 143
Parsons School of Design, 192
Pratt Institute, 196
Prospect Park, 94
Sherwood Building, 172
Sotheby's, 177
Spanierman Gallery, Prendergast, Maurice: sketchbook, 8
Whitney Museum of American Art, 240
New Yorker magazine, 63
New York Journal, 164, 178
New York Review of Books, 197, 212
 illustration in (Levine), 212; Fig. 26.3
New York School of Art, 143
New York Times, 172
New York World, 164, 178
Niles, Helen, 144, 162
Norfolk (Virginia)
 Chrysler Museum, Glackens: *Shoppers, The*, 168
North, J. W., 137

Old Watercolour Paper and Arts Company, Ltd., London, 137
Organ, Marjorie, *see* Henri, Marjorie Organ
Organ, Violet, 145, 178
Outcault, Richard Felton, 164

Pach, Walter, 144
Paris
 Académie Julian, 6, 7, 142
 Café de la Paix, 201

Champs-Elysées, 203, 212
Colarossi's studio, 6, 7, 140, 172
Ecole des Beaux-Arts, 142
Eiffel Tower, 207
Musée du Louvre, 208; Poussin: *Triumph of Flora, The*, 208; Fig. 26.1; Whistler: *Arrangement in Gray and Black: Portrait of the Artist's Mother*, 2
Notre Dame, 197, 207, 212
Pont Neuf, 7, 24, 27
Tuileries Gardens, 94
Parsons School of Design, New York, 192
Pastellists, 176
Pennell, Elizabeth, 4
Pennell, Joseph, 4
Philadelphia
 Pennsylvania Academy of the Fine Arts, 142, 164, 168, 172, 194, 240
 Philadelphia Museum of Art, 194
 Philadelphia School of Design for Women, 142
 Tyler School of Art, Temple University, 194, 197, 240
Philadelphia Evening Bulletin, 164
Philadelphia Press, 164
Phillips, Duncan, 6
Pines, Ned L., estate of, Prendergast, Maurice: *Porte Saint Denis, La*, 7
Pope, Louise, 144, 162
Pope Manufacturing Company, Hartford, Connecticut, 69
Post-Impressionists, 6
Poussin, Nicolas, 197, 208
 work by: *Triumph of Flora, The*, 208; Fig. 26.1
Pratt Institute, New York, 196
Prendergast, Charles, 6, 8, 117, 140–42
 artistic development of, 140
 art organizations and, 140
 collaborations with Maurice Prendergast, 140
 drawings by Maurice Prendergast formerly owned by, 8, 60, 61, 63, 134, 136, 138, 139
 The Eight and, 140
 in England, 6
 exhibitions of the work of, 140
 fire in the studio of, 62–63
 frames designed and produced by, 6, 140
 friendship with Glackens, 140, 168
 in Italy, 140
 in New York, 6, 140
 panels carved and painted by, 140
 in Paris, 6
 relationship with Maurice Prendergast, 8, 140
 sketchbooks by Maurice Prendergast annotated by, 7, 60, 62, 94, 106, 132, 134
 sketchbooks of, 140, 142
 works by: *Allegory*, 140, 142; No. 9;

Prendergast, Charles (*continued*)
 Beach Scene with Prancing Goats,
 142; Fig. 9.2; *Hill Town*, 140; Fig.
 9.1; *Spirit of the Hunt, The* (with
 Maurice Prendergast), 140
Prendergast, Eugénie, 7, 63, 140
 drawing by Charles Prendergast formerly
 owned by, 142
 drawing by Maurice Prendergast owned
 by: *White Horse and Circus Rider,
 The*, 61, 110; Fig. 4.17
 drawings by Maurice Prendergast
 formerly owned by, 8, 60, 61, 62,
 63, 134, 136, 137, 138, 139
Prendergast, Lucy, 6
Prendergast, Maurice Brazil, 6–139
 abstract elements in the work of, 72,
 112, 134, 136
 artistic development of, 6, 7, 134, 139,
 140
 in Boston, 6, 7, 8, 60, 61–62, 67, 91, 94,
 110, 117, 132, 134
 collaborations with Charles Prendergast,
 140
 as commercial artist, 6, 8, 60, 62, 69, 81,
 91, 106, 110, 112, 119, 124, 131
 deafness of, 6, 136
 death of, 140
 decorative panels designed by, 6
 The Eight and, 6
 in England, 6
 exhibitions of the work of, 6, 60, 132;
 posthumous, 60, 61, 62
 experimental quality of the work of, 6,
 136, 137
 in France, 6, 7, 45, 62, 64, 69, 86, 94,
 106, 132 .
 friendship with Glackens, 168
 influence of, 168
 influences on, 6, 7, 91, 94, 99, 140
 in Italy, 6, 62, 94, 132, 134, 140
 monotypes by, 6, 60–61, 67, 78, 94, 110,
 123
 in New York, 6, 94, 140
 oil paintings by, 6, 7, 37, 139
 patrons of, 94, 132
 posthumous titling of the work of, 137
 sketchbooks of, 7, 8, 63, 138; annotations
 by Charles Prendergast in, 7, 60,
 62, 94, 106, 132, 134; condition of,
 60, 62–63; conservation treatment
 of, 117, 118; Figs. 4.19, 4.20; designs
 for posters in, 60, 62; ideas for
 commercial work in, 60, 62, 78, 81,
 106, 112, 124, 128; lettering used on
 the drawings in, 67, 69, 86, 91, 112;
 nonpromotional elements of, 60;
 numbering of, 7, 60; page of financial
 transactions in, 117; portraits in,
 86, 114; studies for monotypes in,
 60–61, 67, 82, 94, 97, 110, 123;

studies for watercolors and paintings
 in, 7, 22, 31, 37, 53, 55, 57, 59,
 60–61, 82, 86, 99, 110
style of, 6, 62, 69, 72, 78, 81, 82, 112,
 114, 117, 119, 123, 124, 126, 131,
 134, 136, 137, 139
subjects and motifs of, 6, 7, 60, 61–62,
 69, 78, 82, 86, 94, 102, 106, 110,
 131, 132, 134, 137, 138–39
travels of, with Charles Prendergast, 6,
 140
watercolors by, 6, 7, 60, 78, 94, 99, 132,
 134, 140
working methods of, 6, 7, 8, 60, 67, 78,
 82, 86, 97, 99, 102, 112, 114, 119,
 121, 124, 126, 131, 134, 136
works by: *Afternoon*, 61, 123; Fig. 4.23;
 Afternoon in the Park, 7, 59;
 Fig. 3.9; *Along the Boulevard*, 7, 31;
 Fig. 3.4; *At a Fountain in the Public
 Garden (Frog Pond)*, 61, 94, 97;
 Fig. 4.12; *Bareback Rider*, 61, 110;
 Fig. 4.16; *Boston Watercolor
 Sketchbook (1899 Sketchbook)*, 62,
 78, 82, 86, 99, 121, 134, 136;
 Figs. 4.5, 4.9, 4.10, 4.14, 4.21, 5.2;
 Boulevard des Capucines, 7; *Circus
 Scene with Horse* (private collection),
 110; *Circus Scene with Horse* (Terra
 Museum), 110; *Crescent Beach*,
 60–61, 82; Fig. 4.8; *Excursionists,
 Nahant*, 136; Fig. 6.1; *Flying Swings,
 The*, 134; Fig. 5.1; *In the Bois*, 7;
 Fig. 3.2; *In the Park*, 7, 53; Fig. 3.6;
 *Large Boston Public Garden
 Sketchbook*, 8, 45, 60–131; No. 4;
 Late Afternoon, Summer (*Late
 Afternoon; Afternoon on the Beach*),
 134, 136; No. 6; *Low Tide,
 Beachmont* (Lehman), 136–38;
 No. 7; *Low Tide, Beachmont*
 (Worcester), 137; Fig. 7.2; *My Lady
 Nicotine: A Study in Smoke* (Barrie),
 illustrations for, 60, 81, 91, 106,
 112, 119, 131; Figs. 4.7, 4.11, 4.15,
 4.18, 4.24; *Nouveau Cirque*, 110;
 Old Shipyard, The, 60, 67; Fig. 4.4;
 Paris Boulevard in the Rain, 7, 57;
 Fig. 3.8; *Paris Sketchbook*, 7–59;
 No. 3; *Picnic*, 6; *Pier, The*, 136;
 Fig. 6.2; *Porte Saint Denis, La*, 7;
 Promenade, 6; *Public Garden
 (Boston), The*, 61; Fig. 4.3; *Sketches
 in Paris*, 7, 37; Fig. 3.5; *Spirit of the
 Hunt, The* (with Charles
 Prendergast), 140; *Standing Nude
 Woman and Studies of a Hand, a
 Leg, and Feet*, 138–39; No. 8; *Street
 Scene*, 61, 123; Fig. 4.22; *Swings,
 Revere Beach*, 62, 132, 134; No. 5;
 Tuileries Gardens, Paris, The, 45,

81; Fig. 4.6; *Two Girls on a Bridge*,
 7, 22; Fig. 3.3; *Two Women in a
 Park*, 7, 59; Fig. 3.10; *White Horse
 and Circus Rider, The*, 61, 110;
 Fig. 4.17; *Woman and Girl*, 7, 55;
 Fig. 3.7; *Woman Walking Seen from
 Behind*, 8; Fig. 3.1
Preston, James Moore, 168, 170, 172–75
 works by: *East Hampton House,
 Autumn*, 172, 174, 175; No. 18;
 Easthampton View, 174; *France*,
 172, 174, 175; No. 16; *French
 Countryside*, 172; Fig. 16.1; *Meadow,
 The*, 172, 174, 175; No. 17; *Red
 Roofs*, 172
Preston, May Wilson, 168, 172
Providence
 Rhode Island School of Design, 195
Provincetown
 Hans Hofmann School, 194
Pulitzer, Joseph, 164
pumice paper (*papier pumicif*), 176, 177

Quinn, John, 6, 140

"Reggie and the Heavenly Twins" comic
 strip, 178
Rembrandt van Rijn, 142, 164, 167, 197,
 212, 215
 works by: *Jan Six*, 207; *Saskia Looking
 Out of a Window*, 167; *Self-portrait
 as the Apostle Paul*, 212; Fig. 26.2
Remenick, Seymour, 194
 work by: *Still Life, Interior*, 194; No. 23
Renoir, Pierre Auguste, 99, 164, 168
Rhode Island School of Design, Providence,
 195
Ribera, Jusepe de, 144
Rome
 Campus Martius, 192; Fig. 21.1
 Piazza Santa Maria in Campitelli, 193
 Santa Maria in Aracoeli, 193
 Santa Maria in Campitelli, 193
 Santa Rita da Cáscia, 192, 193; Fig. 21.1
 Temple of Apollo Sosianus, 192, 193;
 Fig. 21.1
 Temple of Janus, 192, 193; Fig. 21.1
 Theater of Marcellus, 192
Root, Edward, 6
Rotterdam
 Museum Boymans-van Beuningen,
 Rembrandt: *Saskia Looking Out of
 a Window*, 167
Royal Academy of Arts, London, 2
Royal Society of Painters in Water Colours,
 London, 137
 rubbing of stamp of, Fig. 7.1
Ruskin, John, 2

Salon, Paris, 2
Salon des Refusés, Paris, 2
San Francisco
 Fine Arts Museums of San Francisco,
 Achenbach Foundation for Graphic
 Arts, Prendergast, Maurice: *In the
 Park*, 7, 53; Fig. 3.6
Sargent, John Singer, 144
Sartain, Emily, 162
Sears, J. Montgomery, 94
Sears, Sarah Choate, 94
Shinn, Everett, 6, 142, 164, 168, 170, 172,
 176
Sloan, Dolly, 144, 145
Sloan, John, 6, 142, 143, 144, 145, 164,
 167, 168, 172
Society of American Artists, 164
Society of Independent Artists, 140, 168
Sotheby's, New York, 177
Southrn, Frank L., 142
Soyer, Moses, 240
Spanierman Gallery, New York
 Prendergast, Maurice: sketchbook, 8
Spanish-American War, 168
Spark, Victor, 136
Spiro, Mr. and Mrs. Harry, collection of,
 Prendergast, Maurice: *Public Garden
 (Boston), The*, 61; Fig. 4.3
Spoleto
 Festival dei due mondi, 193
 Palazzo Arroni, 193
Steinlen, Théophile, 168
Stetzer, Mr. and Mrs. John J., collection of,
 Preston: *French Countryside*, 172;
 Fig. 16.1
Studio, The, magazine, 7
 sketches reproduced in (Prendergast,
 Maurice), 7–8; Fig. 3.1
Swinburne, Algernon, 2

Tarbell, Edmund, 99
*Tess of the d'Urbervilles: A Pure Woman,
 Faithfully Presented* (Hardy), 64
Tiffany's, New York, 192
Truex, Van Day, 192–93
 works by: *Rome III*, 192–93; No. 21;
 View of Spoleto, 192, 193; No. 22
Twachtman, John H., 176, 177
Tyler School of Art, Temple University,
 Philadelphia, 194, 197, 240

Unidentified artist
 work by: *Farm Scene (Long Island Farm)*,
 5; No. 2
United States Military Academy, West Point,
 2
University of Manitoba School of Art,
 Winnipeg, 195

Van Kemmel, Eugénie, *see* Prendergast,
 Eugénie
Velázquez, Diego Rodríguez de Silva, 142,
 144, 164
Vose Galleries, Boston, 94

*Walks and Rides in the Country Round
 About Boston* (Bacon), 132
Washington, D.C.
 Corcoran Gallery of Art, Prendergast,
 Maurice: *Afternoon*, 61, 123; Fig.
 4.23
 Freer Gallery of Art, Whistler: Peacock
 Room, 2
 National Gallery of Art, Whistler:
 *Symphony in White, No. 1: The
 White Girl*, 2

National Museum of American Art, 240
Weir, Robert W., 2
Whistler, James Abbott McNeill, 2–4, 7,
 144, 176
 works by: *Arrangement in Gray and
 Black: Portrait of the Artist's Mother*,
 2; *Museum Interior(?) with a Man
 Seated (Figure in an Interior)*, 3–4;
 No. 1; *Nocturne in Black and Gold:
 The Falling Rocket*, 2; Peacock
 Room, 2; *Symphony in White, No.
 1: The White Girl*, 2
Whitmarsh, Hubert P., 60, 63, 117
Wilde, Oscar, 2
Wilde, W. A., and Co., Boston, 69
Williamstown (Massachusetts)
 Williams College Museum of Art,
 Prendergast, Charles: *Beach Scene
 with Prancing Goats*, 142; Fig. 9.2;
 Prendergast, Maurice: *Pier, The*,
 136; Fig. 6.2; sketchbooks, 8
Wilmington
 Delaware Art Museum, Prendergast,
 Maurice: sketchbook, 8
Wilson, May, *see* Preston, May Wilson
Winnipeg
 University of Manitoba School of Art,
 195
Worcester Art Museum, Prendergast,
 Maurice: *At a Fountain in the Public
 Garden (Frog Pond)*, 61, 94, 97;
 Fig. 4.12; *Low Tide, Beachmont*, 137;
 Fig. 7.2
World's Fair, New York (1939), 140

Yale University, New Haven, 195
"Yellow Kid, The," comic strip, 164